P9-COO-920

Wild
L.A.

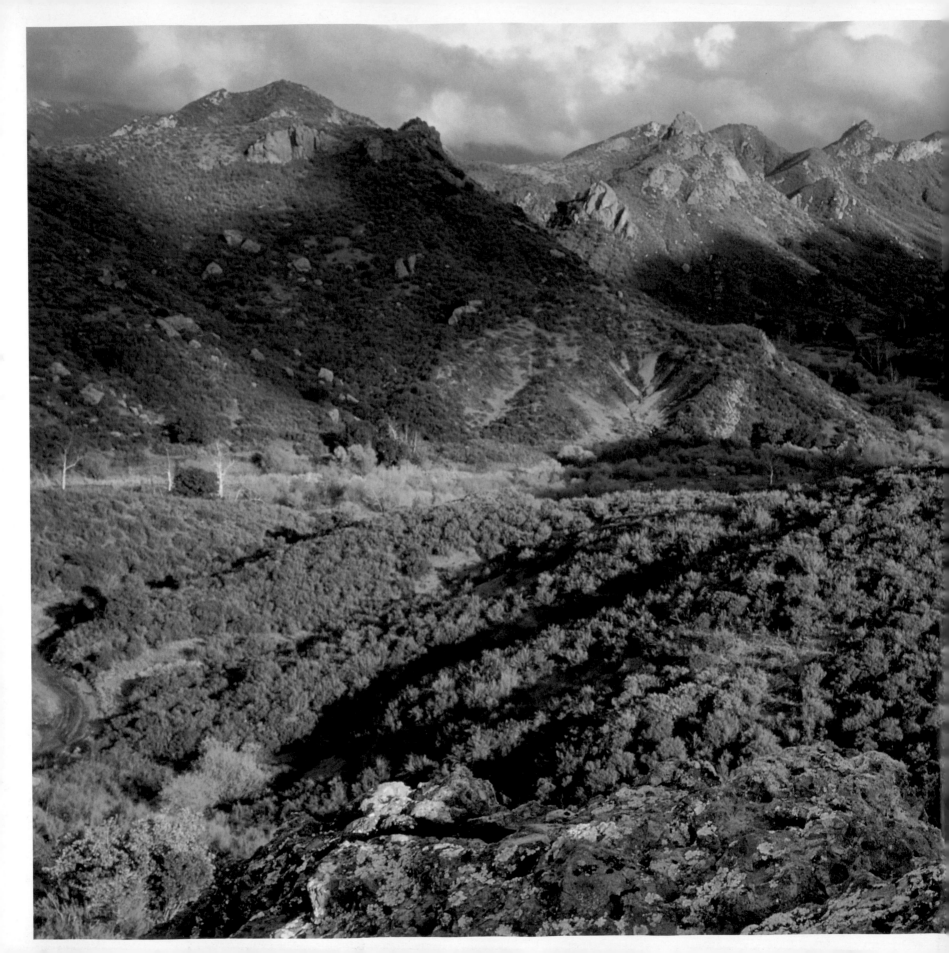

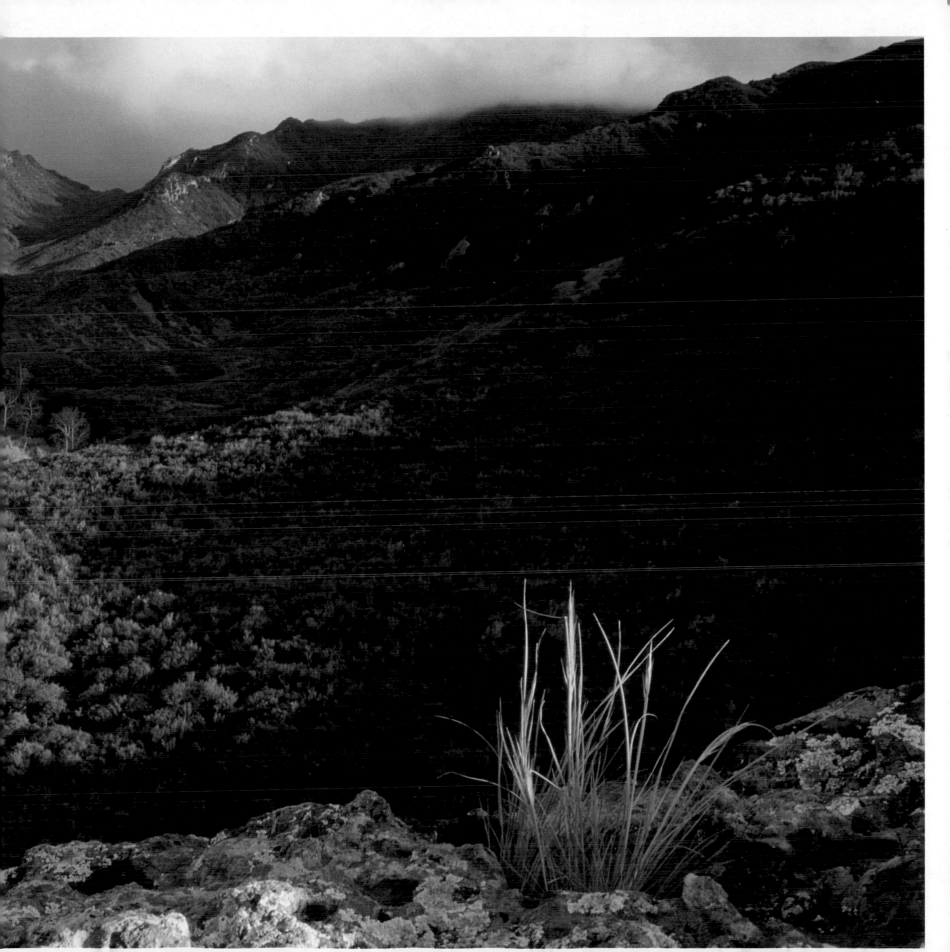

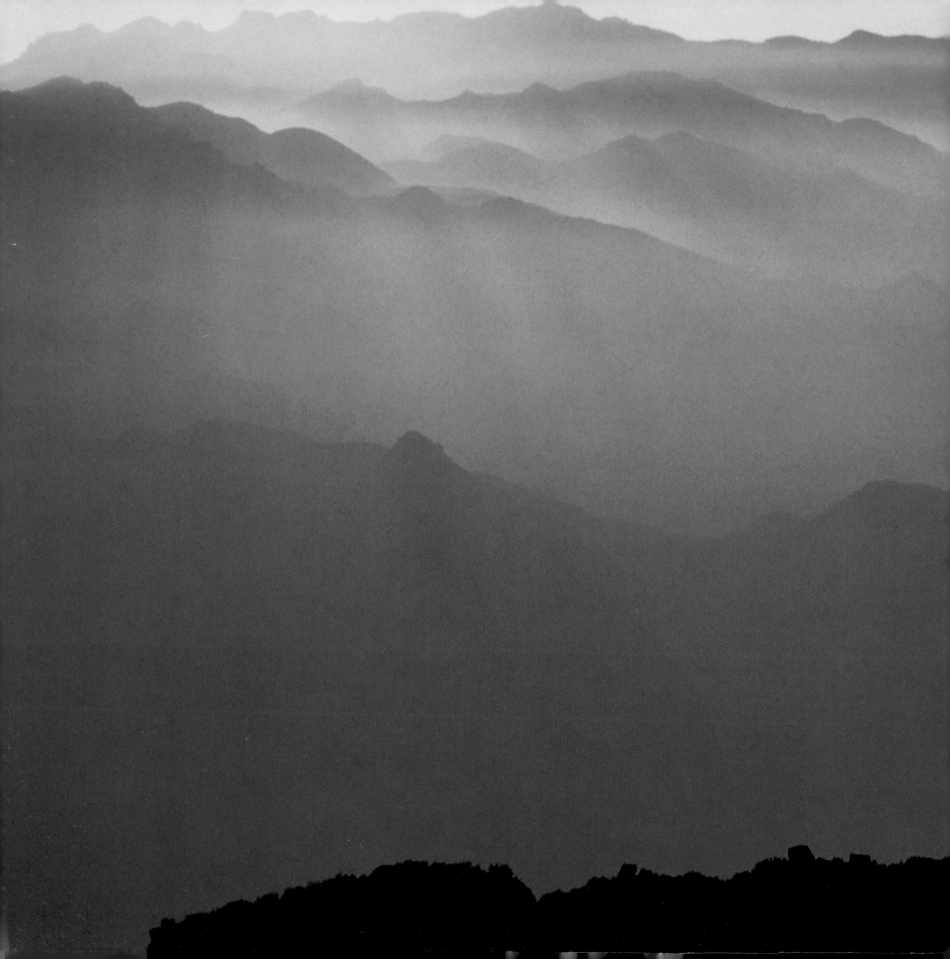

Wild L.A.

A CELEBRATION OF THE NATURAL AREAS IN AND AROUND THE CITY

TEXT BY JAMES LAWRENCE

GALEN ROWELL, SERIES EDITOR

SIERRA CLUB BOOKS

SAN FRANCISCO

The Sierra Club, founded in 1892 by John Muir, has devoted itself to the study and protection of the earth's scenic and ecological resources—mountains, wetlands, woodlands, wild shores and rivers, deserts and plains. The publishing program of the Sierra Club offers books to the public as a nonprofit educational service in the hope that they may enlarge the public's understanding of the Club's basic concerns. The point of view expressed in each book, however, does not necessarily represent that of the Club. The Sierra Club has some sixty chapters throughout the United States and in Canada. For information about how you may participate in its programs to preserve wilderness and the quality of life, please address inquiries to Sierra Club, 85 Second Street, San Francisco, CA 94105, or visit our website at www.sierraclub.org.

Text copyright © 2001 by James Lawrence
Map copyright © 2001 by Sierra Club
Photographs copyright © by individual photographers as credited on page 192

All rights reserved under International and Pan-American Copyright Conventions. No part of this book may be reproduced in any form or by any electronic or mechanical means, including information storage and retrieval systems, without permission in writing from the publisher.

First paperback edition 2003

Published by Sierra Club Books
85 Second Street, San Francisco, CA 94105
www.sierraclub.org/books

Produced and distributed by
University of California Press
Berkeley and Los Angeles, California
University of California Press, Ltd.
London, England
www.ucpress.edu

SIERRA CLUB, SIERRA CLUB BOOKS, and the Sierra Club design logos are registered trademarks of the Sierra Club.

Project editor: Linda Gunnarson
Book and cover design: Tom Morgan and John O'Brien
Map: GreenInfo Network
Preproduction: Linda Bouchard and Lynne O'Neil

Library of Congress Cataloging-in-Publication Data
Lawrence, James, 1945–
 Wild L.A.: a celebration of the natural areas in and around the city/text by
 James Lawrence; foreword by Galen Rowell.
 p. cm.
 Includes bibliographical references (p.).
 ISBN 1-57805-074-X (hardcover: alk. paper)
 ISBN 1-57805-103-7 (paperback: alk. paper)
 1. Natural areas—California—Los Angeles Region. 2. Natural areas—
California—Los Angeles Region—Pictorial works. I. Title.

 QH76.5.C2 L38 2001
 508.794'93—dc21
 2001020554

Printed in Spain
07 06 05 04 03
10 9 8 7 6 5 4 3 2 1

photographs
pages **2–3**: *Valley where MASH television show was filmed, Malibu Creek State Park* page **4–5**: *Sunset view from Saddle Peak, overlooking Malibu Creek State Park* page **7**: *Humboldt lily* page **8**: *After the rain, Malibu Creek State Park* pages **10–11**: *California poppies, Antelope Valley* page **12**: *Red-shouldered hawk and chicks* pages **14–15**: *Sycamores along Malibu Creek*

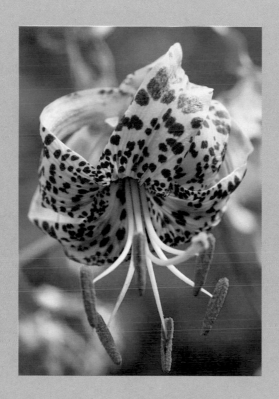

For Bridget Ciel and Jamie Mae
Beloved daughters, irreplaceable friends, you have
taught me everything about
love, devotion, and trust.

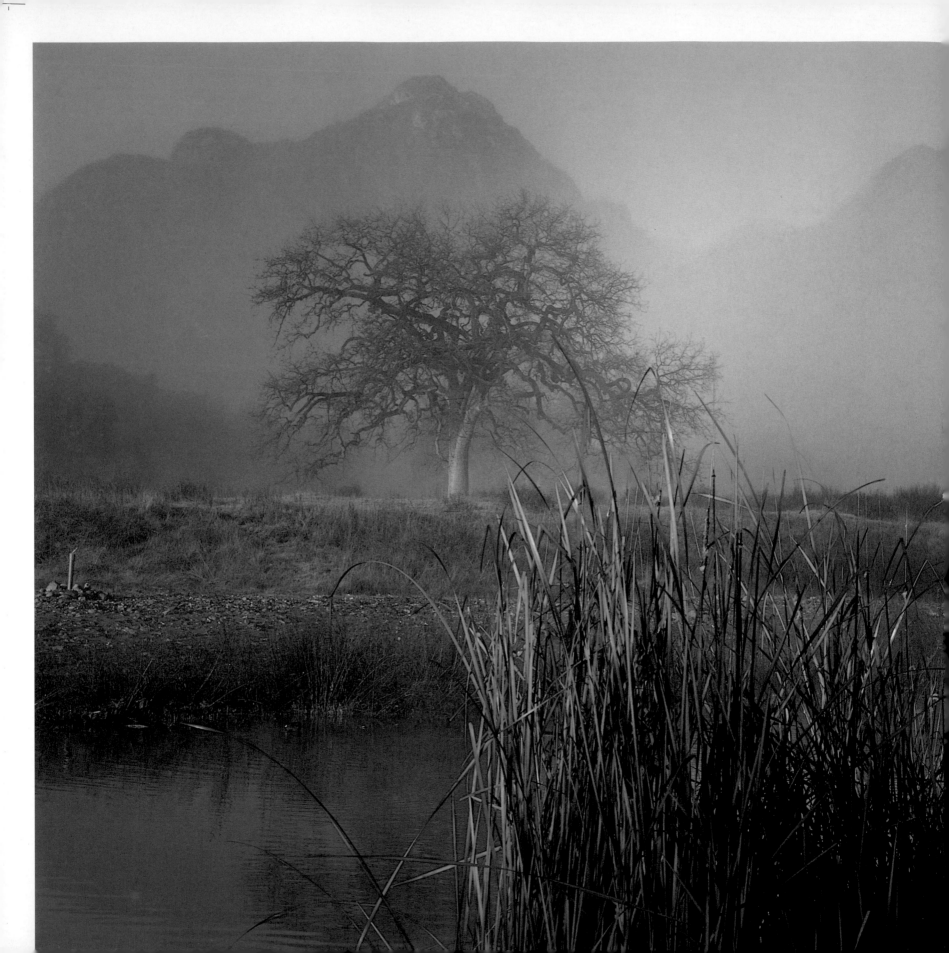

Acknowledgments

I am deeply grateful to Sierra Club Books editor Linda Gunnarson, who thought of me for this project and lit up my enthusiasm with her own. She and I were both surprised and challenged by how expansive and complex Wild L.A.— the experience and the book—turned out to be. Without her consummate editing skills and patient counsel, the project could not have been completed. Linda's never-wavering belief in the book and its message and her endless good cheer got me back on track and kept me going.

Many other friends and colleagues along the way provided invaluable guidance from beginning to end: Galen Rowell, whose very life of high adventure, art, wisdom, and humanity in the service of the natural world provides constant inspiration (and recurring fits of unabashed envy); Helen Sweetland, publisher of Sierra Club Books, for her hands-on editorial contributions and determination to see this project through; Bill Corcoran of the Sierra Club, who generously shared his time and comprehensive knowledge of conservation efforts throughout Los Angeles and helped immeasurably to inform my surprisingly incomplete appreciation of the Big Picture; David Brown of the Sierra Club, whose decades of devotion to saving and protecting Santa Monica Mountains and Rim of the Valley open space opened my eyes to a scope and nuance I had scarcely imagined from my own excursions; Jean Bray, public-relations godsend from the National Park Service Visitor Center in Thousand Oaks, California, for her gracious help in providing key information for the book; Tom Gamache, whose sensitive, lyrical photography graces so many of the pages of this book; Gary Valle, a hang-gliding cronie from the 1970s who provided photography for the book and a memorable reminiscence of the day the bulldozers took down a favorite natural area; Jeff Yann of the Sierra Club for his amiable insights into the Puente-Chino Hills Wildlife Corridor; Harriet Burgess of the American Land Conservancy for important information on the late-breaking Vista Pacifica purchase in the Kenneth Hahn State Recreation Area of central Los Angeles; Richard Jackson for more than two decades of magnificent wildlife photography that gives Wild L.A. much of its "animal magnetism"; likewise Don DesJardin for his covey of wonderful bird images; and the other photographers whose works grace these pages with an astonishing and vivid illustration of just how rich and varied are the flora, fauna, and landscapes of Greater Los Angeles; Laura Cohen, director of the Rancho Mission Viejo Land Conservancy and my own private docent on a private tour of the Conservancy's beautiful reserve in Orange County; and finally to Marti Frederick, longtime friend and counselor, for the wonderful story of the cougar in Happy Camp Canyon.

May all their visions of concern and love for nature ignite a flame in hearts around the world, to light our way back toward Eden.

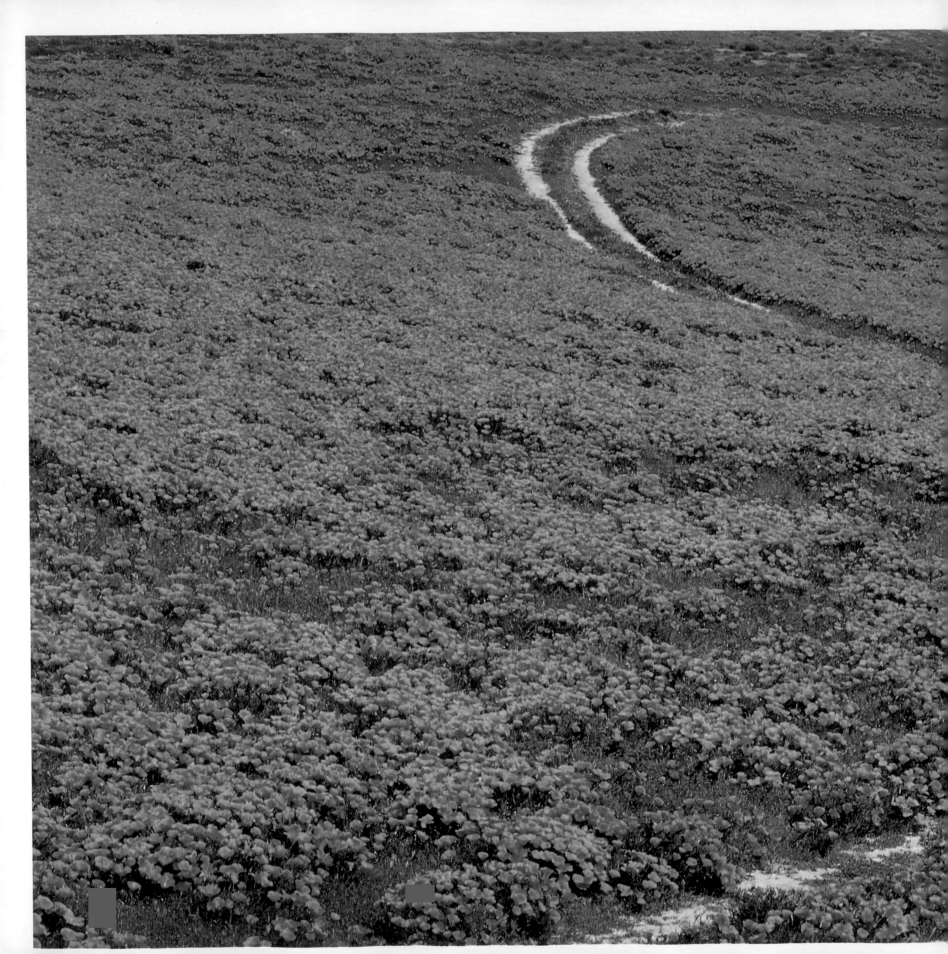

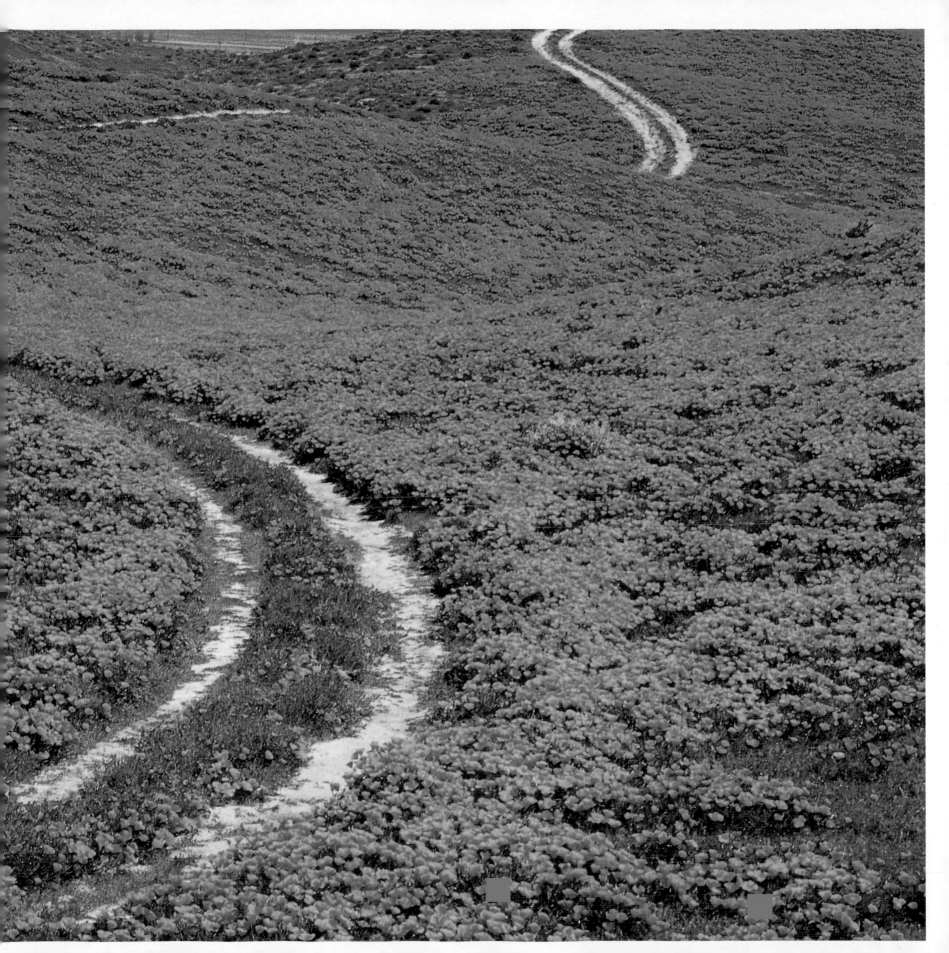

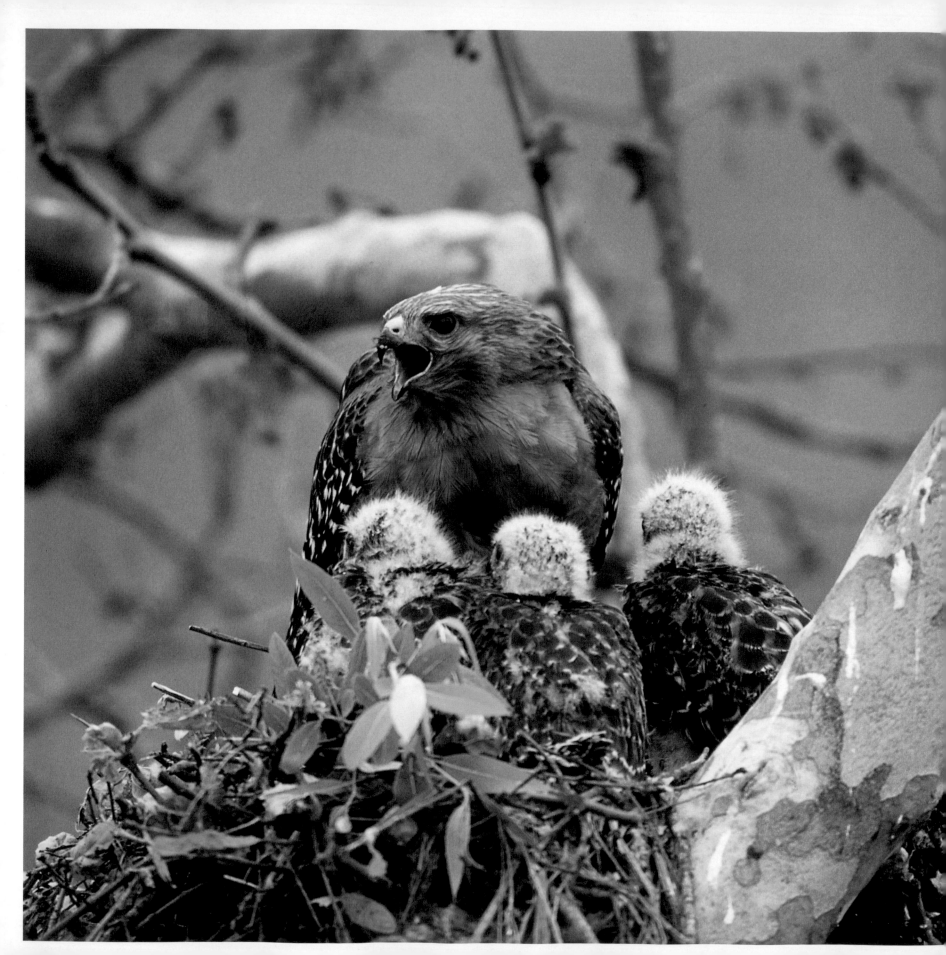

Contents

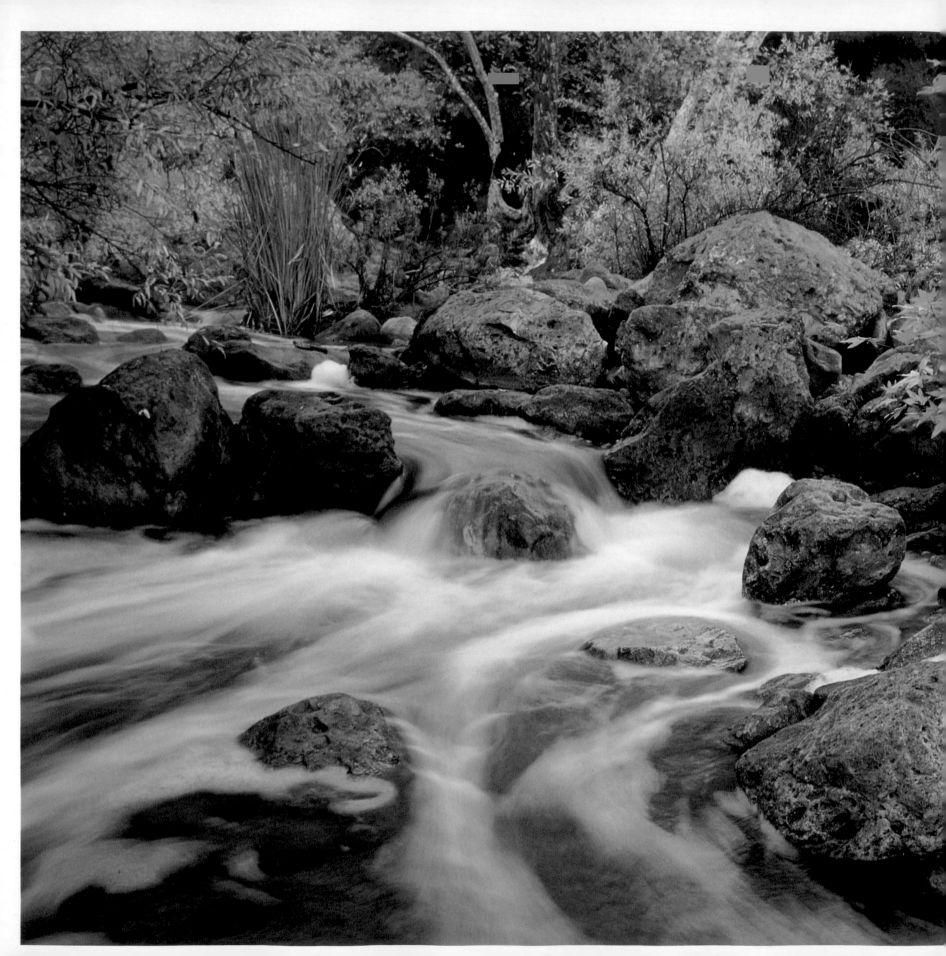

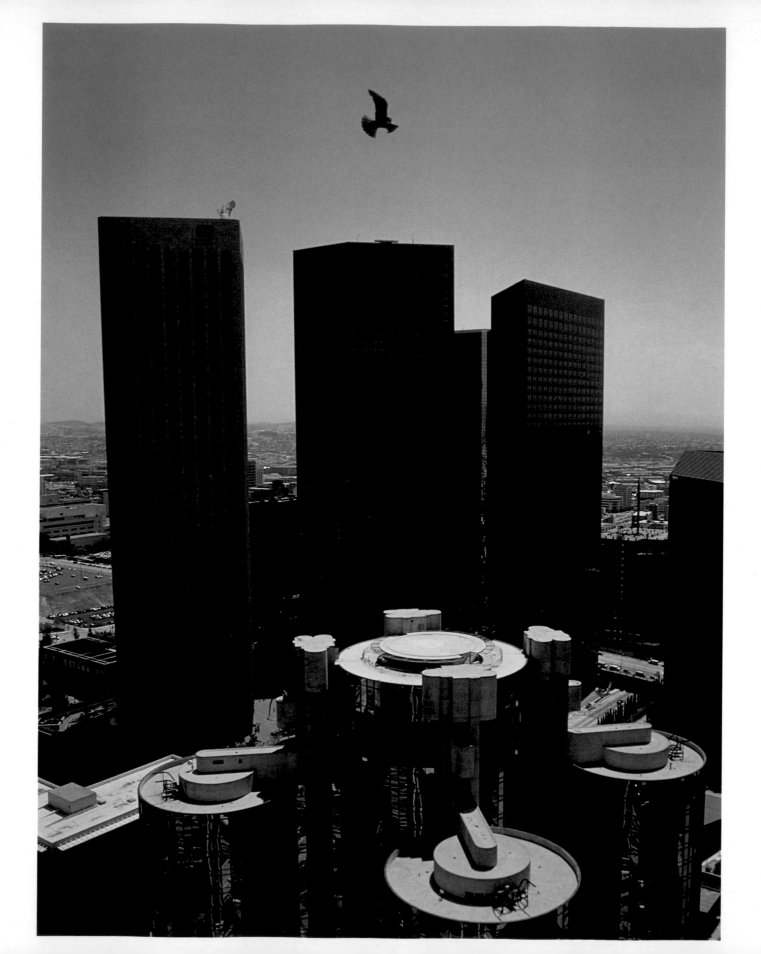

opposite: *Peregrine falcon over
downtown Los Angeles*

Foreword

One of the most surprising facts I learned in grammar school was the size of Los Angeles. The millions of people I could readily accept, but a city with 467 square miles? It would have to have so much open space.

I grew up in Berkeley, where 100,000 souls fit into just nine square miles, yet the wild, undeveloped hills behind my home that I loved to explore whetted a lifetime appetite for hiking, rock climbing, natural history, and photography. Without that youthful connection to wildness, my life would have unfolded ever so differently. I would not have traveled the seven continents on expeditions and photography assignments, nor would I have come to realize how many of the values I sought at the ends of the Earth were actually there in my own wild backyard.

Had I not had this early connection with wild places, my visits to Los Angeles would have been like family road trips where everyone's attention is drawn to the lights of the city and the bustle of the freeways. I never would have had some memorable encounters that directly fit the subject of this book, especially stepping out the thirty-ninth-floor window of the Union Bank for a quite different purpose than that of despondent investors of the 1930s.

The year was 1990, and I was on a *National Geographic* assignment to document the amazing recovery of California's peregrine falcons. Ornithologists had called the peregrine "the world's most successful flying bird" until the bird's eggshells began breaking from DDT contamination. By the 1970s, only two nesting pairs had been found in all

of California. Until captive-bred peregrines were reintroduced, the last wild sighting in Los Angeles County had been in 1946.

At first glance, the peregrine perched on the narrow window ledge of the bank looked as tame as a caged bird. As I inched toward her nest, her fierce, wild stare told me otherwise. Moments later, her mate swooped unseen out of the sky and literally parted my hair. Brian Walton, the biologist who had invited me to photograph his monitoring of the pair's eggs, motioned me back a few feet. The bird looked away and struck an insouciant pose.

When I asked Brian why the birds had been placed on a building, he chuckled and replied, "We released them in the wild elsewhere in the county. This is a classic nest site. It's their real estate equivalent of El Capitan. They seek out ledges on vertical cliffs inaccessible to egg predation from where they can dive on passing birds. These birds are wild and free."

Wilderness is as much a state of mind as of the environment for humans and falcons alike. Outside that window I found wild Los Angeles, though most of my species choose the more horizontal expanses scattered between and beyond the eighty-eight incorporated cities of Los Angeles County.

I've gotten into the habit of spontaneously searching out islands of natural open space wherever I travel, even in the most improbable situations. When I found myself staying at a Santa Monica hotel for two nights on a book tour, I tossed my running shoes and shorts on the back seat of my

opposite: *Pirate's Cove, with Point Dume in the background*

rental car as I tried to follow a schedule prearranged for me that wouldn't have been tight in a more centralized metropolitan area. I ended up late for everything, from my Pasadena lunch interview that ended at one-thirty, to my Santa Monica book signing at two, to my Northridge interview at four.

On the way back to my hotel, rush-hour traffic on the San Diego Freeway slowed to a crawl. As the sun was dropping ever lower in the sky, I noticed vast open spaces to my right. On a whim, I pulled off the nearest exit, changed in the car, vaulted a fence, and ran off into the rolling hills. Linking scant trails, parts of old roads, and dry washes with occasional brushy detours, I reached a distant summit as the clouds were turning crimson at sunset. Only later did I learn that I had been on San Vicente Mountain within the Santa Monica Mountains National Recreation Area. Running down the other side, I soon hit a dirt road that turned out to be an unpaved section of Mulholland Drive. By the time I reached my car beside the freeway in the gathering dark-ness, the peak of rush hour had passed, and I felt totally renewed by yet another mini-exploration of urban wildness.

Countless similar adventures closer to home led me to write and photograph *Bay Area Wild*, published in 1997, the book that inspired this Sierra Club Books series. Only as I began to research it did I come to realize that protected wildlands within forty miles of San Francisco actually surpass those of Yosemite National Park in land area, visitation, and biodiversity. These facts were not previously common knowledge, because—as in Los Angeles—the lands are a patchwork quilt managed by different public and private agencies. Viewing them as a singular regional heritage, like a national park or wilderness area, greatly increases the likelihood of stewardship. It is my hope that the pages that follow will not only raise your own consciousness about the great extent and natural beauty of wild Los Angeles, but also help keep these lands protected and accessible for future generations. Everywhere on Earth, quality of life is inextricably tied to quality of landscape.

—Galen Rowell
March 2001

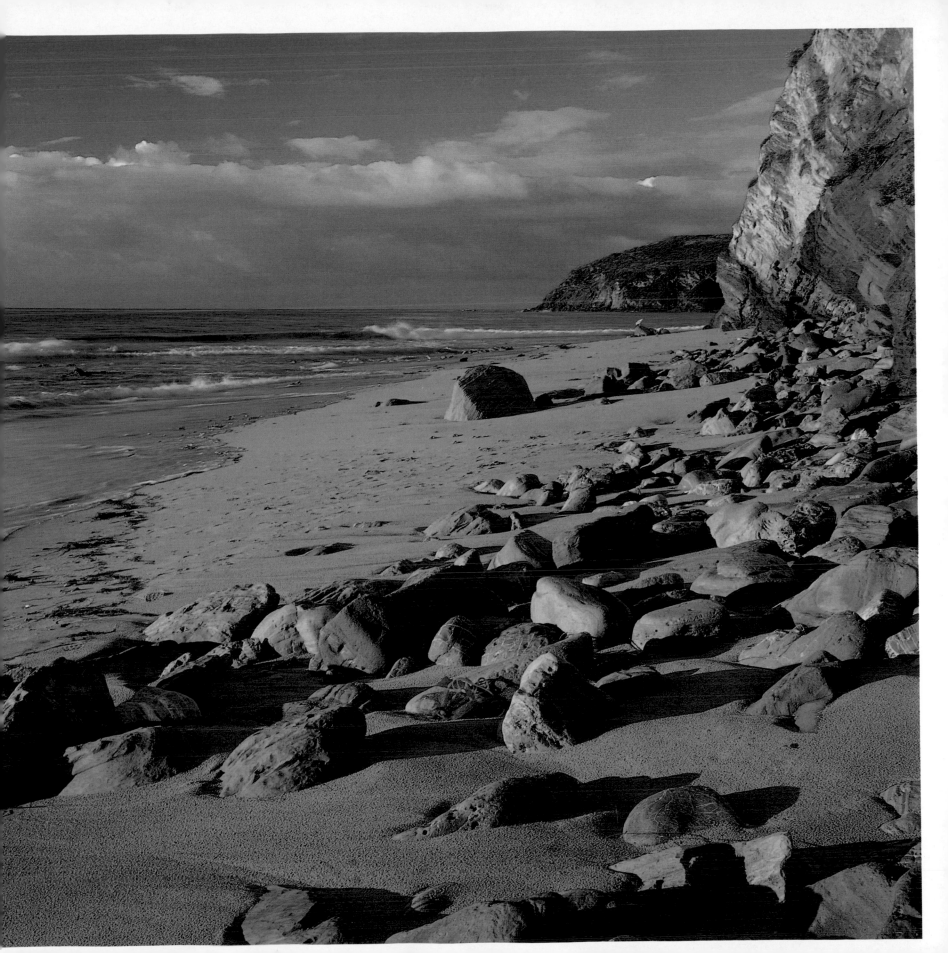

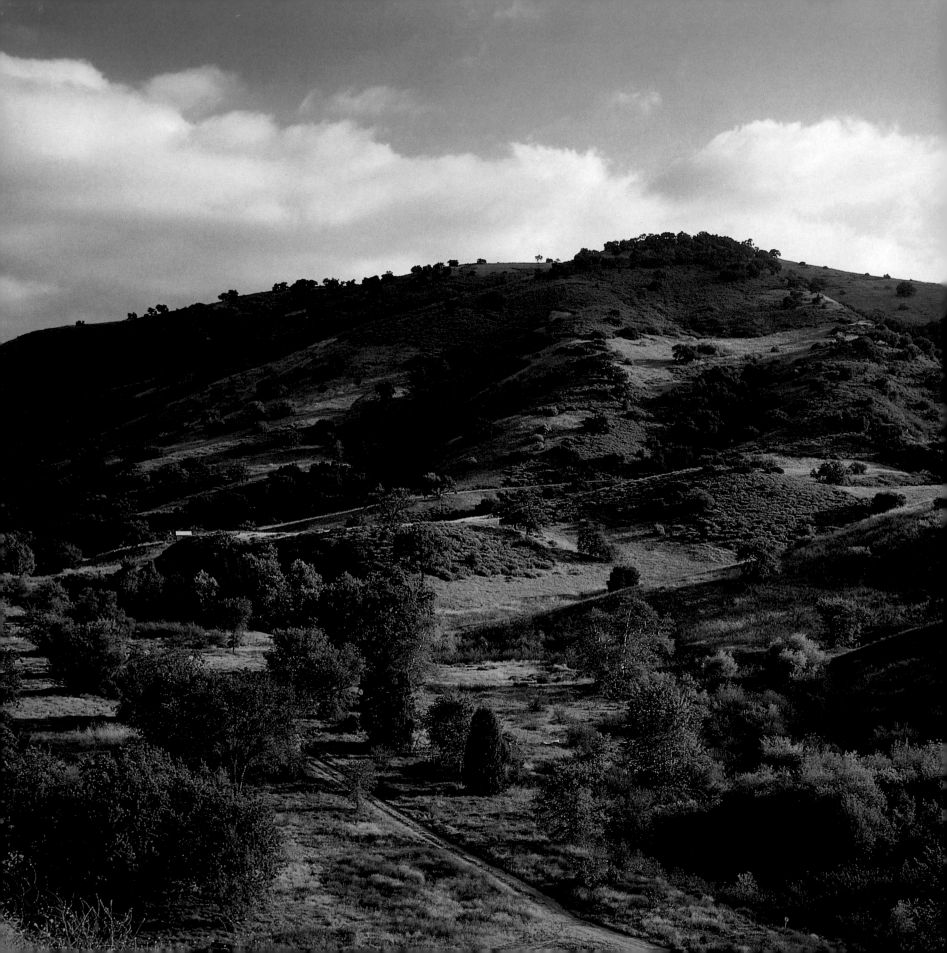

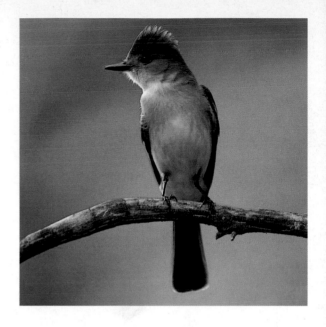

opposite: *The embattled Ahmanson Ranch property, Simi Hills* **right:** *Ashthroat flycatcher, Rancho Mission Viejo Land Conservancy Wilderness Reserve*

A Walk on the Wild Side

TO SEE A WORLD IN A GRAIN OF SAND / AND HEAVEN IN A WILD FLOWER, / HOLD INFINITY IN THE PALM OF YOUR HAND / AND ETERNITY IN AN HOUR. **–WILLIAM BLAKE**

For years I lived within the rush and crush of the megalopolis we call the City of Angels, yet I never knew about this magic place that spreads out before me like a dream. Framed by blue sky and warm sunlight, soothed by the gentle caress of sage-scented mountain breezes, a small sylvan lake in Malibu Creek State Park lies like a bright jewel in a hollow below steep slopes. Ducks glide around clusters of willowy reeds and bulrushes rising from the shimmering water. Dense scrub, sycamores, and oak trees fill a rough and rocky terrain that rises steeply into a ring of dusky-green mountain walls.

Wild
L.A.

opposite: *A sea of poppies in the Antelope Valley, with the Tehachapi Mountains in the distance*

This is wild country. If I didn't know better, I'd swear I was in the middle of the Central Coast mountains, 300 miles away. Yet a mere half-hour drive would put me smack-dab in the center of one of the densest urban concentrations in the world: downtown Los Angeles, California.

My leg muscles burn with the afterglow of exercise from the strenuous up-and-down trail behind me. Time for a break. I take the trail down to the water's edge and lean against a large sandstone boulder. Soon, my awareness shifts from the broad panorama to the sinuous movement of reed shadow on breeze-dancing water just a few feet away. The hypnotic rhythm stirs a tide of warm and nameless joy within me, as if I had happened upon a long-lost friend.

How long has it been since I last felt this rush of simple aliveness? I don't remember, and so it has been too long.

Like any good mother, all that Mother Nature requires of us is to show up from time to time for a little visit. With her heady aromas of sage, eucalyptus, and trail dust, or in her simple infinities of light and shadow on water, she helps restore us, like grains of colored sand, to our place within the cosmic mandala.

In such innocent pleasures as watching wildlife or taking in vistas uncluttered by human development, thoughts are free to run to our connection with all of creation. The sharp head movements and swelling brow of an American wigeon are ghostly evocations of the dinosaurs. Hiking a high, crumbling, ochre edge of sea cliff to watch a hundred swallows dart erratically overhead, swooping and rocketing in the blustery uplift of air, I wonder at the ordered chaos of all communities.

Moving through the natural world, separated for a time from the choking angularities of the city, we remember that life, simple life, is a rich and challenging journey unto itself.

The thought of finding nature's beauty in the midst of the frenzied sprawl of Los Angeles seems preposterous. This is, after all, life-in-the-fast-lane territory where the car is king and urban growth its domain. When we try to wrap our minds around the ocean of houses and shopping malls and the vast venous network that ties them all together—the freeway system—we understand what Gertrude Stein meant when she once said about another California city: "There's no *there*, there."

There is today, if anything, too *much* there, there. If most Angelenos don't typically experience a rush of nature consciousness in their mad dashes around town, it's hardly a surprise. The media image holds fast: we expect to encounter fashion mavens, not wildlife; to race by office buildings and strip malls, not meadows and wooded trails; to retreat to neverending tracts of cookie-cutter houses, not seek out rookeries, sea-cliff caves, and underground burrows.

And yet, that common predisposition to write off Los Angeles as the place where nature has irretrievably fallen to the bulldozer and paving machine is misplaced. Yes, L.A. is the place where, it seems, a good park is hard to find. But the city of 15 million souls has a surprisingly green side to its

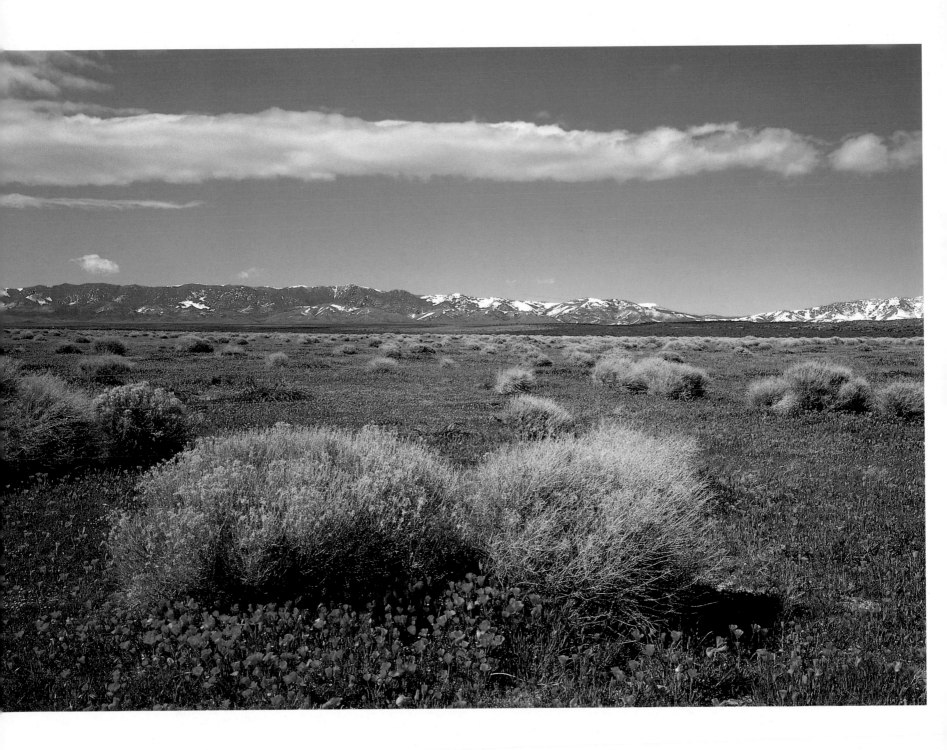

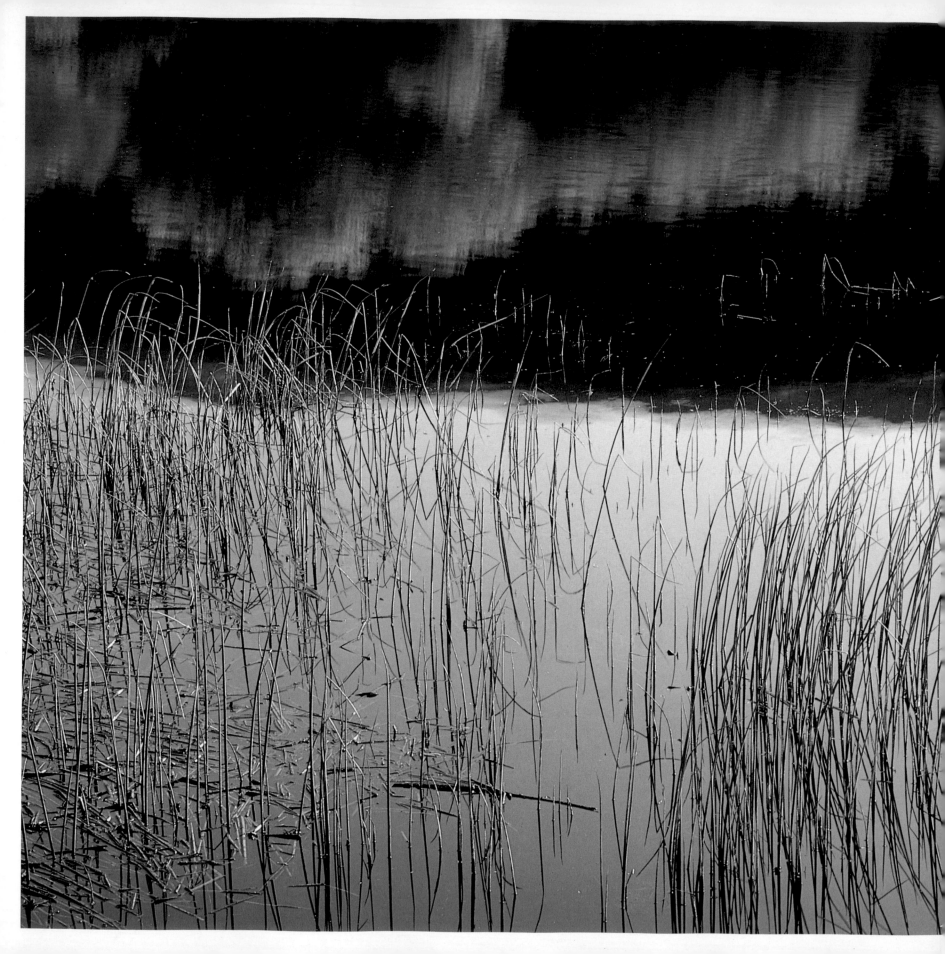

opposite: *Spring pond, Gorman Hills* **below:** *Western tree frog calling, Harding Canyon, Santa Ana Mountains*

personality, an alter ego whose full depth and complexity often elude even native Angelenos. There is indeed a Wild L.A. You just have to know where to go.

Wild L.A. lives in the midst of palm-tree-lined, traffic-flooded boulevards, among the hillside mansions and blue-gem spray of swimming pools, just beyond the near horizon of high-rise corporate might. The surprising truth is, a more diverse, bountiful natural environment exists within the city and county limits of Los Angeles than within perhaps any other city in the United States. And, since all L.A. roads lead to everywhere, they can quickly carry you—whether by car, metro, or bicycle—to tiny enclaves and surprising expanses of natural respite far removed from the bustle of city life.

Once a broad coastal floodplain, ringed by mountains high and low, fed by a large and ambling river that the first Spanish explorers called "Our Lady of the Angels of Porciúncula," the Greater Los Angeles area still contains mountain wilderness areas, open canyon meadows, running waters full of fish, and wildlife sanctuaries. Because there are, in truth, so many parks, forests, and natural areas to consider in Wild L.A., we will limit our journeys of discovery to those requiring no more than a ninety-minute drive from downtown. Most of L.A.'s wild places can be reached in under an hour, and many are a mere fifteen-minute drive from downtown's landmark Terminal Annex. These natural getaways embrace a diversity of environments even most natives fail to appreciate fully.

"From the mountains to the sea, to all of Southern California, a good evening" is how Jerry Dunphy, the silver-haired news anchor, has welcomed viewers to his television broadcasts since 1960. Given enough time, he might add, "…and to the arid deserts and high chaparral, the grasslands and oak and eucalyptus groves, the rocky offshore islands, wildflower meadows, marine wetlands, creeks and streams, lakes and ponds, pine forests, beaches, and thousands of miles of hiking trails."

The surprising diversity of wildlife in the region includes an astonishing array of birds: more than 500 varieties are found on the Los Angeles Audubon Society's

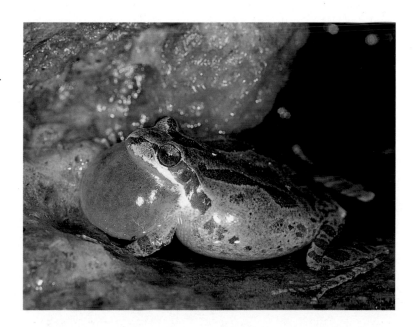

bird-watching checklist. The many climate zones—from arid desert to subtropical mountain to moist marine—confer a broad range of mammals, reptiles, and insects as well, from the commonly encountered jackrabbit, garter snake, and monarch butterfly to the rarely seen mountain lion, red racer snake, and Santa Monica shieldback katydid.

Nearly fifty of L.A.'s wildlife species are on both state and federal threatened or endangered species lists. On Anacapa Island, northwest of Los Angeles, the endangered California brown pelican enjoys its only nesting site in the western United States. Over the chaparral- and pine-covered mountain canyons, the endangered bald eagle soars in search of prey. In the high western Mojave Desert and arid Antelope Valley, the threatened desert tortoise struggles for survival against ongoing suburban development of the greater Mojave.

From December to the end of February, thousands of people board whale-watching boats to witness the pageantry of another creature recently removed from the endangered species list: the gray whale. In their annual migration from the Arctic to Baja California, thousands of grays and Earth's largest of mammals, the blue whales (on the federal but not the state endangered list), pass as close as half a mile from the mainland coast.

From the mountains to the sea…welcome to Wild L.A.

The World Wildlife Fund lists Southern California's temperate, moist coastal region, which reaches from the state's Central Coast down to northern Baja California, among its Global 200 "Ecoregions" under the broader category "Mediterranean Shrub and Woodlands." Although there are only five such zones in the world, they are home to 20 percent of the entire planet's plant species.

The dominant vegetation throughout the Greater Los Angeles and Southern California region is chaparral—that dense, dry, often impenetrable ankle-to-sometimes-tree-high groundcover of small-leaved, evergreen plant communities. Virtually every undeveloped area in the Los Angeles Basin and throughout Southern California is cloaked in varieties of indigenous and introduced chaparral plants that thrive in the warm, wet winters and long, dry summers of the Mediterranean-type climate.

Chaparral vegetation loves it here. Rather than sprouting in spring and lying dormant throughout winter, this scrubland flora makes the most of the coastal region's mild winters. New shoots appear not only in spring but also after the late-fall rains. They grow strong throughout the moist winter months and flower and fruit in the growing warmth of spring. Visitors to Southern California's chaparral are familiar with such dense ground-cover plants as chamise, spiny saltbush, scrub oak, and manzanita.

Within this scrubland thrives a rich variety of animal life. Seed-eating rodents; reptiles, such as the rattlesnake, coral king snake, and California tree frog; and insects, such as the tarantula, are superbly adapted to the biome. Some are year-round dwellers, while others, including ground squirrels,

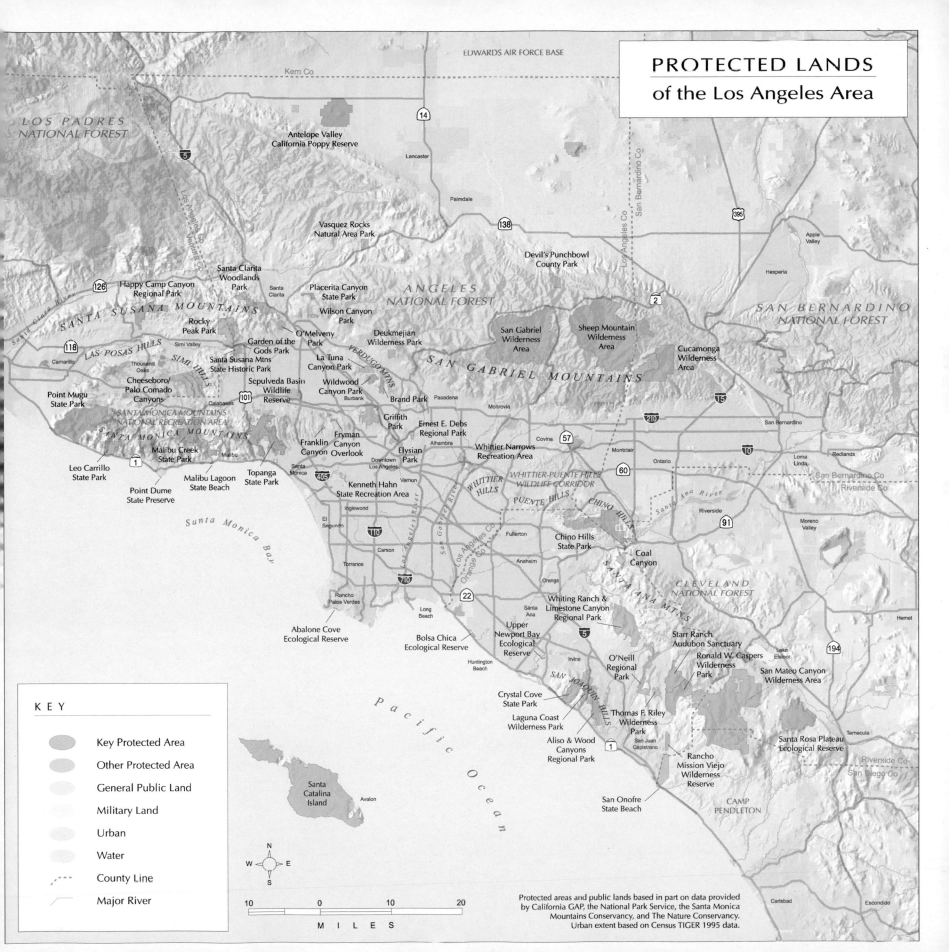

PROTECTED LANDS
of the Los Angeles Area

EDWARDS AIR FORCE BASE

Kern Co

LOS PADRES
NATIONAL FOREST

Antelope Valley
California Poppy Reserve

Lancaster

Palmdale

Apple
Valley

Hesperia

Vasquez Rocks
Natural Area Park

Devil's Punchbowl
County Park

SAN BERNARDINO
NATIONAL FOREST

Happy Camp Canyon
Regional Park

Santa Clarita
Woodlands
Park

Placerita Canyon
State Park

Santa
Clarita

ANGELES
NATIONAL FOREST

Cucamonga
Wilderness
Area

Sheep Mountain
Wilderness
Area

San Gabriel
Wilderness
Area

SANTA SUSANA MOUNTAINS

Rocky
Peak Park

Wilson Canyon
Park

Simi Valley

LAS POSAS HILLS

O'Melveny
Park

Deukmejian
Wilderness Park

SAN GABRIEL MOUNTAINS

Garden of the
Gods Park

Camarillo

Thousand
Oaks

SIMI HILLS

Santa Susana Mtns
State Historic Park

La Tuna
Canyon Park

VERDUGO MTNS

Cheeseboro/
Palo Comado
Canyons

Sepulveda Basin
Wildlife
Reserve

Wildwood
Canyon Park

Calabasas

Point Mugu
State Park

SANTA MONICA MOUNTAINS
NATIONAL RECREATION AREA

Burbank

Brand Park

Pasadena

Monrovia

San Bernardino

SANTA MONICA MOUNTAINS

Griffith
Park

Ernest E. Debs
Regional Park

Whittier Narrows
Recreation Area

Montclair

Loma
Linda

Redlands

Leo Carrillo
State Park

Malibu Creek
State Park

Malibu

Franklin
Canyon

Fryman
Canyon
Overlook

Elysian
Park

Alhambra

Covina

WHITTIER-PUENTE HILLS
WILDLIFE CORRIDOR

Ontario

San Bernardino Co
Riverside Co

Point Dume
State Preserve

Malibu Lagoon
State Beach

Topanga
State Park

Santa
Monica

Downtown
Los Angeles

Kenneth Hahn
State Recreation Area

Vernon

WHITTIER
HILLS

PUENTE HILLS

CHINO HILLS

Riverside

Santa Monica Bay

Inglewood

Los Angeles River

El
Segundo

Fullerton

Chino Hills
State Park

Moreno
Valley

Carson

Anaheim

Coal
Canyon

SANTA ANA MTNS

CLEVELAND
NATIONAL FOREST

Hemet

Torrance

Orange

Rancho
Palos Verdes

Long
Beach

Santa
Ana

Whiting Ranch &
Limestone Canyon
Regional Park

Starr Ranch
Audubon Sanctuary

Lake
Elsinore

Abalone Cove
Ecological Reserve

Bolsa Chica
Ecological Reserve

Upper
Newport Bay
Ecological
Reserve

Irvine

O'Neill
Regional
Park

Ronald W. Caspers
Wilderness
Park

San Mateo Canyon
Wilderness Area

Huntington
Beach

SAN JOAQUIN HILLS

Crystal Cove
State Park

Thomas F. Riley
Wilderness
Park

Laguna Coast
Wilderness Park

San Juan
Capistrano

Santa Rosa Plateau
Ecological Reserve

Temecula

Aliso & Wood
Canyons
Regional Park

Rancho
Mission Viejo
Wilderness
Reserve

Riverside Co
San Diego Co

Pacific Ocean

Santa
Catalina
Island

Avalon

San Onofre
State Beach

CAMP
PENDLETON

KEY

Key Protected Area

Other Protected Area

General Public Land

Military Land

Urban

Water

County Line

Major River

N
W E
S

10 0 10 20

MILES

Protected areas and public lands based in part on data provided
by California GAP, the National Park Service, the Santa Monica
Mountains Conservancy, and The Nature Conservancy.
Urban extent based on Census TIGER 1995 data.

Carlsbad

Escondido

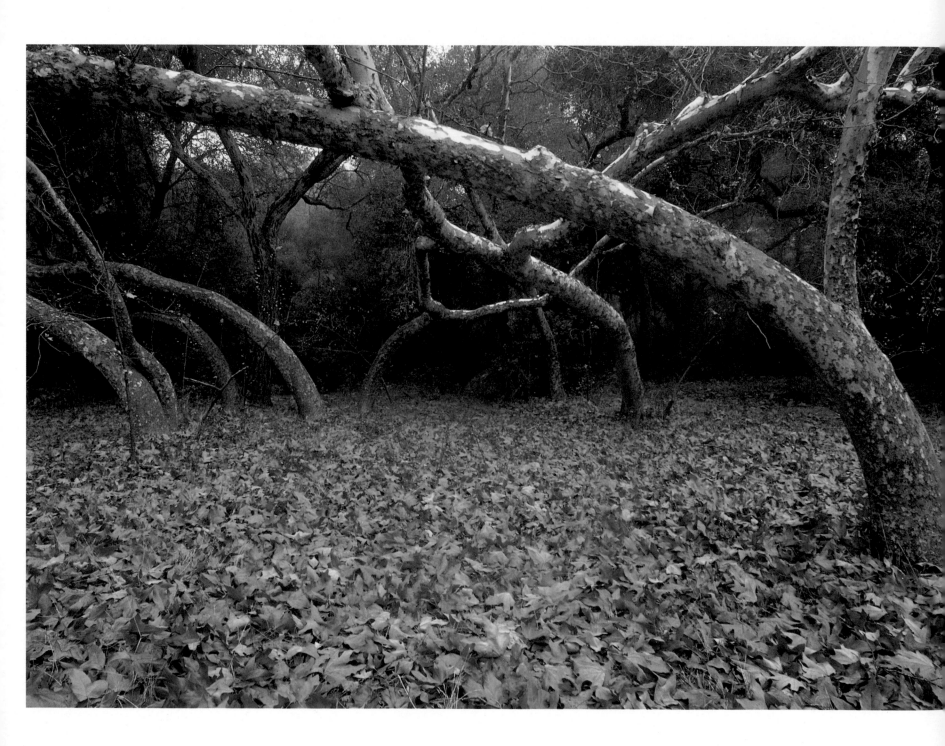

opposite: *Sycamores in an ocean
of leaves, Santa Rosa Plateau
Ecological Reserve*

kangaroo rats, and scores of bird species, migrate into adjacent cooler woodlands before the summer heat arrives.

Wild L.A.'s world-celebrated climate beguiles residents and visitors alike into a false sense of security, for this is a land of high drama as well. Although California is famous for its massive San Andreas Fault, which runs the length of the state, underground Los Angeles is a fracture zone of hundreds of other small and large faults. As if earthquakes weren't enough excitement for the locals, the entire region is also susceptible to cataclysmic wildfires during the dry summer months, especially when the Santa Ana winds blow from the desert to the sea. Yet, in a fascinating example of natural adaptation, fire proves to be essential to the health of the very scrublands it threatens; it is an indispensable agent for the chaparral's regeneration.

Within this larger climatic context, discrete microclimates abound. The mountains that ring Los Angeles squeeze moisture from the rising air as it drifts eastward, creating the desert regions of the Mojave. Southern California's miles of sandy beaches offer a cooling respite during the summer, when temperatures can soar more than thirty degrees higher just a few miles inland.

Millions of transplants to the L.A. area would confess that they moved here mostly for the climate. Balmy temperatures, ranging from lows rarely below freezing to highs that only occasionally break 100 degrees Fahrenheit, help explain why so many more continue to arrive in the area. A thriving economy only increases the allure. Yet, in the end, it may be

L.A.'s unexpectedly rich array of natural areas that ultimately earns the lasting devotion of the people who live here.

L.A., the bustling, freeway-dependent city, can bewilder the senses. In the chapters ahead you will discover another side to Los Angeles through its many natural areas. There are the obvious icons: the Santa Monica Mountains, Griffith Park, and Catalina Island. There is also a wealth of relatively unknown areas of restored and protected wildlands nestled within and around the city. At the end of our journey, we will know this place in a new way—as a great metropolis with its wild soul intact.

Our adventure begins with "Santa Monica Mountains," exploring the broad coastal mountain zone of more than 150,000 acres that forms the western wall of the Los Angeles Basin, which ends at the curve of Santa Monica Bay. The fifty-mile-long rise of low, rocky, chaparral- and tree-cloaked mountains climbs and widens to present its highest peaks to the sea. Visitors enter this dramatic and changeable mountain realm from the serpentine Pacific Coast Highway or from the many roads and freeways that run just beyond its northern boundaries.

Picturesque waterfall canyons and grottos; coastline vistas above movie-star communities; hundreds of miles of hiking, biking, and horse trails; and well-managed recreational areas, large and small, form an aggregate of protected wildlands and parklands known as the Santa Monica Mountains National Recreation Area.

opposite: *Japanese Garden at Donald C. Tillman Water Reclamation Plant, adjacent to Sepulveda Basin Wildlife Reserve*

Nowhere else in and around Los Angeles will you find so large an area that is more representative of the local Mediterranean biome or find greater opportunity for diverse immersions in nature. Stream-fed grottos, riparian woodlands, high-plateau chaparral vistas, breathtaking ocean views, lakes, ponds, grasslands, and valleys make this recreation area a popular destination year-round.

In "Rim of the Valley" we move north from the Santa Monica Mountains into rocky, high hill systems and low mountain buffer zones that set off densely populated areas such as the San Fernando and Simi Valleys and the Oxnard Plain. Many tracts of small, transverse mountain ridges offer rugged escapes for adventurous hikers, hang-glider pilots, and mountain bikers through undeveloped preserves and natural areas and beautifully maintained parks.

The rugged, rocky country of the Simi Hills, Oak Ridge, Big Mountain, and Santa Susana Mountains continues the high western barricade sometimes called the "Rim of the Valley" that begins along the Santa Monica Mountains' northern edge. Up steep riparian canyons, across high ridge trails, and through verdant oak valleys and lowlands, you can occasionally find signs of mountain lions or even encounter a surprise winter snowfall, and it all begins just twenty-five minutes from downtown L.A.

"Wild in the City" takes us to a surprising variety of natural areas, from mountain-wall foothills to broad ocean beaches, in the very heart of the city. Along with long-standing natural sanctuaries such as Griffith Park (the largest park within any city limits in America), newly developed areas such as Kenneth Hahn State Recreation Area (reclaimed from an ugly, oil-derrick-bristling hillside), Sepulveda Basin Wildlife Reserve (one of the few wetland areas along the fifty-one-mile-long Los Angeles River), and Ernest E. Debs Regional Park (a hilltop, 282-acre wooded wilderness expanse and bird sanctuary just a few miles from downtown Los Angeles) enrich the opportunity for Angelenos to have a nature experience right in their own backyards.

Just twenty-two miles out to sea, Santa Catalina Island offers an almost completely unspoiled nature experience. Along the way between Catalina and the long, sandy shores of L.A. proper, the upwelling of cold, nutrient-rich ocean currents ensures a treasure of pelagic bird sightings, abundant sea life, and, in winter, the chance to spot migrating gray and blue whales.

Mix in the Los Angeles coastal areas that run south from Santa Monica through the rocky cliffs and migrant bird stopovers of the Palos Verdes Peninsula, and you find an astonishing variety of natural areas to explore.

"San Gabriel Mountains" celebrates the range that forms a twenty-four-mile-wide divider between the Mojave Desert and the Los Angeles Basin. The high, rugged Angeles and Los Padres National Forests are the "Little Sierra" of Los Angeles. More than 650,000 acres of mostly undeveloped mountains offer camping, hiking, swimming, boating, winter skiing, and mountain biking in wilderness settings. And

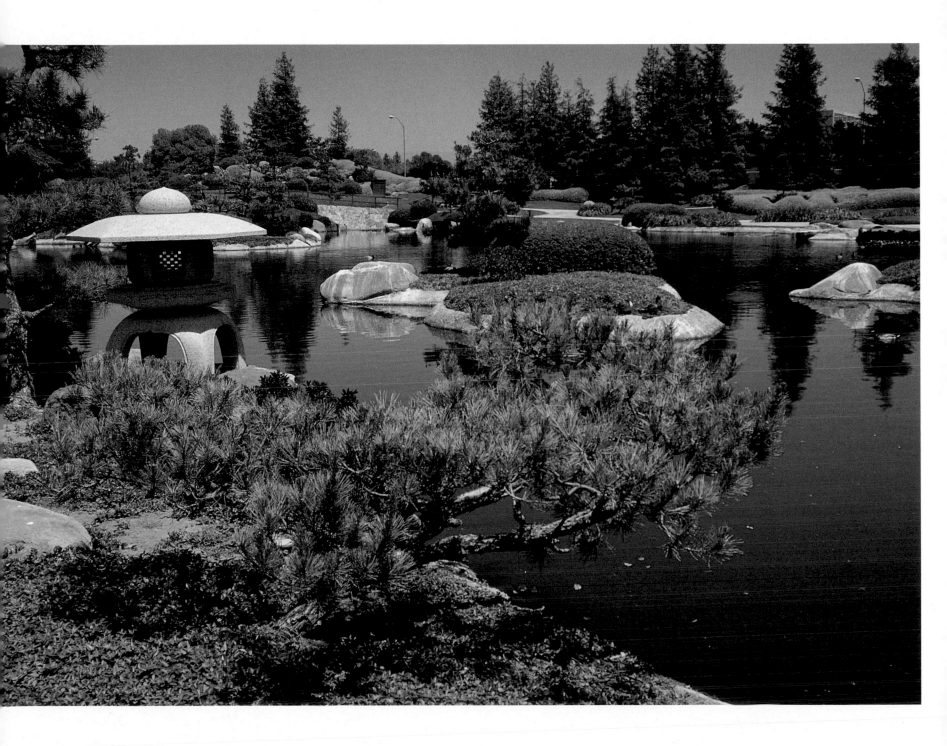

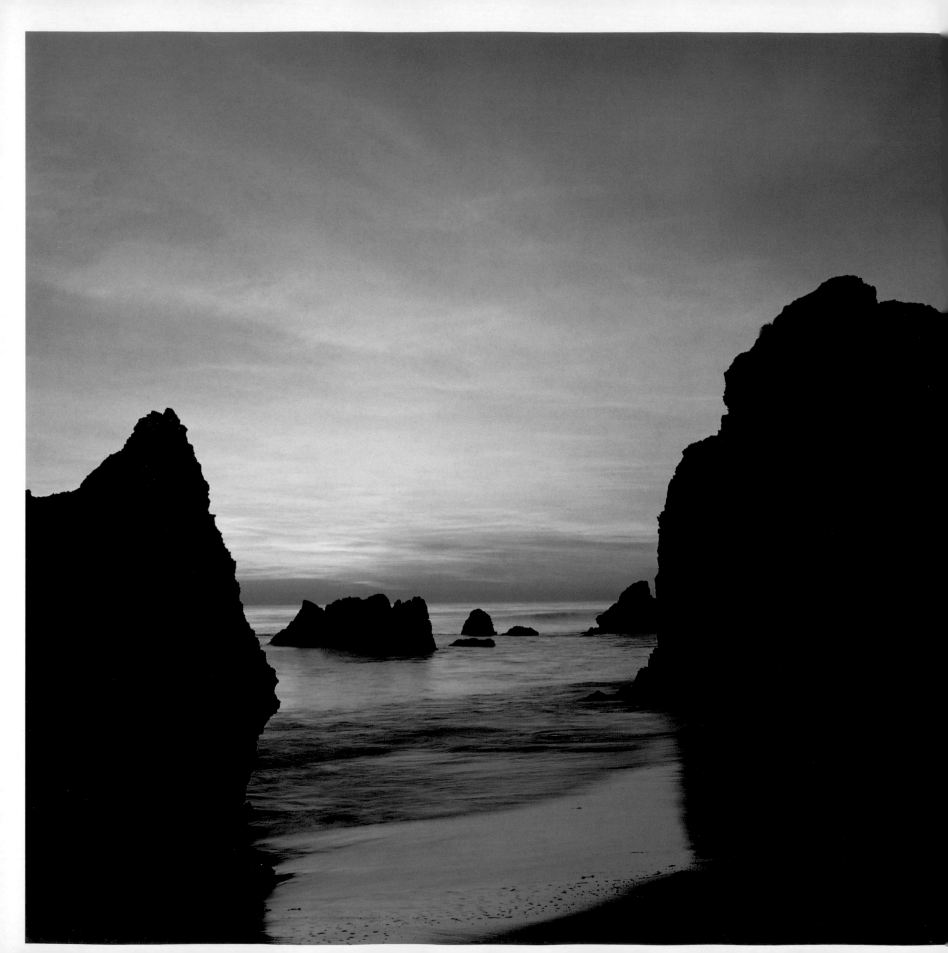

opposite: *Winter sunset,*
El Matador State Beach

a path runs through it: a major section of the 2,600-mile Pacific Crest Trail.

The San Gabriels are the mainstay of the natural mountain barrier that traps cool, moist ocean air, bestowing the Mediterranean climate on the city and a harsh aridity on the Mojave. All along its miles of deciduous, pine- and chaparral-covered slopes lie natural and manmade lakes, numerous wilderness and protected areas, and open expanses such as the Gorman Hills, which explode every spring into a dazzling profusion of wildflowers. Gorman draws photographers and nature lovers from all over the world to view its annual, mile-wide riot of hillside lupine purples and poppy golds.

Also included in this chapter are areas ranging out into the foothills that separate the fringe deserts to the north and east from the Los Angeles Basin. The Antelope Valley and the western Mojave Desert draw thousands of visitors each year. One of the last stands of virgin juniper and Joshua tree forests in the world thrives in a protected area not far from the resplendent Antelope Valley California Poppy Reserve.

Devil's Punchbowl County Park (with its fascinating crater-rim trek through primordial geology) and Lost Lake (a largely unknown wetlands refuge in the foothills above the desert), along with El Mirage Dry Lake (a favorite desert movie location and site of hang gliding, ultralight flying, and land-yacht sailing), bring depth and topographical variety to the traditional expectation of flat, featureless desert.

"Santa Ana Mountains" completes our sojourn through Wild L.A. by bringing us full circle to the gentle hills, forests, mountains, and coast of the southeastern Los Angeles area, which includes parts of Los Angeles, Orange, Riverside, and San Bernardino Counties. A rich variety of natural refuges breaks the stranglehold of urban sprawl throughout this region, from the undulating rise of Chino Hills State Park to the protected lands of the Cleveland National Forest. From Upper Newport Bay Ecological Reserve (home to 200 species of birds, including six on the endangered list) to Bolsa Chica Ecological Reserve, new vigor manifests in the defense of restored and undeveloped wild lands.

Finally, the last chapter, "The Long View," steps back to take a brief survey of the history and future of conservation efforts to preserve forever a Wild L.A. Just two centuries ago, Los Angeles was an open coastal plain that was home to several thousand Native Americans and a small town of Spanish settlers. Today, 15 million residents and millions more visitors fuel an appetite for urban expansion that shows no sign of abatement.

There are few easy answers to the ever-changing puzzle of how to ensure protection of existing open lands. It will take political will and citizen involvement to reform decades-old patterns of poor planning and to protect and restore the natural heritage of the region.

In the meantime, let us walk through these refuges, reveling in the habitat, wildlife, and connection with the natural world that they afford us. By coming to know them, we will learn to love and better understand wildness itself. And in that, to quote Thoreau, is the preservation of the world.

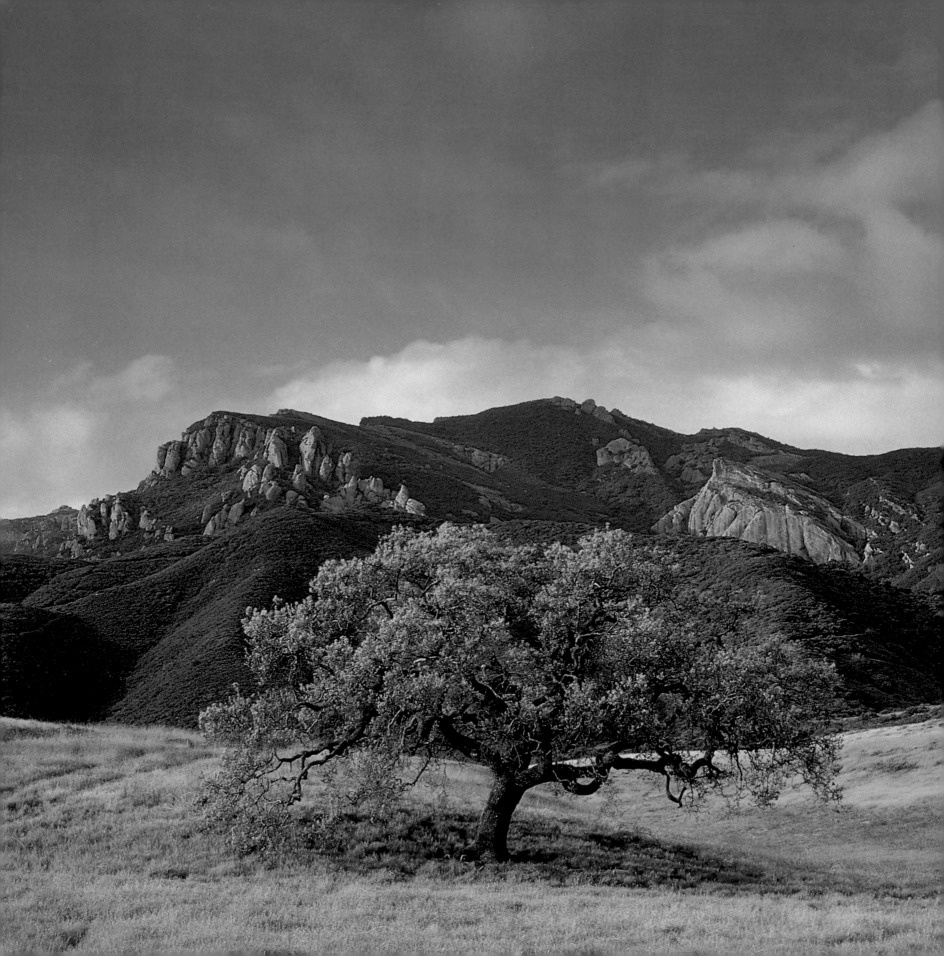

opposite: *Oak, grass, and sky,*
Rancho Sierra Vista/Satwiwa
right: *Endangered dudleya,*
Malibu Creek State Park

Santa Monica Mountains

THIS IS WHAT IS THE MATTER WITH US: WE ARE BLEED-
ING AT THE ROOTS BECAUSE WE ARE CUT OFF FROM THE
EARTH AND SUN AND STARS. —D. H. LAWRENCE

Wild
L.A.

There's only one way to get to Sandstone Peak, the highest point in
the coastal mountain realm of the Santa Monica Range: on foot. The
climb is at times steep and challenging as you work your way up the
rocky trail through sage and head-high, ruby-barked manzanita. You
feel you've earned something of·value in sinew and spirit when you
make it to the top. You've also earned something more: a spectacular
view. On a clear day at the 3,111-foot summit, after a winter storm
or when the fire-breathing Santa Ana winds have blown the haze and
smog out to sea, you can see the entire fifty-mile-long range.

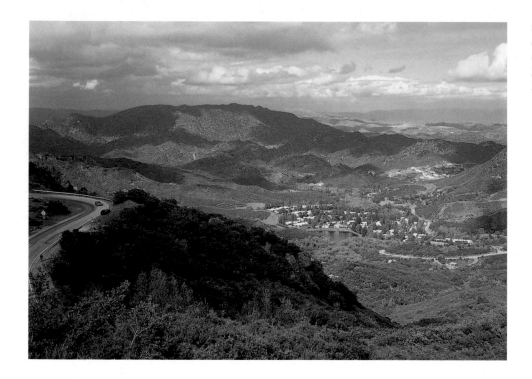

left: *Seminole Springs overlook on Mulholland Drive*
opposite: *Sunrise, Sandstone Peak and Boney Ridge, Point Mugu State Park*

If we were to climb skyward for a broader view, to wheel and bank like the California condors that once soared the thermal air currents of the Santa Monicas, we would see a single 250-square-mile wedge of transverse mountains rising right out of the Pacific Ocean.

Seen in its entirety, the east-west range curves like a gentle smile in a dark-green arc of chaparral-covered, rugged highlands and savannahs; deep, stream-cut canyons that rival Colorado's Royal Gorge and the Grand Canyon; softer hills and gentle valleys that run to golds and dusky browns in summer; and coastal headlands, beaches, and dunes fronting the blue-green Pacific.

At its western limits, the range drops steeply down from Sandstone Peak onto the Oxnard Plain, the coastal flatland that ends at the angled Central Coast of California. At its eastern end, it falls away from its last, if modest, rise—Mount Hollywood in Griffith Park—to disappear into the urban gridwork of the Los Angeles Basin, within easy view of L.A.'s earthquake-defying skyscrapers.

Myriad bedroom communities encroach upon most of the Santa Monica Mountains' north-facing inland foothills. From the Oxnard Plain through the rise of the Simi Hills, all the way east to the suburban maze of the San Fernando Valley, these northern walls mark where ongoing development clashes with mountain country.

From such heights, one thing becomes immediately clear: at the end of the century-long urban explosion for which Los Angeles is notorious, the Santa Monica

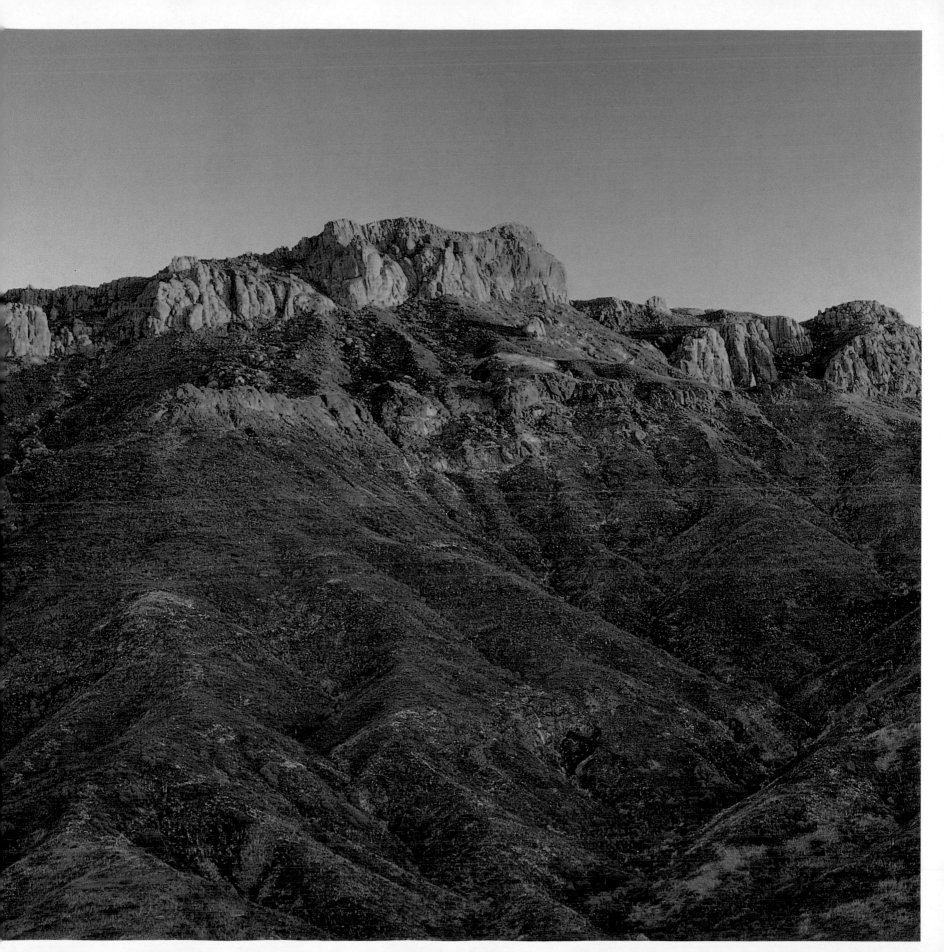

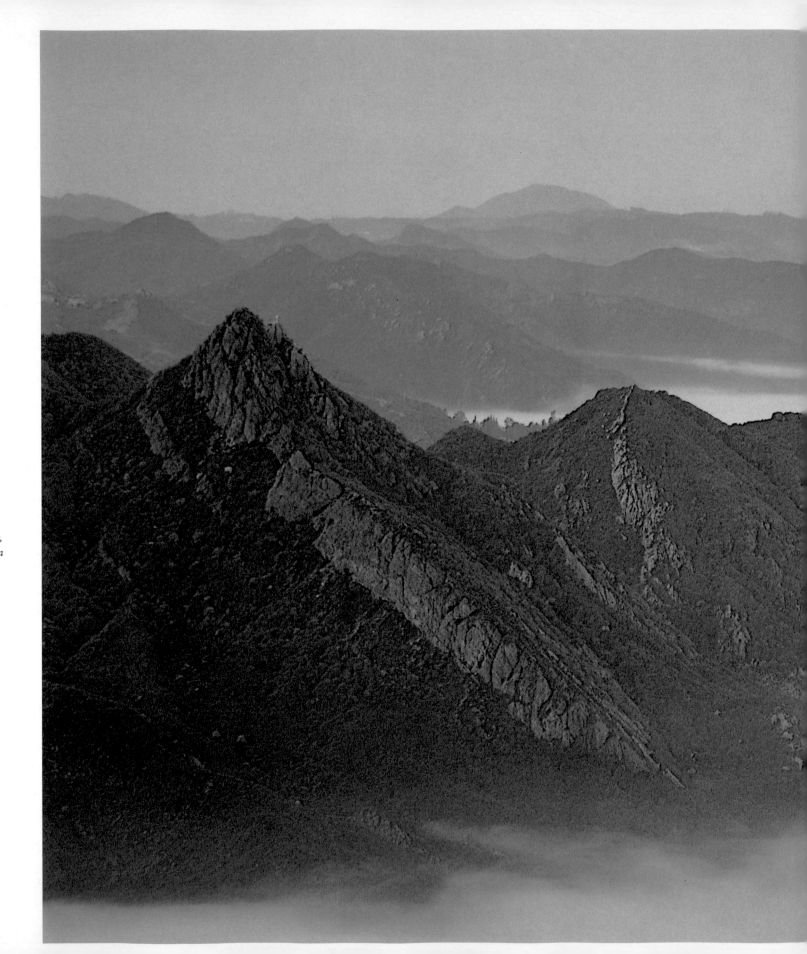

right: *Misty winter morning, Malibu Canyon from Piuma Road*

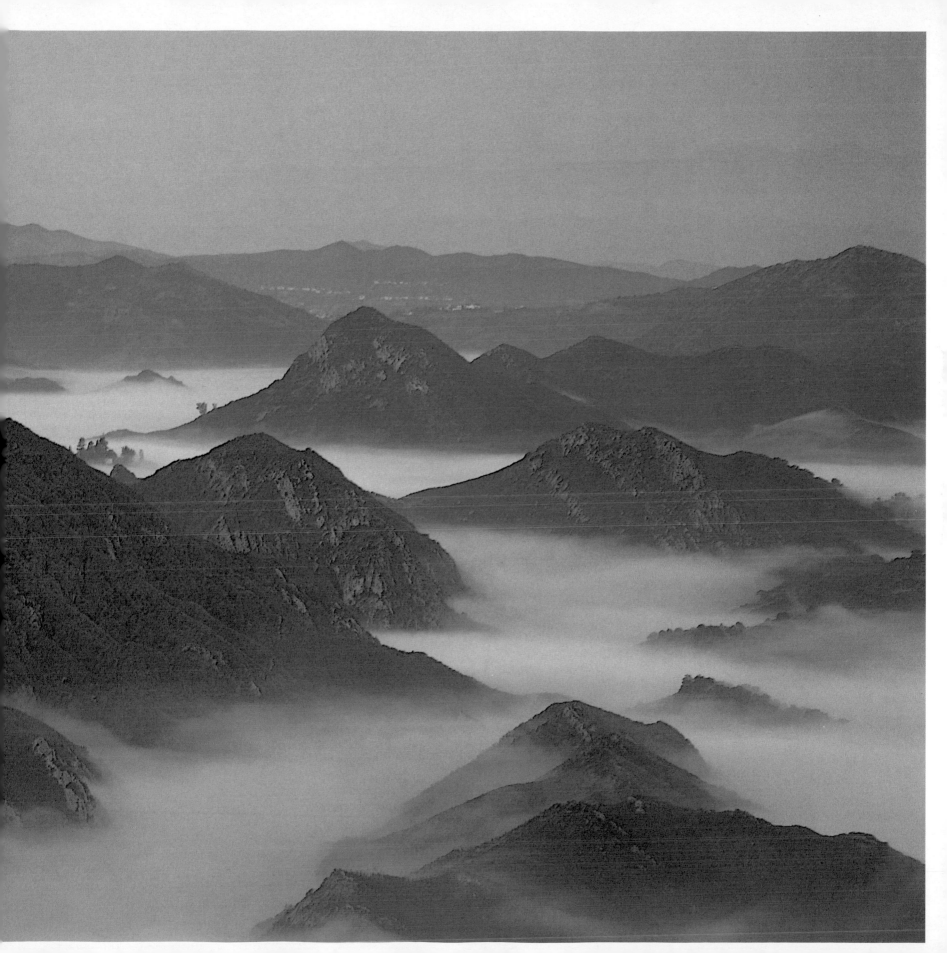

left: *Nature as artist—sycamore roots and leaves*
opposite: *Sycamores and mist on the Backbone Trail*

Mountains have survived relatively unspoiled, if only through the prodigious efforts of the range's defenders. What remains is a battleground where public lands stand out against private holdings to provide nourishment for the spirit and respite from the stresses of city life.

Many parts of this once-pristine environment have fallen to Western civilization's most lethal weapon against natural order: the bulldozer. A pastiche of constructions breaks the easy-flowing line of the Santa Monica Mountain landscape: phalanxes of ridgetop housing developments; gated beachfront communities; sea bluffs overflowing with a hodgepodge of architectural styles; and isolated vacation compounds complete with peacock colonies, horse corrals, and bright-green carpets of sod-roll grass.

Yet what makes the Santa Monicas so extraordinary is that so much of its natural and scenic splendor endures so close to one of the world's largest cities. Bare rock and chaparral-covered peaks and hills still rise unspoiled to shelter pastoral meadows that fill with spring fog and winter mists. And even though Mulholland Highway brings traffic to the high ridges along most of the range's length, the Backbone Trail Corridor and its feeder trails provide shoe-leather-only access from coastal and inland population centers. In all, more than 600 miles of hiking trails web through the range's coastal steeps and interior.

The Malibu Coast is characteristic of the uneasy coexistence of private property and public lands in the Santa Monicas. A carnival-like atmosphere predominates along its

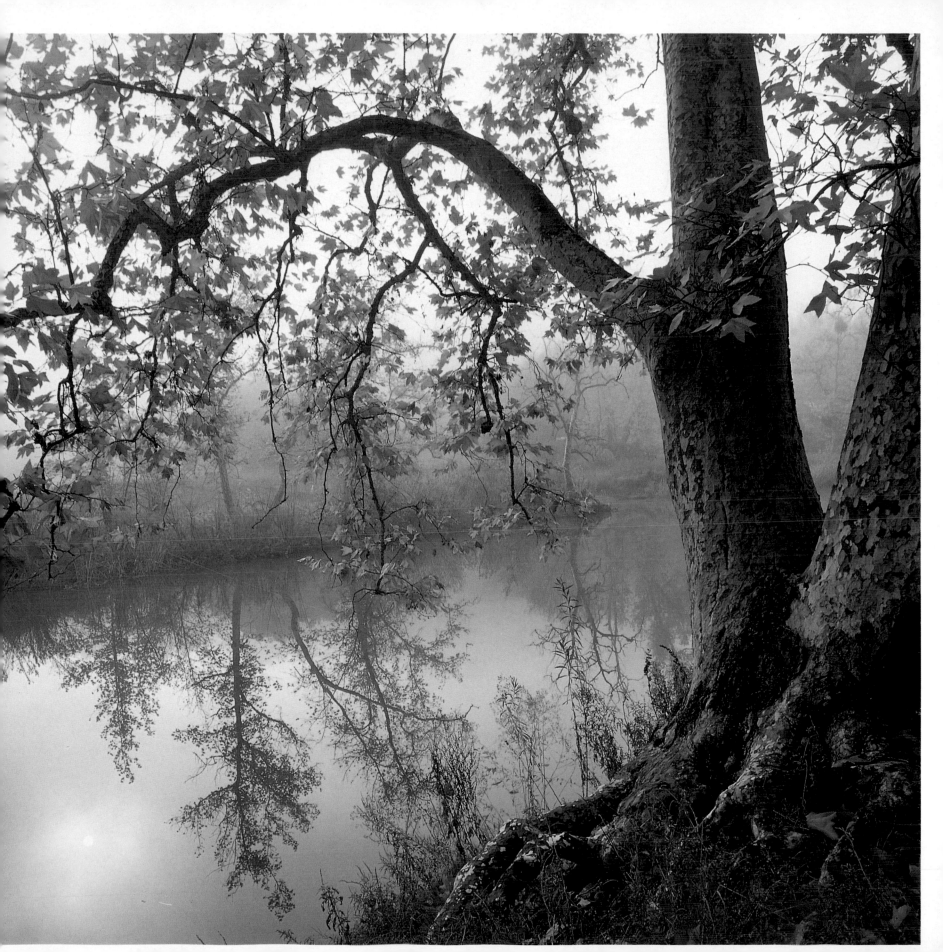

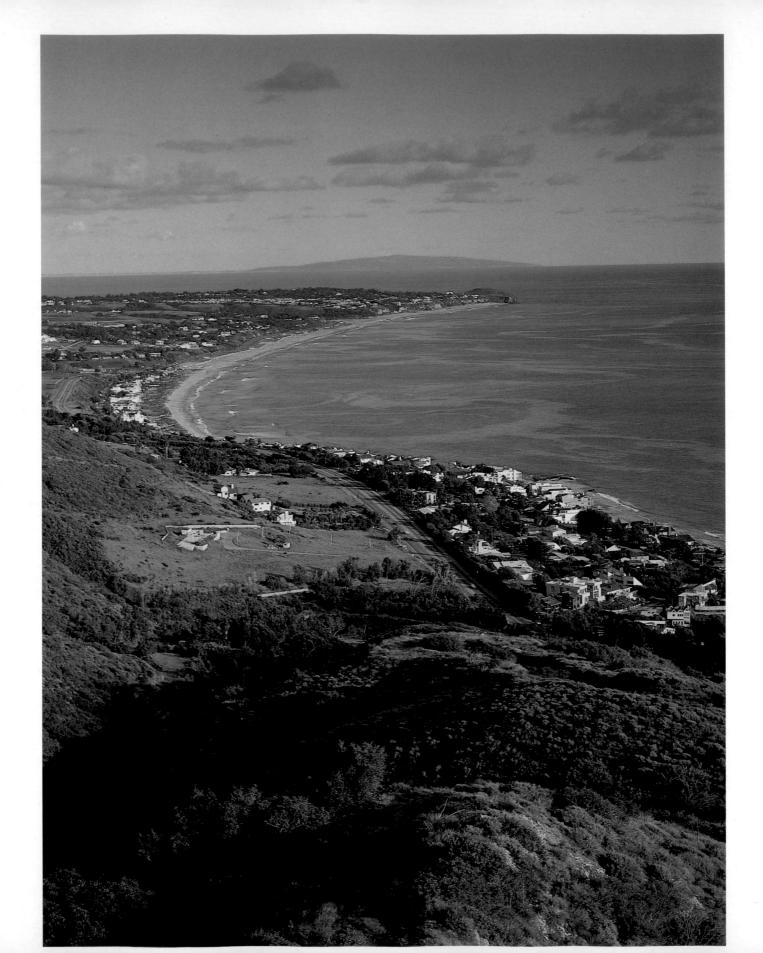

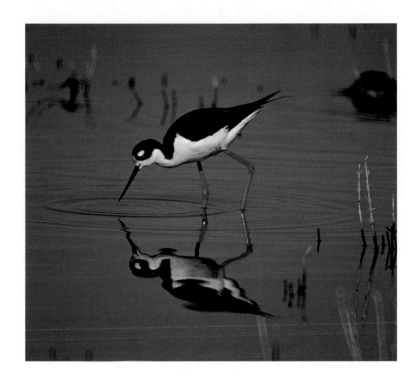

opposite: *Wild coastal mountains and urban dwellings, looking southeast toward Point Dume* right: *Black-necked stilt*

shores. On any weekend, show-biz people, surfers, real-estate millionaires, and inner-city workers share the only roadway that runs along the coast—Highway 1, or the Pacific Coast Highway, built in 1928 to link the Oxnard Plain with Santa Monica Bay.

This rush-about realm could also be called the "Malibu Firecoast." Increasingly catastrophic firestorms rage through the area on average every two-and-a-half years, driven by furious Santa Ana winds that funnel down the coastal canyons.

Fire is endemic to the semiarid Mediterranean climate, which gives rise to its signature botanical community: chaparral, from the Spanish chaparro, or "place of the scrub oak." The term loosely describes a family of dense,

small-leaved, evergreen, woody plant types, such as coastal sage scrub, toyon, scrub oak, chamise, California lilac, and manzanita, found not only on the coast but also in the range's more mountainous interior.

Chaparral is a community of superbly adaptive flora that actually requires regular cycles of fire to thrive and regenerate. Thus chaparral zones are fire zones. Human dwellings, of course, do not thrive on fire—and therein lies the rub. The longer and harder humans try to hold fire at bay, the more ferociously it returns. In recent years, billion-dollar conflagrations up and down the Southern California coast have made the point.

Until the first Spanish settlement was founded along the Los Angeles River in 1781, Malibu's strip of alternating

below: *Dudleya "liveforever" succulent, one of many dudleya varieties* **opposite:** *El Matador State Beach*

white, sandy beaches, plunging mountain headlands, steep riparian canyons, and pastoral meadows knew only the tracks of animals and the footprints of the native Chumash and Tongva (the latter called Gabrieliños by the Spanish) who thrived here. *Umalibu* was the Spanish word that approximated the Chumash *Humaliwo*, the native village that flourished for centuries near Malibu Lagoon. Varying translations of the Chumash word have a common root: loudness, as in "the surf sounds loudly" and "over there it is always noisy." Today, *Umalibu* might as aptly describe the constant din of traffic from nearby Santa Monica and Los Angeles.

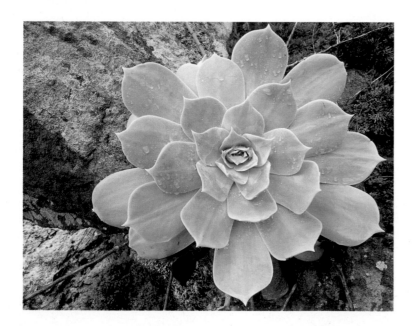

The Santa Monica Range expands to eight miles at its widest point. If we start along the Malibu Coast and wind up the steep, brush-covered coastal flanks along any of the several roads that penetrate its rustic interior, we discover a surprising diversity of ecosystems and unique landforms: coastal strands with dunes and beaches; wetlands that serve birds migrating along the Pacific Flyway; rock-walled grottos, lakes, and swimming holes; pastoral oak and cool riparian woodlands; valley oak savannahs; chaparral-covered, boulder-rich ridgeline trails; and ranch-like grassland meadows. Twenty-six distinct natural communities support a variety of habitats for more than fifty-three species of mammals and nearly four hundred species of birds, including thirteen nesting species of raptors. There are also fifty threatened or endangered animal species struggling to survive amid the pressures of civilization.

Going against the general grain of the rest of California's north-south mountains, the range was driven up from the sea roughly 10 million years ago. In the eons since, constant seismic activity and erosion have carved out an impressive array of plunging coastal and interior canyons.

In the Santa Monicas, the presence and commingling of all three rock families—igneous, sedimentary, and meta-morphic—reflect the geologic turbulence of the entire region. Ten feet up a road cutout in Topanga Canyon, my daughter and I, on a sixth-grade field trip, once marveled at prehistoric fossils imbedded in extravagantly convoluted layers of sedimentary seabed rock—some 1,500 feet above the sea.

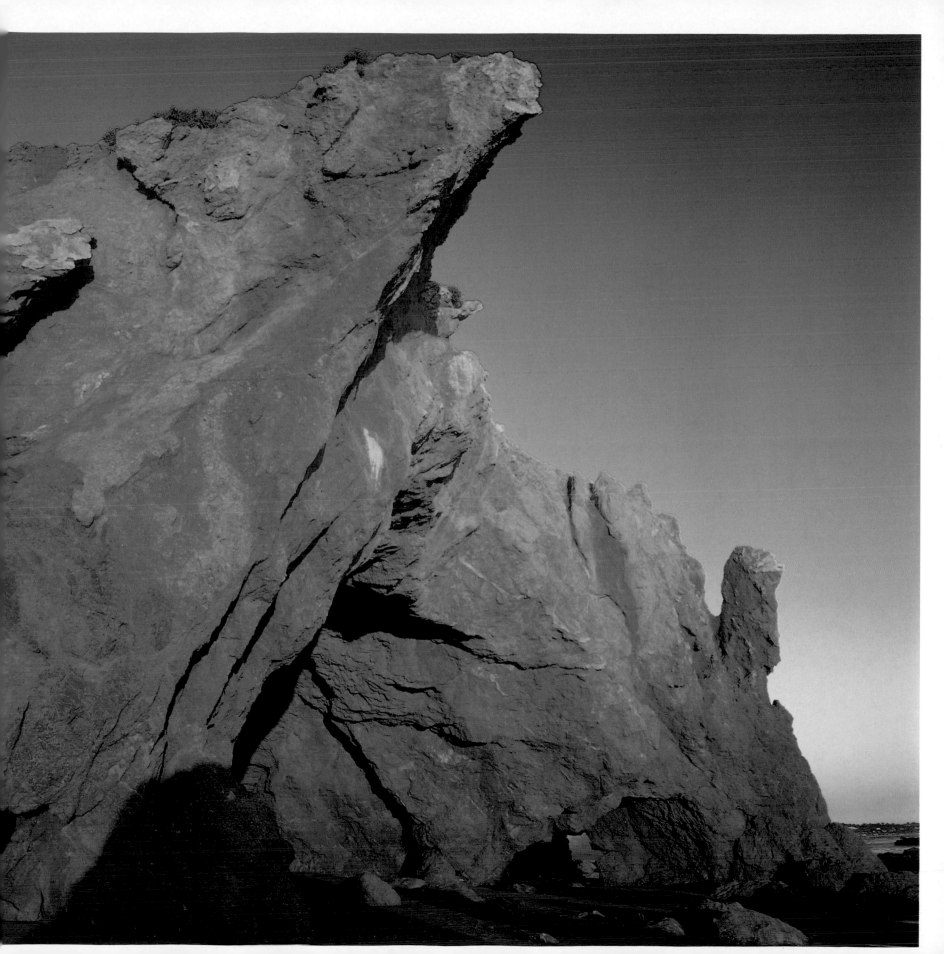

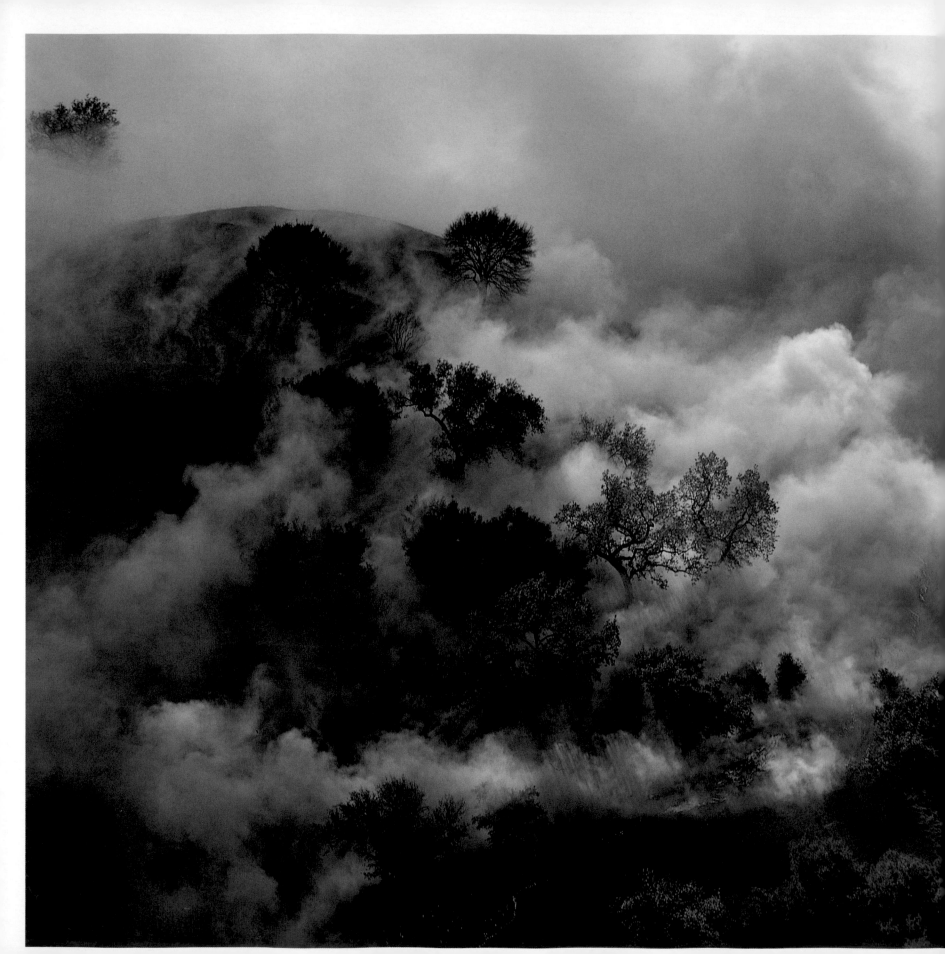

Water's erosive power—from falling winter rains and the daily battering of ocean waves—persists, even in these mountains that are rising faster than they can be worn down. Abrasive debris, from gravel to boulders, rubs away at the landforms, leaving behind rounded hills on its inexorable courses down through the lower elevations, where it builds up valleys. And creeks and streams in the Santa Monicas have a long, steep fall in many areas, allying gravity to their relentless works.

Roaming the trails and roadways that meander through and along this majesty of flowing ridges and sparkling shores gives pause for gratitude. The entire Santa Monica Range might have been irreversibly lost to rampant development forty years ago were it not for heroic conservationist efforts to save it, culminating in the landmark establishment by Congress, in 1978, of the Santa Monica Mountains National Recreation Area (SMMNRA).

The congressional act did its best to forge a consortium of existing and new administering bodies with one common purpose: to oversee and protect the natural, aesthetic, and cultural value of the entire Santa Monica Mountains region for future generations. It brought together such organizations as the Sierra Club, Santa Monica Mountains Conservancy, L.A. Wild, Save Open Space—Santa Monica Mountains, the California Native Plant Society, and the Mountains Restoration Trust, which carry on the good fight against profit-motivated developers and their political allies.

The congressional act implements a conservationist vision that grew out of the emotionally charged environmentalism of the 1960s and 1970s. It acknowledges the jurisdiction of some sixty-odd state and local park agencies already in place and the efforts of private organizations, while establishing the National Park Service as the chief overseeing body. The mandate has proved effective but, given the mix of strategies, frequently contentious. In just the last few years of the twentieth century, an improving spirit of cooperation among the various agencies and their sometimes disparate agendas brought hope for the future. Plans to acquire more land for preservation—roughly 15,000 acres—is an important part of this evolving SMM-NRA consciousness.

The National Park Service coordinates planning and activities for all the public holdings among the various agencies while offering an array of educational and recreational programs to the public. Outdoor talks, guided walks and activities, handsome visitor centers, and numerous camps offer a rich immersion in the area's natural and cultural history.

Commanding the high ground of the Santa Monicas is the seventy-mile Backbone Trail Corridor, which is actually a linear park averaging up to one-quarter mile wide and designed originally by the state to protect woodlands, streams, and rock formations along the route, as well as the trail itself. It threads nearly the entire length of the range, from Will Rogers State Historic Park in the foothills above

below: *Pale swallowtail butterfly*
opposite: *Peter Strauss Ranch*

Santa Monica to the western wilderness areas of Point Mugu State Park. Hikers along the Backbone Trail will soon be able to travel its entire length and camp overnight, without ever leaving publicly held lands.

As a member of that minority breed, the native Angeleno, I have wandered alone and with family and friends across the Santa Monicas' drowsy, oaken valleys of summer, along its high, windy autumn trails, over its storm-whipped winter beaches, and through its steep-walled, wildflower-flushed spring canyons. Yet even after thirty years of familiarity with these mountains, I saw no obvious way of organizing their natural wonders.

A map of the recreation area reveals a mildly bewildering patchwork of park, campsite, and road names. If we opt to group them geographically, a fitting place to start is in the eastern part of the range, with what the Santa Monica Mountains Conservancy calls the "Big Wild." Here we find a large block of existing and potential parklands, covering some of the most beautiful and rugged expanses of highlands and canyons in the range. This is the last major natural enclave before the Santa Monicas devolve into the densely populated lower elevations of Beverly Hills and West Hollywood. The Big Wild's contiguity of parks, protected areas, and hoped-for future acquisitions includes Topanga State Park, Temescal Gateway Park, the pending lower Topanga Canyon acquisition, San Vicente Mountain Park, Will Rogers State Historic Park, Marvin Braude Mulholland Gateway Park, and the Eastport purchase, which embraces the eastern half of Sullivan Canyon.

Topanga State Park is not only the jewel of the Big Wild but one of the major naturalist holdouts of the entire range. Its 11,000 acres fall entirely within Los Angeles city limits, making it the largest park entirely within a major city in North America. The State of California is in the process of buying 1,600 acres of land that flanks lower Topanga Creek all the way to the beach. When completed, the park will live up to its Tongva name, believed to mean "the place where the mountains meet the sea."

Wildlife can be seen everywhere in Topanga. Even the shy and elusive mountain lion has been spotted

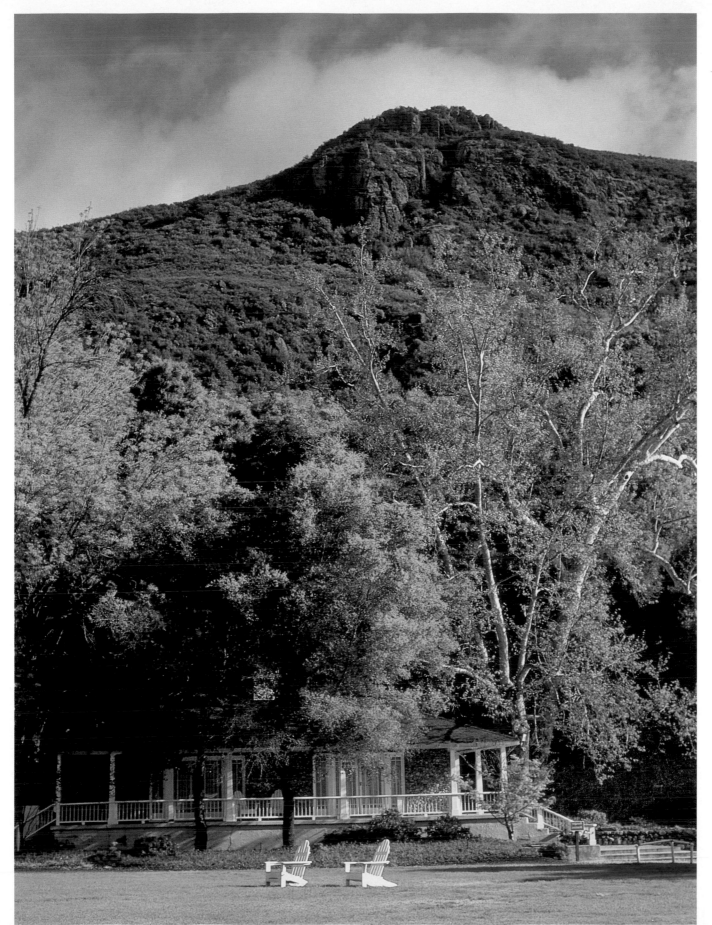

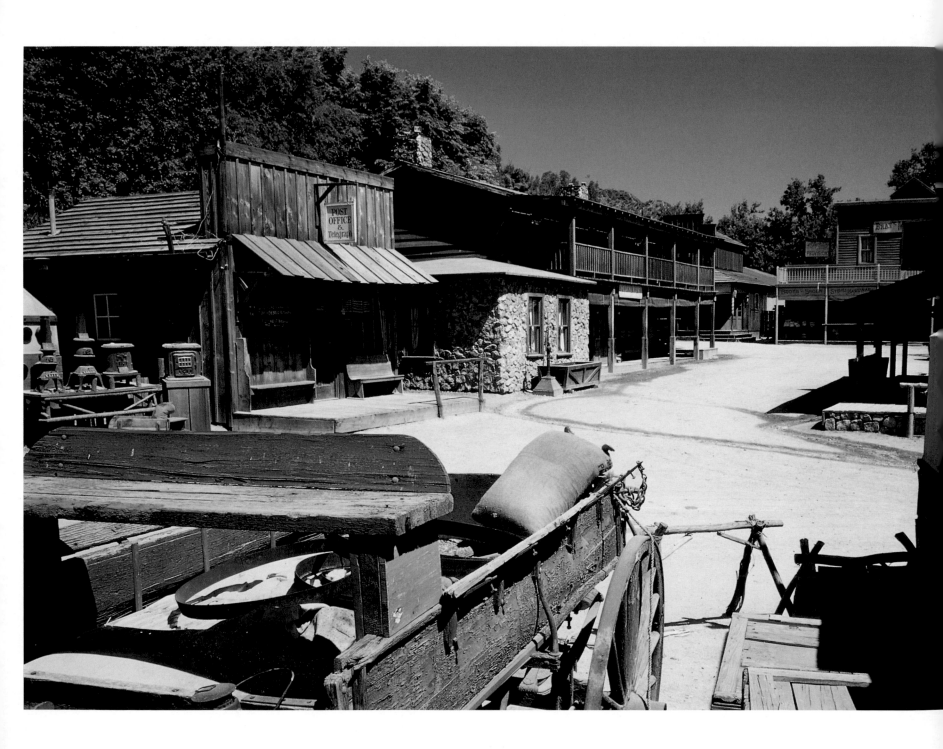

opposite: *Old West movie
set at Paramount Ranch*
right: *Schoolhouse set,
Paramount Ranch*

among the high outcroppings of eroded, pocky Topanga sandstone, typical of uplifted seabeds from the Miocene, 3 to 25 million years ago. Opportunistic raccoons often slink boldly out of the scrub in plain sight of campers and snacking hikers, hoping to purloin scraps of food or even a whole backpack stuffed with goodies. They typically haunt streams, ponds, and other watery places, catching frogs, shellfish, and other marine life, as well as birds and many other small animals.

Badgers are found in the Big Wild too, although rarely, due to loss of their grassland habitat. Other commonly seen animals include deer, woodpeckers, and those other panhandlers, the noisy scrub jays, along with hawks and the occasional falcon and golden eagle wheeling overhead.

Peregrine falcons and least terns, both endangered species, can also be seen.

Moving west from the Big Wild brings us to the mountain and canyon hollows of the Saddle Peak region. Although less of a unified geographic region, Saddle Peak describes a large swath of wild areas that includes the pristine beauty of Cold Creek Canyon Preserve, Cold Creek Valley Preserve, and Red Rock Canyon Park, a sculpted sandstone boulderland of caves and overhangs. The Santa Monica Mountains Conservancy, the Mountains Restoration Trust, and the State of California continue in their efforts to buy up lands surrounding Saddle Peak and the populated canyon bottoms and ridge flanks that run west to Malibu Creek State Park.

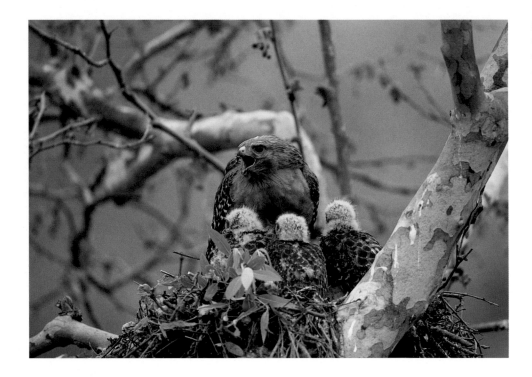

left: *Red-shouldered hawk and chicks* **opposite:** *Sycamore in autumn, Reagan Meadow, Malibu Creek State Park*

Cold Creek itself rises from springs within a north-facing basin of sandstone boulders and picturesque cliffs. Even today, the water is so pure it remains a standard against which other Santa Monica Mountain waterways are measured. The watershed is a hardy ecosystem, with alternating oak forests, mixed chaparral, and coastal sage scrub. Deep in the canyon, western sycamores, California bay trees, coast live oaks, pitcher sage, and big-leaf maples bring welcome shade and vibrant colors.

Bobcats, coyotes, gray foxes, and raccoons are some of the commonly seen mammals in this area. Red-shouldered hawks and turkey vultures patrol the skies while snakes, lizards, and seasonal wildflowers add to the area's diversity. Found along Cold Creek and in a few other coastal canyons is the colorful mountain king snake—a snake of mountain pine forests that has adapted to the cool shade of riparian forests—a relic of the Pleistocene.

There may be no more immediate and evocative reconnection to the whispering soul of the Santa Monica Mountains than to make that simple turn off Highway 101 onto Las Virgenes Road into the 10,000 or so acres of Malibu Creek State Park and its adjacent public lands. If the sight of mule deer along the approaching road hasn't already eased your transition from nerve-jangled city driver to casual country wanderer, parking in the visitor lot or campground certainly will. There, you look up into the sun-drenched bowl formed by Castro Crest and Goat Buttes, holding court over green canyons below. Secluded

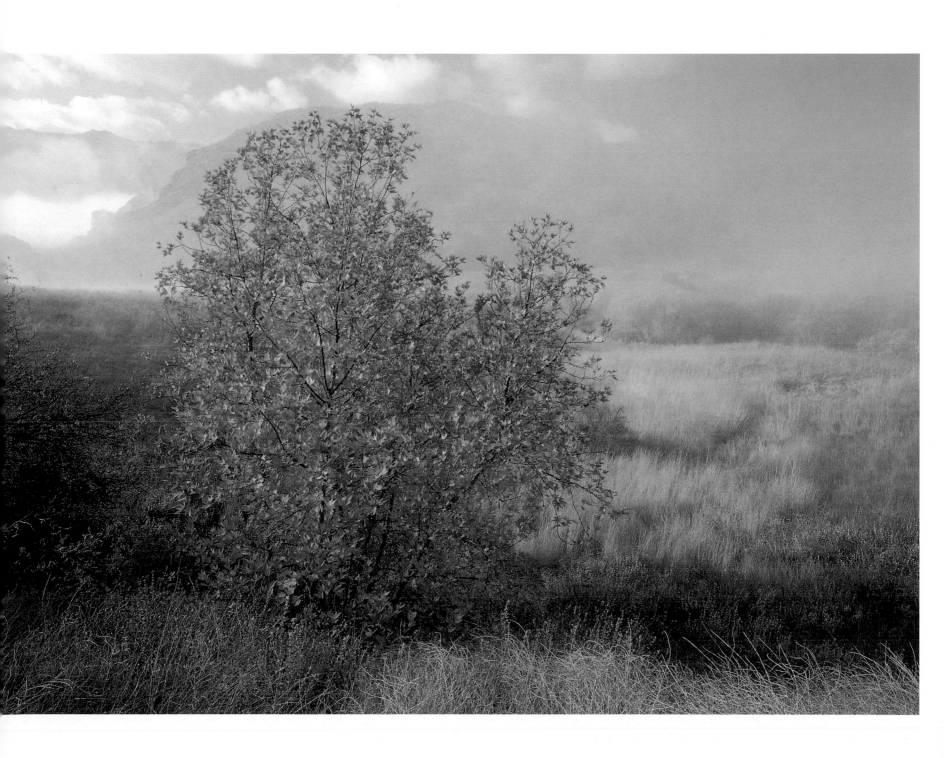

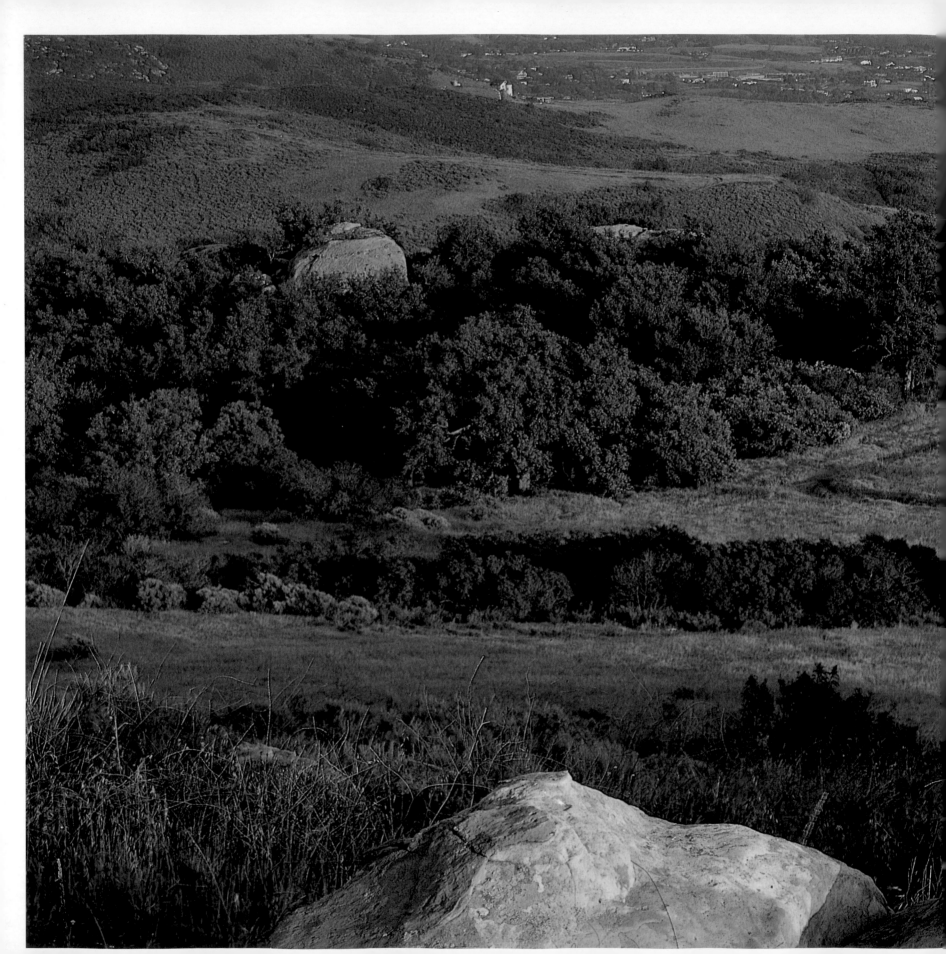

left: *Looking toward Point Dume from Charmlee Wilderness Park*

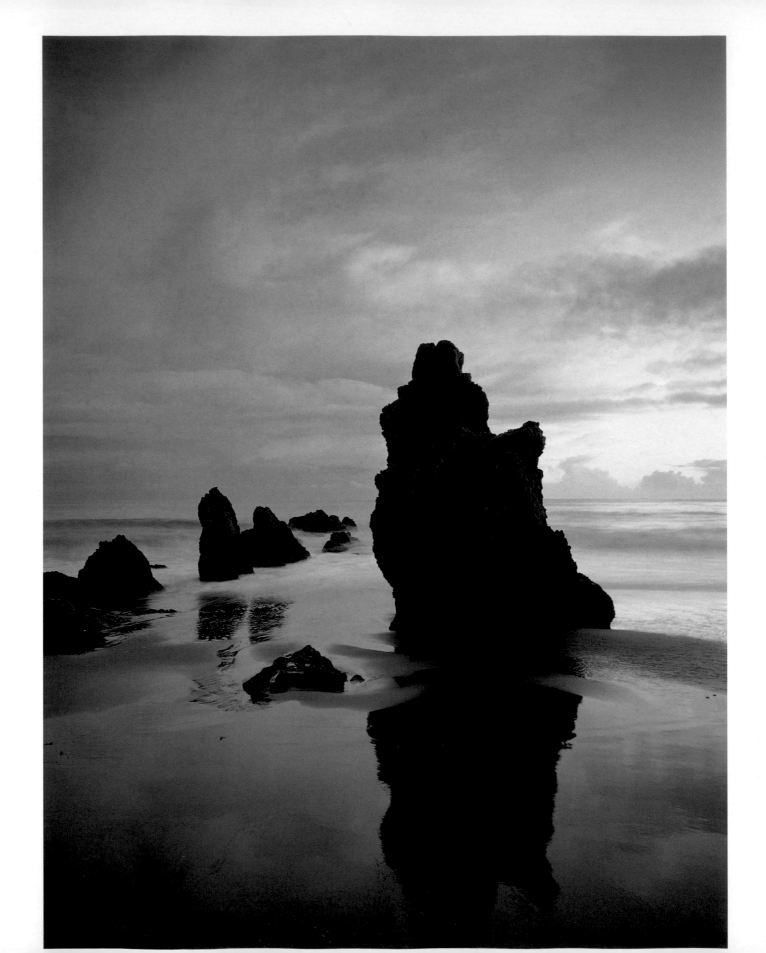

opposite: Clearing winter storm, El Matador State Beach
right: *Sea otter, once common off the Malibu Coast*

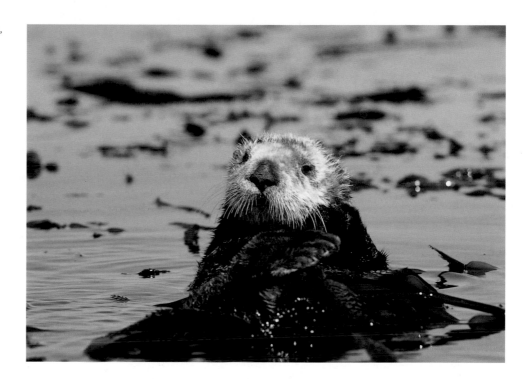

waterfalls, riparian and oak woodlands, and inviting meadows are open to hiking, biking, and horseback riding along twenty trails high and low. On any given weekend year-round, the park is a busy place.

As I walked into the park one recent afternoon, the sight of a group of smiling inner-city children in soaking-wet clothes, fresh from an autumn-afternoon swim in Rock Pool, took me back to my early fatherhood years. I remembered my daughters' bright smiles and giddy laughter as they ran here with wild abandon, kicking up clouds of dust into the oak-filtered sunlight.

So when I take to the dirt pathways of Malibu Creek, climbing up through adjacent Tapia Park to the rough-and-tumble mountain chaparral of the high Backbone Trail, or

when I stroll along a meadow road lined with oaks and sycamores, I feel restored to my place in the wider world. Suffused with the beauty of these mountains and canyons, I feel the wellspring of love for my own children overflow to all the world's children, wild creatures, sheltering skies, and renewing lands. Such epiphanies bring a surge of abiding affection for nature's very hum and growl, breeze and gale, as if all things were part of us, as if we belonged to them the way we do to our own children. Because, of course, we do.

Now, think what a little walk through the verdant hollows and hot-rock heights of Malibu Creek might do for you.

Although Malibu Creek State Park is the Santa Monicas' centerpiece, its many adjacent parks and trails add a rich variety to any visit to the area. Riding up Mulholland

Highway just north of the park takes you to Paramount Ranch, the site of many movie shoots over the years. Nearby Peter Strauss Ranch, once owned by the film actor, is a treasure in its own right. Earlier developers tried more than once to turn the property into a Disney-like natural amusement park. Though known for its charming ranch ambiance,

the park offers its greatest pleasures along a hillside trail through live oaks, California bay trees, and scrub oak.

Up through these mountain canyons, turkey vultures and red-tailed hawks wheel and soar. In the right place, such as among the boulders of Castro Crest, patient bird-watchers may glimpse a peregrine falcon or a rare golden eagle soaring high above.

Las Virgenes/Malibu Canyon Road runs all along the Malibu Creek watershed, following an eight-mile natural corridor from the Ventura Freeway to the north, through the mountains and down through dramatic Malibu Canyon, where it ends at Highway 1 and Malibu Lagoon State Beach. The tremendous variety of landscapes and eco-systems in the watershed made it a natural environment for human habitation. The Chumash built their largest village, Umalibu, right here on the shores of Malibu Lagoon and established other villages in the interior valleys of what is now Malibu Creek State Park.

Umalibu dwellers launched their *tomols* (plank boats) at the coast to fish and trade with people of the Channel Islands. Abundant wildlife, including deer and fish, helped native villages thrive for perhaps 2,500 years, until the Spanish arrived at the Southern California coast.

Native American inhabitants of the Santa Monica Mountains left records of their culture throughout the range, in hundreds of enigmatically beautiful rock art sites, village ruins (although sadly, most dwelling sites have been lost), hunting areas inland and along the coast, ancient

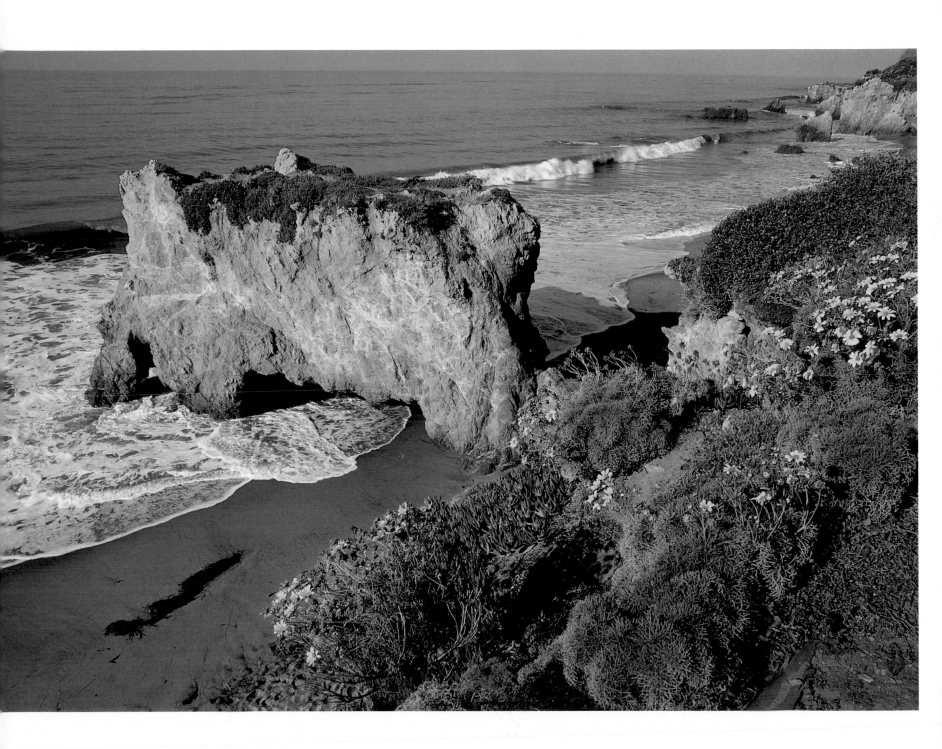

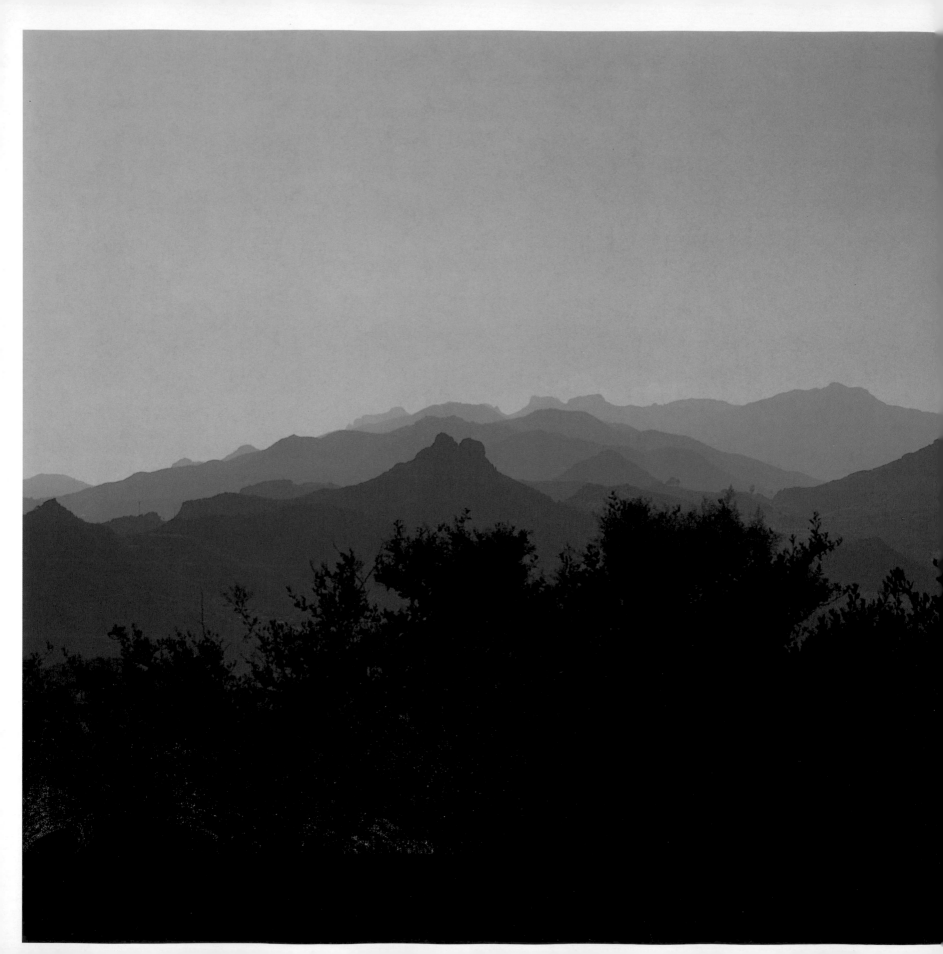

*opposite: Santa Monica
Mountains majesty*
*right: Pacific rattlesnake,
California's only native
poisonous snake*

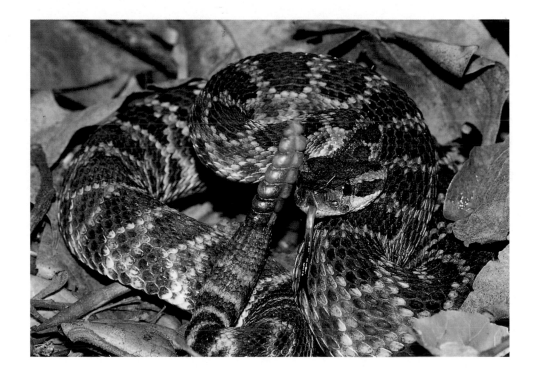

burial sites, and sacred ritual grounds. Many such sites are now protected within the SMMNRA. Here, descendants of these ancient peoples and visitors from all over the world can gain new respect for and understanding of a way of life largely bulldozed from the Western world.

Before white explorers and settlers brought their visions of empire to the Southern California shores (and when grizzly bears still roamed the Santa Monicas), the land's natural bounty and temperate climate had provided an unspoiled paradise for as many as 500,000 indigenous people. Recent archaeological studies date the first paleo-Indians of the Santa Monica Mountains back more than 13,000 years, to a time when lower sea levels made the off-shore Channel Islands into one large island. In fact, the islands are actually the westernmost extension of the Santa Monica Range.

The Chumash had an advanced monetary system based on the lovely little purple dwarf olive seashell. They also had a sophisticated appreciation of astronomy. They spoke the Hokan language and lived in large communal dwellings called "aps." These domed houses were framed with willows and thatched with bulrushes. Dense, woven tule-reed mats provided floors and privacy partitions for the several families who shared them.

A fascinating replica of an ap, built by modern Chumash descendants, stands today at the Satwiwa Native American Indian Natural Area, adjacent to Point Mugu State Park. At least 3,000 modern Chumash retain their

*right: Springtime bouquet—
lupine, mustard flowers,
and yucca*

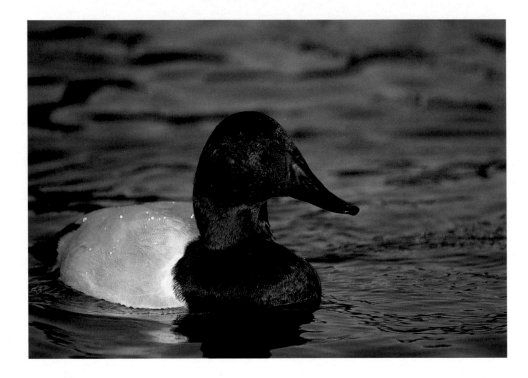

left: *Canvasback duck, the largest duck in California*
opposite: *Autumn colors at Malibu Creek State Park*

cultural identity even as they have fully integrated into modern society. Many work to preserve knowledge of the ancient ways at Satwiwa and other SMMNRA and Southern California sites.

Connecting Malibu Lagoon to Malibu Creek State Park is Malibu Canyon, a steep, magnificent narrows and one of the deepest coastal canyons in the United States. Its precipitous walls plunge from 1,300 to 1,700 feet deep, 70 percent deeper than the Royal Gorge in Colorado and comparable in scale to the inner gorge of the Grand Canyon.

This magnificent landform also marks one of the southernmost runs of steelhead trout in California, biologically significant since this particular genetic strain didn't evolve in Alaska or the Pacific Northwest but in Southern California

waters during the last Ice Age, migrating north as the climate warmed. Like salmon, steelhead return from salt water to spawn in freshwater. Recent National Park Service programs have focused on restoring the feisty game fish to other streams and waterways in nearby Solstice Canyon and Leo Carrillo State Park, farther west along the coast from Malibu Lagoon.

The Malibu Creek watershed also supports some other precariously established residents. Red-legged frogs, California's largest native frog (up to five inches in length), are pond frogs that were virtually wiped out in the Los Angeles area, thanks to Gold Rush miners, who gobbled up their legs, and to another predator, the introduced bullfrog. Programs to reestablish them in nurturing habitats within the SMMNRA are under way.

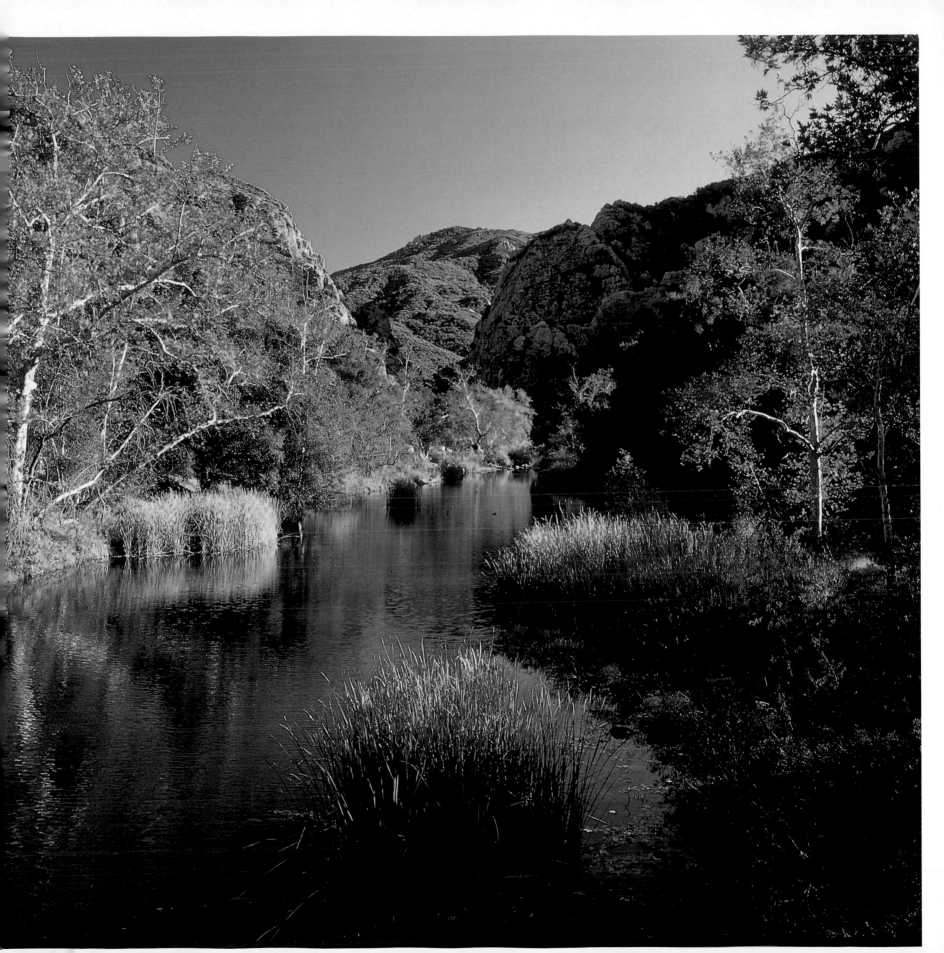

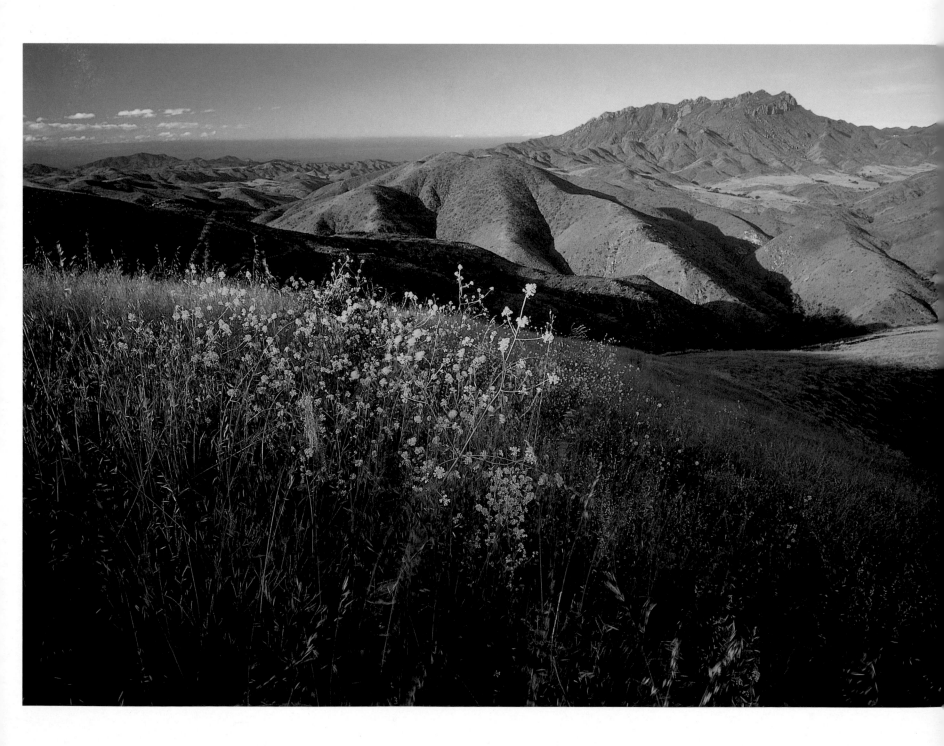

opposite: Wildflower spring along the Backbone Trail, with Boney Ridge in the distance
right: *Rocky "fins" at Castro Crest, Malibu Creek State Park*

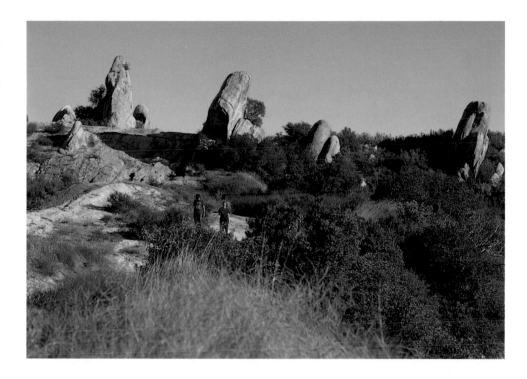

The southernmost stands of valley oaks in California are found in the foothills of the Santa Monicas. Largest of all western oaks, they grow fifteen to twenty feet in diameter and are usually the first oak to establish a foothold in grasslands. They require deep soil to hold fast to the land and don't thrive in marine climates. Valley oaks might easily have become the state's icon, rather than the mighty redwood. Instead, they were eradicated wholesale throughout the state to clear agricultural tracts, to burn as firewood, and to increase grazing yield for livestock (an erroneous notion: some grasses grow taller and more nutritious beneath the sheltering shade canopy of an old oak tree).

Flowering creek dogwoods grow in two canyons, no doubt clones of a shrub that survived the Ice Age 10,000 years ago. Young redwoods have returned and are being reintroduced to a few places (they, too, were more abundant ten millennia ago), notably in Malibu Creek, a good habitat for them. Grasslands, coastal sage scrub, and chaparral provide nurturing environments; yet two plant species (Braunton's milkvetch and Lyon's pentacheata) are endangered, and four species of dudleya stonecrop leaf succulents (including the Santa Monica Mountain dudleya subspecies found growing on volcanic rocks in Malibu State Park) are threatened. The U.S. Fish and Wildlife Service's recovery plan focuses on a roundup of the usual suspects: urban development, smog, habitat degradation, suppressed fire cycles and fire suppression tactics, and increased recreational activity.

opposite: *Sycamore leaf carpet,*
Malibu Creek State Park

Moving west from Malibu Creek, we encounter more broadly undisturbed areas, richly deserving deeper exploration: Solstice and Corral Canyons, accessible above Dan Blocker Beach in the middle of the range; Point Dume; Zuma and Trancas Canyons, only twenty miles from metropolitan Los Angeles but largely untrammeled; Leo Carrillo State Park; Circle X Ranch; and another bright star in the SMMNRA complex, Point Mugu State Park and its adjoining National Park Service land: Rancho Sierra Vista/Satwiwa.

Solstice Canyon Park and its Corral Canyon neighbor offer a bittersweet glimpse of the original vision of the Santa Monica Mountains as one continuous coastal and mountain park. Numerous canyons and coastal slopes were developed before environmental awareness became the potent political force it is today. Solstice and Corral Canyons remain undeveloped, with year-round streams that run onto public beaches with only minimal commercial activity.

Ongoing efforts to buy the land between the two canyons may yet create a large piece of coastal paradise. The dramatic rise of 600-foot hills right off the beach, continuing up to 2,800-foot mountains at the headwaters of Solstice Canyon, less than three miles from the beach, provides ocean/highland drama not found along many other parts of the Malibu Coast.

Point Dume is an upscale, highly developed peninsula that offers one small, easily overlooked natural oasis. Wend your way through the thicket of urban neighborhoods on the peninsula bluff and you'll discover, at the end of a little two-lane public road, a magnificent 250-foot-high rock promontory—Point Dume itself—vaulting up from the lovely, broad public beach. The sheer drama of the westward cliff is only the most visible part of Point Dume State Preserve. Its protected acres of headlands, cliffs, and rocky coves, decked out in giant coreopsis, California poppy, and bladder pod, offer a refreshing counterpoint to the long stretch of golden sand and crashing surf.

At cliff bottom, your inner rhythms shift in sync with the cadence of waves against sea rocks. Enchanted by sequestered Pirate's Cove, where smugglers once landed, you forget there are houses on the bluffs above. Point Dume teaches us that we don't need to journey to faraway wilderness to feel again the beating of our own wild heart.

Beyond Point Dume State Preserve, the Zuma/Trancas Canyon complex comprises a National Park Service unit of surpassingly beautiful, rugged mountain canyons. Zuma Canyon, nearly 2,000 feet deep, and Trancas Canyon offer thrilling vistas and challenging hikes through streambeds and clear pools fed by waterfalls off sheer cliffs.

From Leo Carrillo State Park, which climbs up from the shore along the watershed of the Arroyo Sequit, and west along the coast past Sequit Point and Thornhill Broome Beach to Point Mugu State Park, eight miles of deep canyons and 3,000-foot ridges plunge straight into the ocean. This stretch of rocky and sandy beaches marks the least impacted section of the Malibu Coast.

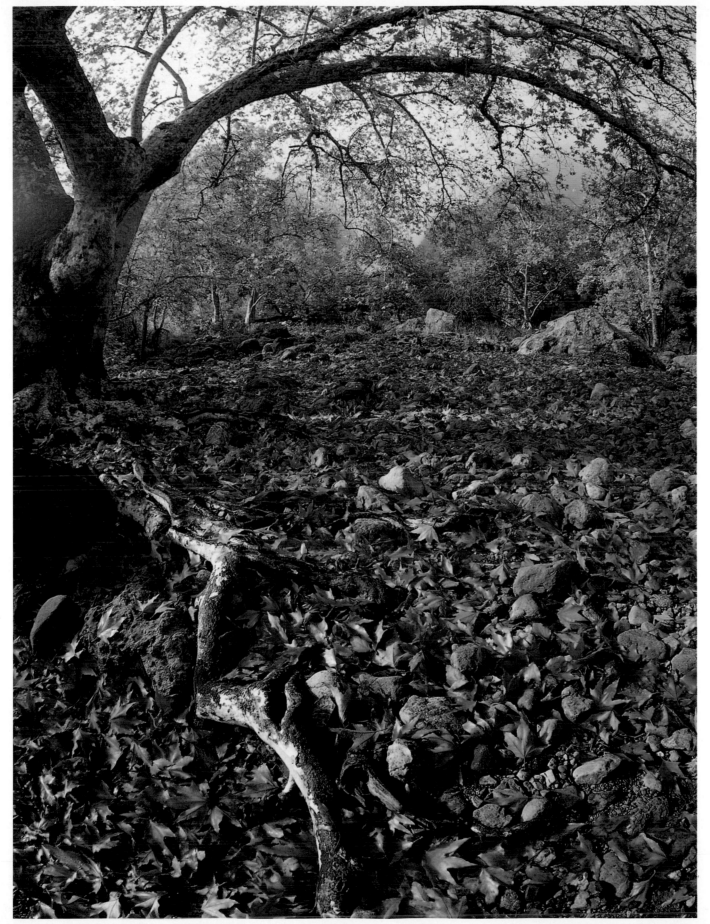

opposite: *California polypody and wild cucumber*
right: *Sycamores along Malibu Creek*

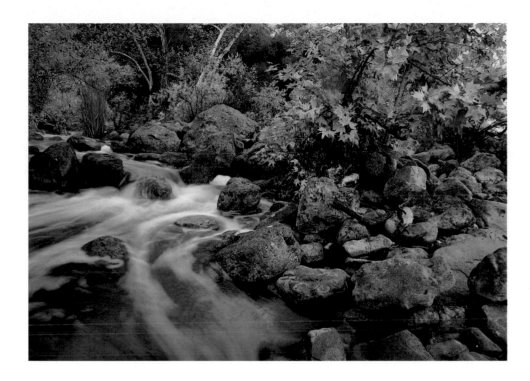

Leo Carrillo State Park, named for the beloved actor (the Cisco Kid's good-natured 1950s TV sidekick, and an early and ardent conservationist who secured many public lands along the coast), is a gem of sandy beaches and inter-tidal zones. Its rocky tidepools teem with starfish, chitons, sea anemones, limpets, urchins, and other sea life. Ground squirrels scamper out across the sand from clumps of coastal sage to compete with scavenging shorebirds, while pelicans ride the air just inches above the waves.

Along all the Malibu Coast, cormorants fly back and forth on fishing sorties. Kelp with stipes of 120 feet or more create underwater forests just offshore where fish and sea lions feed and hide from predators. Estuaries such as Malibu Lagoon and the restricted-access Mugu Lagoon (the largest coastal wetland in Southern California) provide critical habitat for migrating birds. Malibu Lagoon is a focal point of conservationist activism as well: the endangered tidewater goby is making a stand here, alongside the steelhead trout.

Above the lagoons, tidal flats created by two lengthy periods every day of submersion, then exposure, to sun and air, teem with oysters, cockles, sand dollars, mussels, urchins, sandworms, and clams. Salt marshes, flooded only at high tide, are home to reeds, cattails, and bulrushes wherever freshwater flows down from the mountains.

Out in the open ocean, porpoises, harbor seals, sea lions, and the great migrating whales breed, feed, and hunt. Bonita, garibaldi, sheepshead, halibut, and more denizens

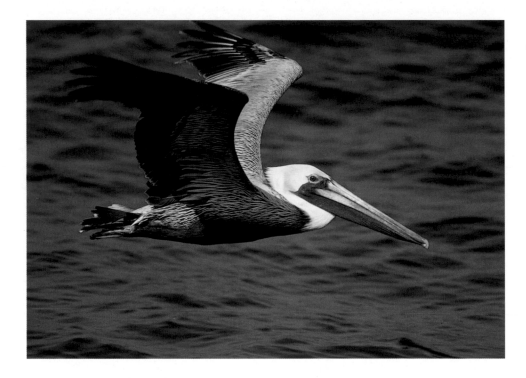

left: *Endangered brown pelican, found from Mexico to Canada*
opposite: *Looking southwest to Point Dume from Pirate's Cove*

of the deep keep sharks, barracuda, and other predators gainfully employed.

The animated antics of many species of shorebirds provide constant entertainment for coastside visitors. Brown pelicans, the largest fishing birds on the West Coast, are on their way back from near-extinction brought on by the use of the pesticides DDT and DDE. Black-necked stilts, sandpipers, sanderlings, plovers, and sharp-crying seagulls quickstep along the wet sands and circle opportunistically overhead.

The Santa Monica coastal and mountain environment provides habitat for an astonishing variety of winged creatures. Many species of ducks—mallards, northern pintails, green-winged teals, cinnamon teals, and canvasbacks—add

their vibrant colors to populations of Pacific loons, great blue and green herons, American avocets, willets, and belted kingfishers. Northern harriers, Cooper's hawks, roadrunners, California quails, and acorn woodpeckers, as well as screech, barn, and great horned owls, add their names to the list of hundreds of bird species, ranging from common to endangered, found here.

Large, magical, four-winged dragonflies make their rounds, skimming above creek water and across stands of summer weeds, including the common yellow mustard flowers that dance to the lightest breeze. Pesky gallflies and no-nonsense gall wasps lay their eggs on oak branches, irritating the trees, which grow woody knobs, sometimes referred to as oak apples, in defense.

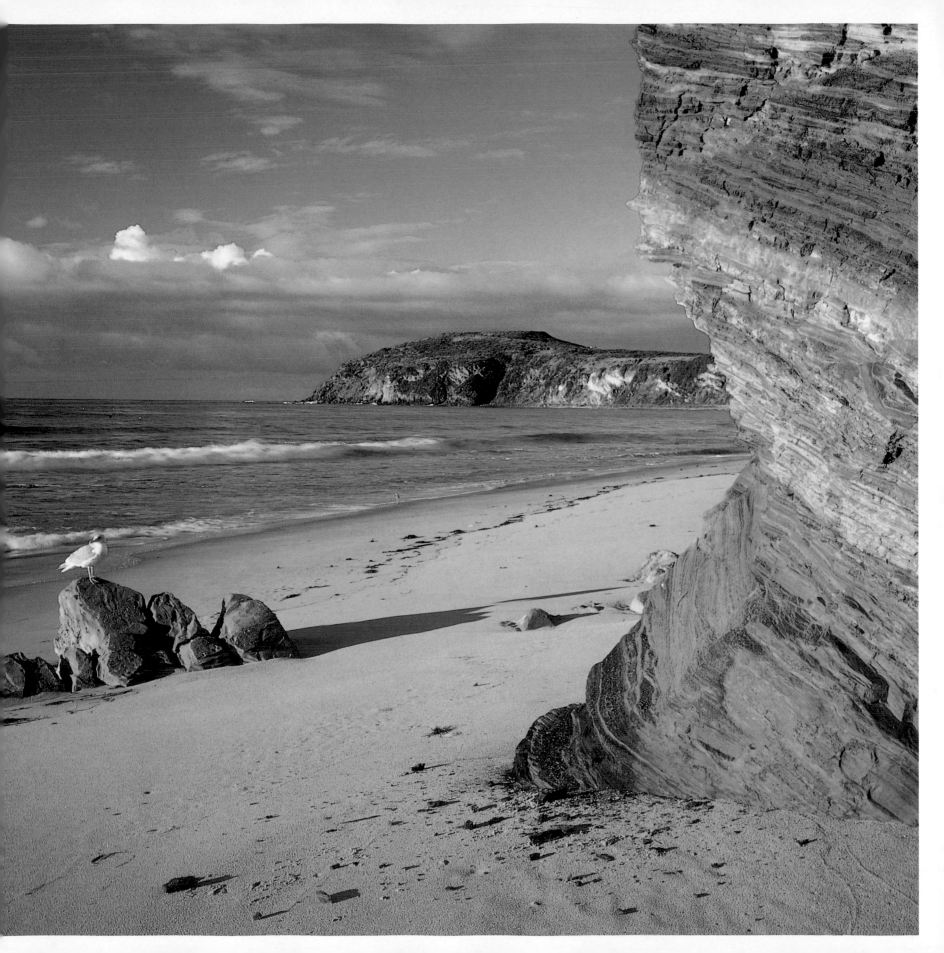

opposite: *Summer reflections, Rocky Oaks* **right:** *Chumash ap dwelling replica, Rancho Sierra Vista/Satwiwa*

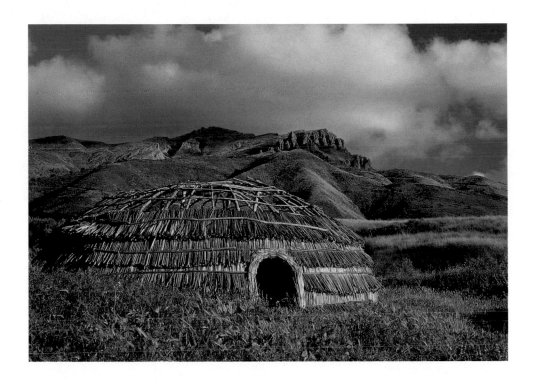

If the waters were rising and Noah had only one place to assemble his flock of creatures, he could do a lot worse than the Santa Monicas.

Back atop Sandstone Peak, where our journey through the Santa Monicas began, we catch our breath and take a last look at the magnificent vista of the Southern California coastline and interior. Thoreau wrote, "I never found a companion that was so companionable as solitude." Atop Sandstone Peak, that sentiment finds a home.

If only we could sweep away all signs of development from this range—but alas, it is an impractical wish. Instead, we might come to realize that the prime appeal of the range lies not only in its areas of unscarred purity but also in the miracle of its accessibility from nearby Los Angeles.

Being human, we need to share what we learn. Built into a modest concrete monument atop Sandstone Peak, a metal box protects a battered spiral notebook. Hundreds of written remembrances, ranging from the mundane to the rhapsodic, speak directly to our common experience of the spiritual benefits gained from time spent in nature.

"First time up with a good friend and Mom and Dad, just in time to see the sun's cozy soul settling into the Pacific," one visitor jotted down.

Another: "I wish the sun would forget to set, but then again don't we all...For once I forgot that I'm afraid of heights."

And perhaps most to the point of our visit to the Santa Monica Mountains: "Oh lord, you're beautiful. Thank you for loving little me."

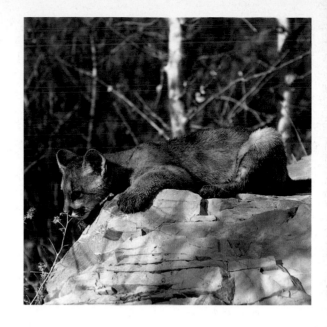

opposite: *Garden of the Gods*
Park, overlooking the
San Fernando Valley
right: *Mountain lion cub (captive)*

Rim of the Valley

THE OLD LAKOTA WAS WISE. HE KNEW THAT MAN'S HEART AWAY FROM NATURE BECOMES HARD...
‑LUTHER STANDING BEAR

Her first thought is that a golden retriever has stretched itself out on a broad, flat boulder, catching the rays of the dawn sun rising above the Santa Susana Mountains. She wonders why a dog would have strayed this deep into the wild. The animal hears their approach and swings its sleek head around. The woman stops dead in her tracks. This is no dog, she realizes, her gaze suddenly riveted by the cold, penetrating stare of a full-grown mountain lion.

She throws her arm out to stop her hiking companion. A jumble of possible actions races through her mind. She had read the

Wild
L.A.

below: *Monarch butterfly on daisy* **opposite:** *Magnificent Cheeseboro Canyon Trail in spring, with Big Mountain and Oak Ridge in the background*

warning on the trailhead kiosk thirty minutes ago in the predawn light. But somehow, shouting, waving her arms, and "standing tall" seem inappropriate…at least for now.

Fifty feet away, the cat's unblinking golden eyes stay locked on hers. "Don't run," she remembers from the poster. "Maintain eye contact." *Well*, she thinks, *we're sure doing that.*

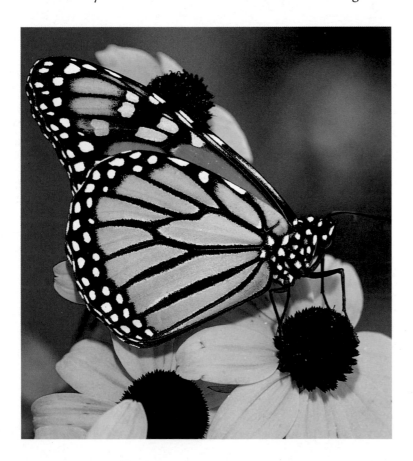

For long moments, *Homo sapiens* and *Felis concolor* stand silent and motionless, connected by what that empty space between them might mean. And the woman wonders, almost abstractly, *If the lion charges, what will I do?*

As if on cue, the tawny cat rises in an arc of liquid movement that carries it directly toward them. It stops. Its eyes remain focused on hers. Another step. Her breath catches in her throat. Then, fast as thought, the lion wheels away, loping powerfully into the nearby, waist-high scrub. She watches it go. Seconds later, she realizes she is still trembling.

Such are the rewards of a simple walk into wilderness.

The truth is, the woman would have been more likely to suffer a fatal car accident than an attack by a mountain lion. In California, no such attacks against humans have been recorded since 1995.

This dramatic encounter took place in one of the dozens of completely unspoiled places you find within an hour's drive north of downtown Los Angeles. The trail in question lies along a ridge top near Big Mountain, within a 3,700-acre wildlife preserve known as Happy Camp Canyon Regional Park. The park is now part of the more than 450,000 acres of lands administered by the Santa Monica Mountains Conservancy (SMMC) that make up what is called the Rim of the Valley Trail Corridor. Happy Camp Canyon was itself once a favorite picnic area on the vast Strathearn Ranch, a sprawling livestock spread run by a pioneering family from the nearby city of Simi Valley. Even today, remnants of ranch life—weathered fences, troughs, and

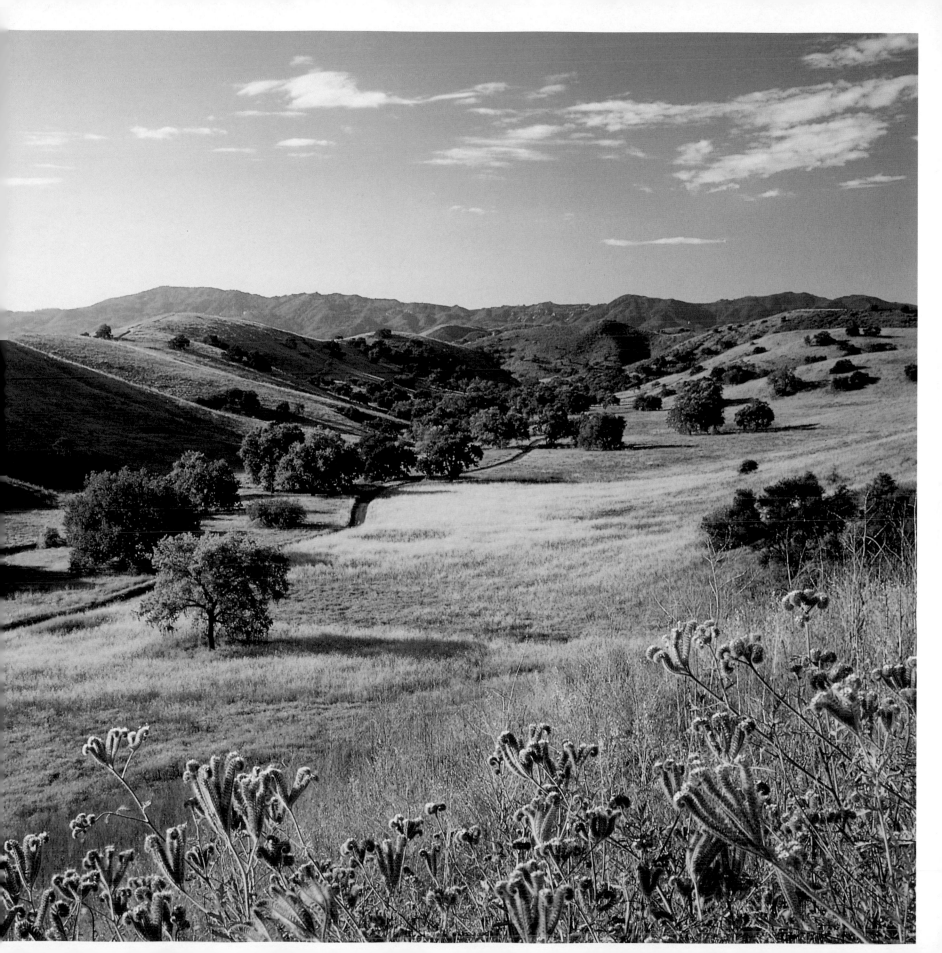

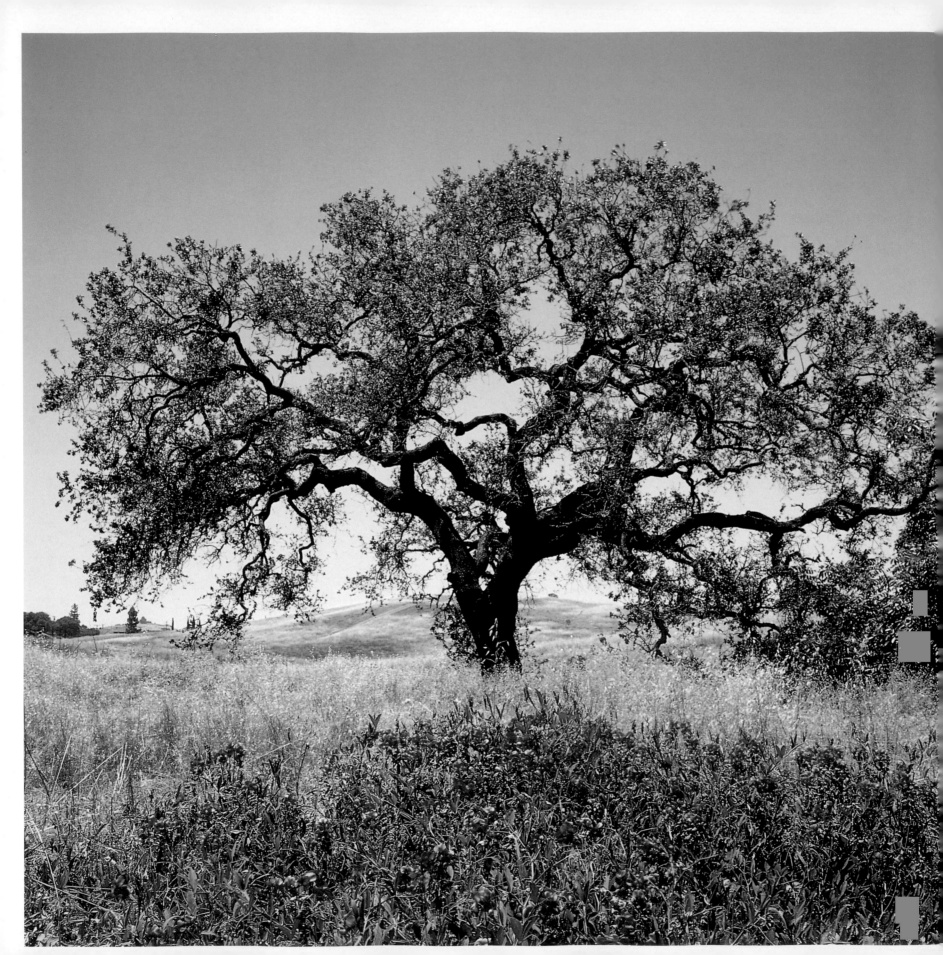

opposite: *California icons—golden grass, spring flowers, and a solitary valley oak*

water tanks—evoke nostalgia for that mid-nineteenth-century Old West life.

Like so many landmarks, towns, and streets up and down the Golden State, Simi Valley got its name from the first humans to live here—Shimiji was the name of a Chumash village. Today, the Strathearn family home is preserved as a state historical site while Shimiji, like the rich culture that founded it, has long since gone to dust.

Simi Valley is the prototypical bedroom community, connected by freeway to one of the busiest, most densely populated areas in Southern California: the San Fernando Valley, which lies directly east, just beyond the pass through the Santa Susana Mountains.

So why pick little-known Happy Camp Canyon to begin our journey of discovery through the hills and mountains above the Santa Monica Mountains? For one reason: This is the soul of Wild L.A. Happy Camp Canyon Regional Park achieves two conservation ideals: It protects unspoiled wilderness close to major population centers, and it links open spaces for migration corridor preservation.

The plan for the Rim of the Valley Corridor was formalized in the California State Legislature's 1990 mandate to the Santa Monica Mountains Conservancy. The SMMC was instructed to acquire and administer a network of protected parks and other publicly held lands in the foothills and mountains encircling the San Fernando, La Crescenta, and San Gabriel Valleys. These many open spaces were to be connected by a nature trail. The ultimate goal of the program is to provide wilderness recreation for visitors and to reestablish an unbroken chain of wildlife habitats from the Santa Monica and Santa Susana Mountains all the way to the Angeles and Los Padres National Forests to the north and east.

The Rim Corridor is easily visualized when we take flight again on condor's wings. Circling up to our vantage point high above the spine of the Santa Monica Mountains, we look north to see one phalanx after another of hills and mountains, layered across our view from west to east. Geologically, the mix of hill and mountain areas within the Rim is part of a group of mountain systems known as the Transverse Ranges.

California's mountain ranges generally run in a north-south direction. The Transverse Ranges, smaller mountains that generally encircle the Los Angeles Basin, come from the collision of the gigantic North American and Pacific Plates. As the Pacific Plate subducts, or slowly dives beneath, the North American Plate, its top crustal layers are scraped off, compressed, and uplifted into mountain masses. That's why fossils from ancient sea beds are found even at high elevations in exposed Transverse Ranges rock.

When plates collide, sometimes cataclysmic seismic activity is to be expected. But in Southern California, the grinding of land masses along the San Andreas Fault and its subfaults also causes a counterclockwise rotation of the mountains. That's how the Transverse Ranges were born.

Filling a broad, flat hollow in their midst is the densely populated San Fernando Valley, separated along its southern

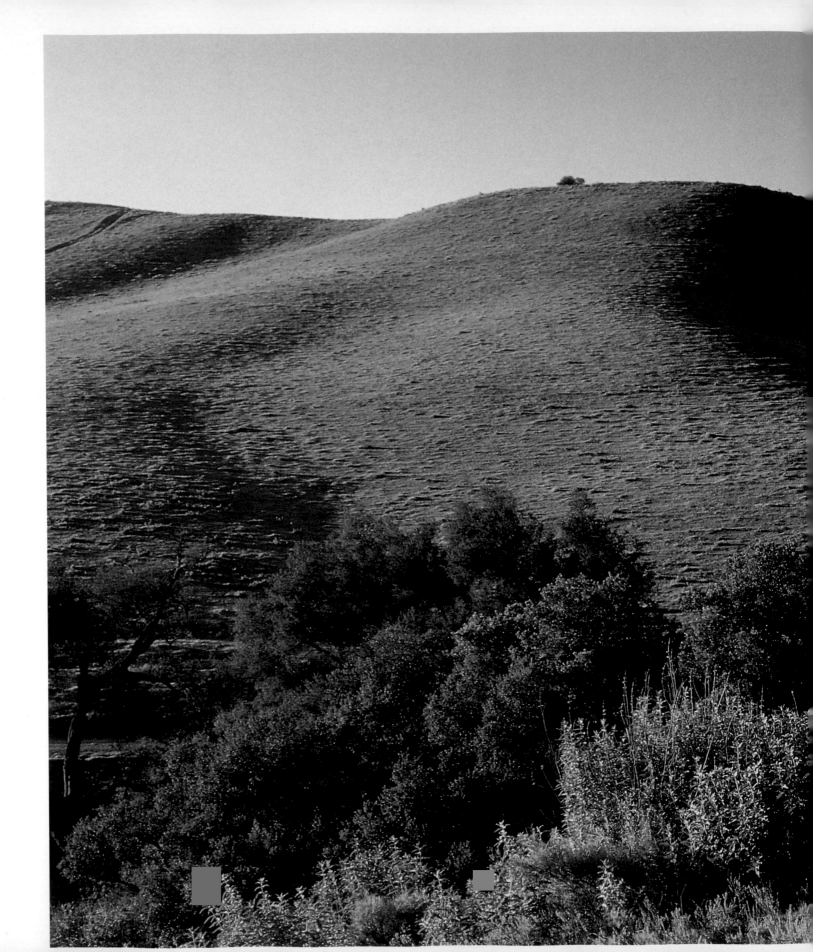

right: *Simi Hills in spring*

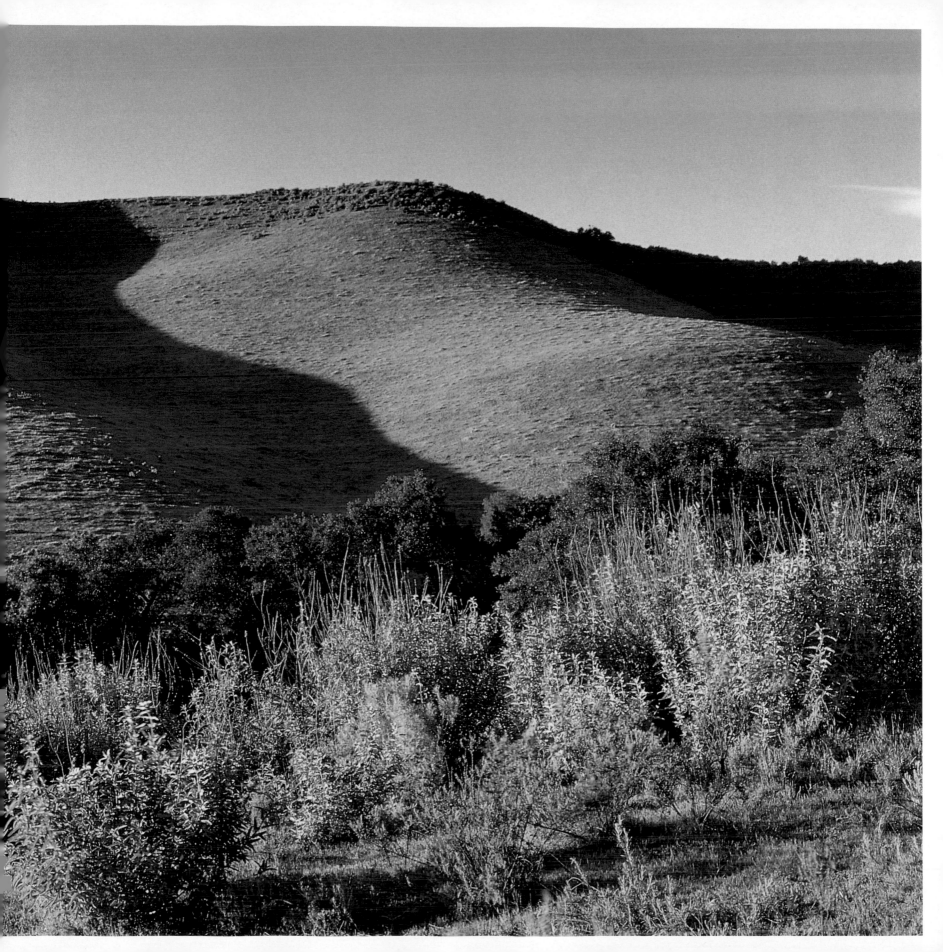

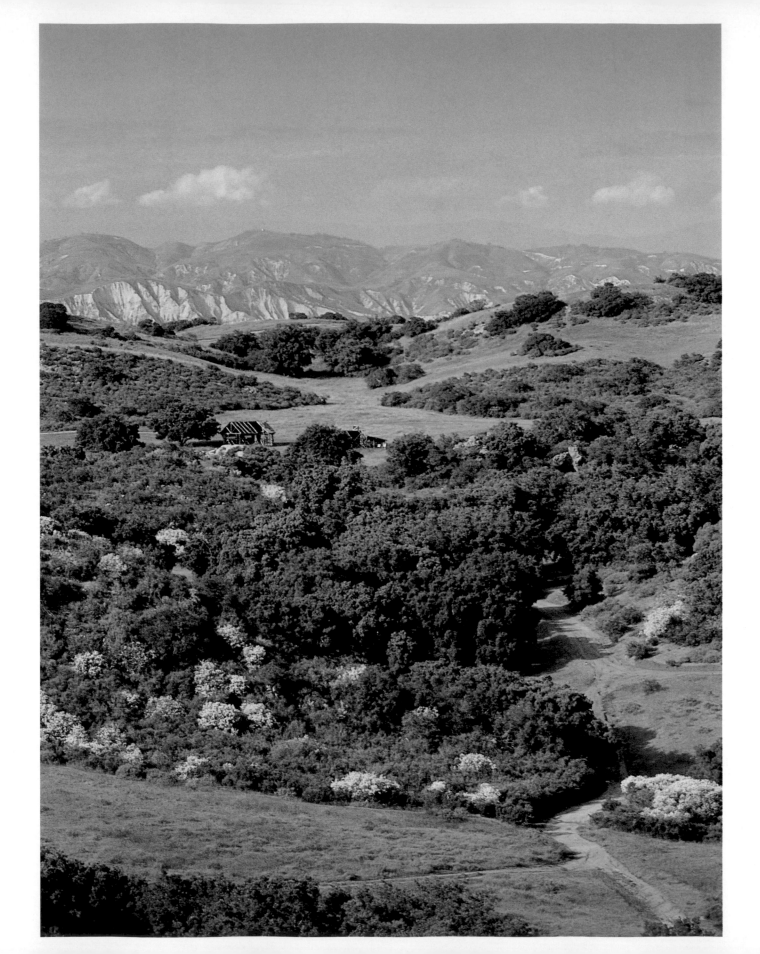

opposite: *Old movie sets in*
Palo Comado Canyon
below: *Western bluebird, in*
competition for habitat with the
house sparrow and European
starling

boundary from the Los Angeles Basin by the last, eastern-most wedge of the Santa Monica Mountains. On that rare winter's day when an Arctic-bred storm swirls out of the Northwest, you can look toward the ring of gentle hills and low mountains that surround the valley and, if the storm's air mass is cold enough, see a bright mantle of snow.

These hills and mountains rise as high as 3,000 feet above the valley and are easily distinguished on a topographical map as an arc of high country capping the valley from west to east. At the western anchor of the Rim, the lower, more rounded Simi Hills and Las Posas Hills rise just north of the Santa Monica Mountains. They offer a much-needed break of bare, rolling hills and bluffs above the sea of urban development that surrounds them on all sides.

Directly to the north and east, Oak Ridge and Big Mountain (Happy Camp Canyon lies between them) join the higher Santa Susana Mountains, which form the steep northern boundary of the San Fernando Valley. At the eastern edge of the Santa Susanas lies Newhall Pass, a deep, winding gap in the mountain wall through which Interstate 5 carries commuters northwest into the suburbs of the booming Santa Clarita Valley. The high country then bends southeast to split into the foothills and peaks of the San Gabriel Mountains, and a parallel range just to the southwest: the Verdugo Mountains and San Rafael Hills that rise to 2,500 feet above Burbank and Glendale. The high, narrow La Crescenta Valley lies between the Verdugos and the San Gabriel Mountains.

A three-mile-wide urban expanse fills the space between the western foot of the Verdugo Mountains/San Rafael Hills ridge and the eastern edge of Griffith Park, where the Santa Monica Mountains end. Two centuries ago, it was a grassland floodplain through which the idyllic, tree-lined Los Angeles River flowed. Today, the concrete flood-control

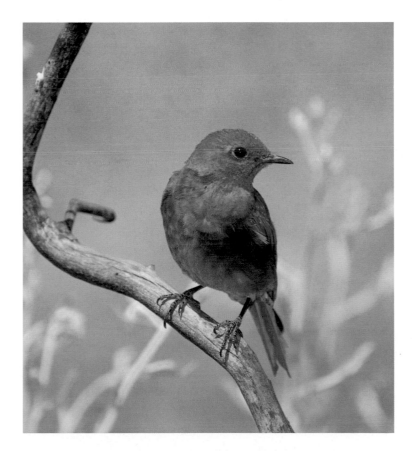

opposite: *Simi Hills, green with spring growth*

channel that replaced the river shares a densely congested space with freeways, commercial high-rises, and the ubiquitous Southern California mazework of city streets. Here is where the Rim of the Valley Trail Corridor ends.

The Santa Monica Mountains Conservancy was created by the California State Legislature in 1979 to centralize the process of acquiring open lands and historical sites in the Santa Monica Mountains and San Fernando Valley region. Its mandate is to create contiguous wild areas throughout the 450,000 acres of existing and potential holdings surrounding the Simi and San Fernando Valleys.

The SMMC's successes so far speak well to the proliferation of grassroots and statewide environmental campaigns dedicated to the future of a "greener" Southern California. Nevertheless, the agency and its partner groups have their work cut out for them. Powerful development interests continue to nip away at the remaining open lands among many privately held oil fields, ranchlands, and estates.

The low-lying Simi Hills and Las Posas Hills at their western flank are vitally important habitat links between the Santa Monica Mountains to the south and the Santa Susana Mountains to the northeast. Without some way to extend their ranges, many species that live in these regions face increasing threat of extinction from urban growth and habitat loss.

The 4,800-acre Cheeseboro/Palo Comado Canyon unit and its planned 2,633-acre Ahmanson Ranch addition exemplify the wildlife corridor concept. Although administered as part of the Santa Monica Mountains National Recreation Area, these two parallel canyons lie in the Simi Hills, north of Highway 101, and should be considered geographically as part of the Rim lands. And they are a true wilderness paradise, reclaimed from the denuded rangeland left by 150 years of cattle ranching. During that period, many native plants were wiped out by heavy grazing and replaced by introduced European annuals such as wild oats, mustard, and thistles. Grizzly bears, once common in the canyons, were systematically killed off by ranchers.

A walk along the many trails that wind through creekside oak and walnut groves and along several low ridgelines is a moveable feast of seasonal delights. In spring and early summer, the long, gentle hills spotted with coast live oaks invigorate the senses with rich green carpets of needlegrass and native wildflowers. In the dry, scorching summer months, a spring, two waterfalls, and nearly fourteen acres of creek-fed wetlands offer shade and respite. In autumn, colors shift to a warmer palette, with the terrain taking on the look of classical Golden California. And in deep winter, the artist Andrew Wyeth would have found inspiration in the muted mouse-brown hills and dusky rough-barked oaks.

Here you find what is perhaps the largest southerly stand of valley oaks in the entire world. The diversity of habitat—open grass, scrub brush, and creekside and hill-crowning woods—provides ideal shelter and hunting grounds for prey and predators alike. Tracks and sightings of

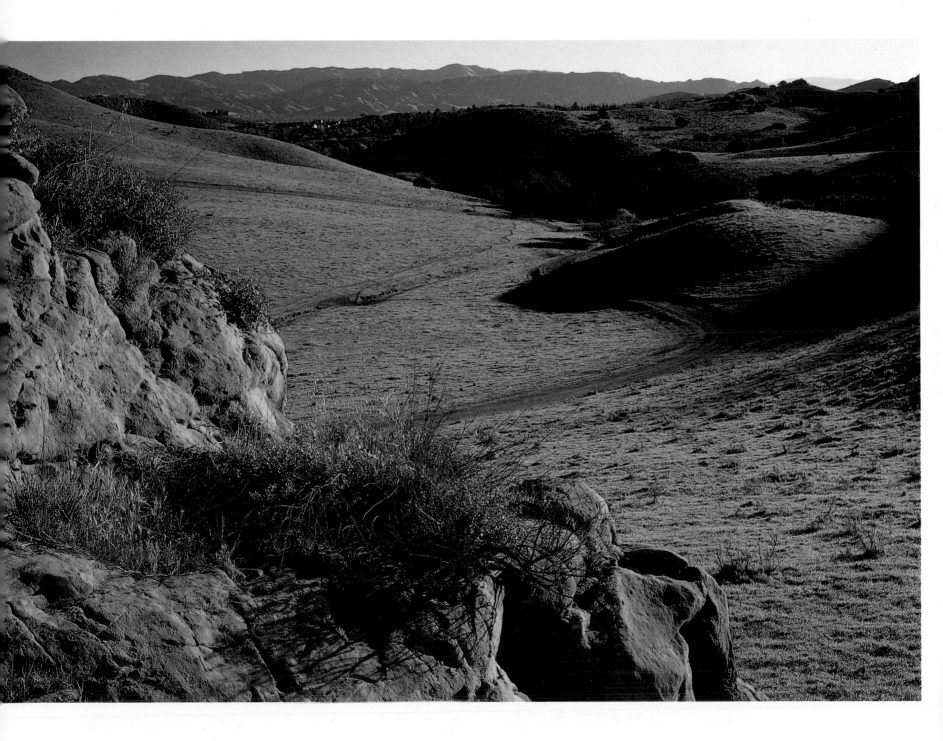

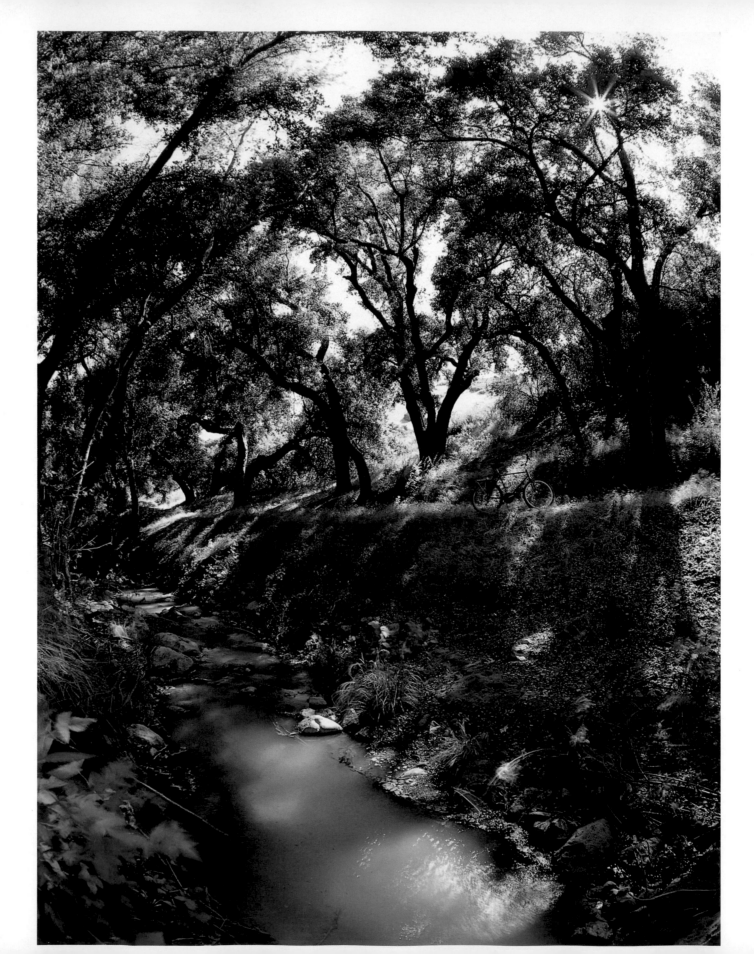

opposite: *Sulphur Creek,*
Cheeseboro Canyon

mountain lions, bobcats, gray foxes, badgers, deer, racoons, rabbits, mice, rattlesnakes, and many other species are common. The abundance of raptors such as owls, hawks, and several varieties of falcons indicates just how robust the ecosystem's prey population is. Cheeseboro Canyon alone has the largest concentration of birds-of-prey nesting sites in the continental United States.

Visitors who hike and bike the miles of trails use many of the same pathways as the Chumash Indians who lived here for thousands of years. Woods and dense tangles of brush line the north-south flowing creeks that join the waters of Malibu Creek to run to the sea at Malibu. Riparian plant life needs more water than the typical scrub-adapted plants of open-space chaparral and grasslands. That's why the dominant plant systems along the creeks—red and black willow, California walnut, western sycamore, mulefat, and California bay laurel—often have broad, large leaves.

Protected woodlands throughout the Simi Hills and the Rim's open spaces give threatened or endangered animals such as the least Bell's vireo, a small songbird (not long ago down in number to about 300 pairs), a fighting chance to recover. Other animals continue to thrive in these regions, especially the vigorous raptor populations.

In the Simi Hills, 11 raptor species, including the kestrel and golden eagle, have been spotted, along with 140 bird species, among them northern orioles, hooded orioles, and rufous-sided towhees; 25 reptiles (including rattlesnakes and king snakes); and 50 mammals, ranging from mountain lions, bobcats, gray foxes, and deer to dusky-footed wood rats, brush rabbits, coyotes, and California ground squirrels.

The bounteous diversity of wildlife tells us how native Chumash tribes were able to maintain numerous villages throughout these hills over so many thousands of years. Evidence of their enduring presence whispers to us across the millennia from thirty documented archeological sites within the Cheeseboro/Palo Comado boundaries alone. Fossils of ammonites, clams, snails, and plants, as well as sharks, fish, and even whales, have been unearthed here.

The Simi Hills are far from the haven for wildlife they could be, however. The only known habitat in the world for the San Fernando Valley spineflower lies in the middle of the still-embattled Ahmanson Ranch property, just east of Cheeseboro/Palo Comado Canyons. The flower, found within an oak-strewn native grassland of extremely rare purple needlegrass, was believed until its rediscovery in 1999 to have gone extinct decades earlier.

Save Open Spaces (SOS), a nonprofit conservation organization, continues its campaign to save the remaining 2,600 acres of Ahmanson Ranch habitat from being destroyed by a planned development of 3,050 homes, two golf courses, and a freeway through the middle of the area. The property also contains habitat for the red-legged frog, recently added to the federal endangered species list and protected elsewhere in the state. SOS focuses on maintaining open space, protecting wildlife, and preserving natural resources throughout the Santa Monica Mountains

below: *Blue-eyed grass*
opposite: *Spring trail through the foothills of the Santa Susana Mountains*

National Recreation Area and its adjacent zones. One of its primary weapons is making sure local permit and planning agencies follow existing planning laws—to the letter.

From the sensuous curves of the Simi Hills we glide northeast, skimming the highlands as they rise from average elevations beginning at 600 feet above sea level to where they mature, in the Santa Susana Mountains, at Oat Mountain's 3,747-foot peak in the middle of the range. The Santa Susanas are the dramatic northwestern ramparts visible from everywhere in the San Fernando Valley.

A critical donation made just two years ago to the SMMC brought 4,815-acre Rocky Peak Park into the Rim

of the Valley Trail Corridor. Most of the park—a popular day-use area in the Santa Susana Mountains between Chatsworth and Simi Valley—was once part of entertainer Bob Hope's Runkle Ranch property. One major feature of the park is the wildlife tunnel that environmentalists insisted be built under Highway 118. The tunnel makes it possible for migrating mammals to pass safely through dense urban areas and provides a vitally important link in the Rim-wide wildlife corridor.

Just east of Rocky Peak, in the hills above the town of Chatsworth in the San Fernando Valley's northwest corner, Santa Susana Mountains State Historic Park and Garden of the Gods Park celebrate and preserve the rocky high country made famous in the early days of television. Anyone who remembers "The Lone Ranger" television show will recognize the jutting sandstone boulders and densely foliated scrublands here. Hundreds of westerns and other films were shot all over these rugged highlands, most notably at the Iverson Movie Ranch, once the location of a classic Old West movie set.

Today, visitors readily find a variety of trails looping around steep, brush-choked clumps of massive boulders and hidden canyons. They chase down nostalgic landmarks, such as portions of the old stagecoach trail that ran from Los Angeles to Ventura, or simply enjoy a rustic escape from the congested valley just a ridgeline away.

Farther northeast, Devil Canyon, Porter Ranch, and the wonderful riverine and mountain trail system of O'Melveny

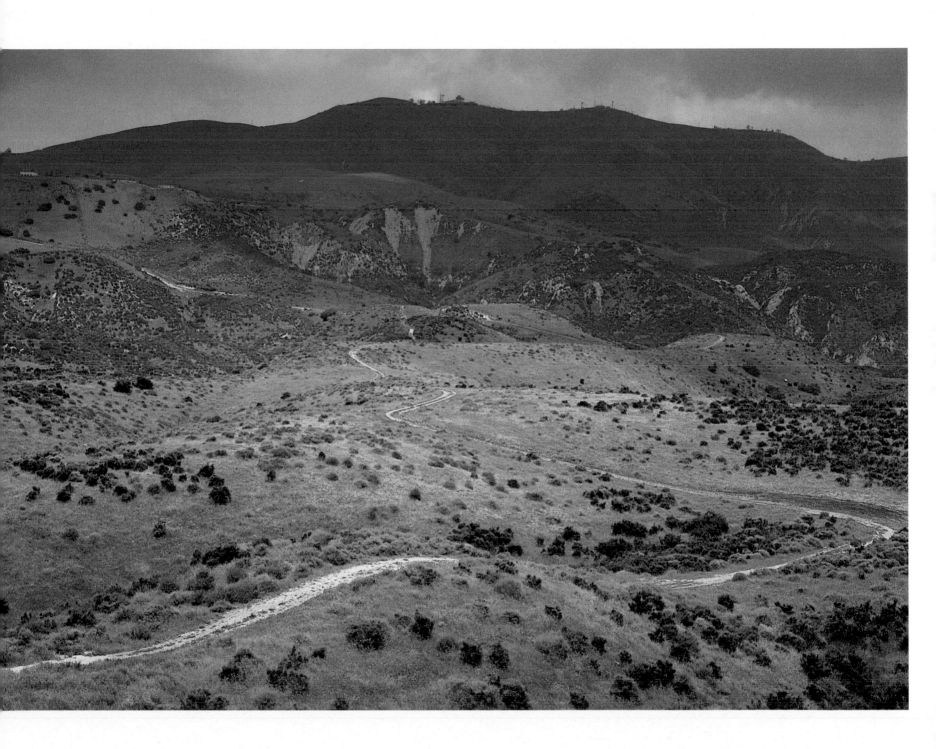

opposite: *San Fernando Valley cities at night from the Verdugo Hills*

Park extend the Rim Corridor lands all the way to Interstate 5, which cuts abruptly through the mountains at Newhall Pass. Among the many north-facing canyons of the Santa Susana Mountains on the western side of the freeway, Santa Clarita Woodlands Park is the site of year-round streams and a mix of tree species that is unique in the world.

Once, petroleum seeps in the region gave local Indians and Spanish missionaries raw material for caulking and sealing boats, roofs, and basketware. The land was developed as an oil field during the twentieth century. In 1995, the SMMC acquired 3,035 acres of oil-company property to create the heart of Santa Clarita Woodlands Park. Additional purchases expanded the woodlands area to 4,000 acres. Today, black bears still roam its steep, rocky slopes and shady groves, just a few minutes' drive from the urban explosion of the Santa Clarita Valley.

Gliding across Newhall Pass brings us to more high country: the foothills of the San Gabriel Mountains, protected within the Angeles National Forest. The Los Pinetos Trail rises up from the 210 freeway, providing one of several gateways into the steep, challenging high country of the San Gabriels.

The foothills and mountains bend southeast, merging into Angeles National Forest lands above the northeastern San Fernando Valley cities of Sylmar and San Fernando. Wilson Canyon Park is one of the highlights of this region. The 242-acre park is rich in wildlife habitat. Coast live oaks, creekside alders, big-leaf maples, and sycamores blend with hillsides of coastal sage scrub species such as buckwheat, sage, and yucca. Visitors to the park spot deer, bobcats, coyotes, mountain lions, more than a hundred bird species, and black bears that come down from higher elevations to forage.

Wilson Canyon stands as a major victory for the SMMC. Long slated for a massive housing development, it was instead bought as parkland in 1995. Now visitors can stroll through oak groves, sit in solitude by the side of a shaded, year-round mountain stream, or look up to see hang gliders and paragliders sail thermal updrafts from nearby peaks.

Southeast of El Cariso Park and Veterans Memorial Park, at the eastern end of the San Fernando Valley, lie the Verdugo Mountains and the San Rafael Hills. La Tuna Canyon Park, Wildwood Canyon Park, Henderson Canyon, and Brand Park together form thousands of contiguous acres of bare, brushy slopes and small, steep, wooded canyons that present a welcome glimpse of green from any part of the valley. Trees, hiking trails, and a stream cover the steep slopes that rise right from the urban boundaries of Burbank and Glendale. The Rim of the Valley Trail Corridor ends here.

Many of the Rim's public areas are easily found. Others almost appear to be jealously guarded local treasures. I spent an hour driving around, frequently stopping to pore over three maps, before I found Happy Camp Canyon Regional Park. Even then I twice overlooked the minuscule four-inch sign that is the sole marker to the park's entrance. In contrast, some Rim parks are easily located, as they present a natural barricade against further urban development.

However you move through the sky-blessed open spaces of the Rim—by foot, bike, or horseback—you can't overlook the dramatic importance of these wilderness buffers. Standing on the ridge-top Modelo Trail in Cheeseboro Canyon or atop Brand Park Trail in the Verdugos brings a panoramic vista that invites a conservationist perspective. Even as the view lifts the spirits, it brings home a powerful truth: All these thousands of acres of wild country were at one time sentenced to the bulldozer. In each of these places where we stand today, knee-deep in oat grass instead of on a curb-lined street, environmentalists raised their voices and said, "No more. Not here. Not ever."

We can give thanks for the vision and ongoing vigilance of the Santa Monica Mountains Conservancy. Walking among oaks and scrub, enjoying the gentle touch of afternoon breeze and the fragrance of sage and wildflowers it brings, we appreciate how essential wilderness is to our humanity.

In just such a mood of reverie, I sat one summer evening on a rock ledge, exhausted but invigorated by my climb up the trail from Brand Park to the top of the Verdugo Mountains. I contemplated the twinkling lights of the San Fernando Valley far below. Half an hour earlier, near the start of the trail, I had hopped in alarm over a slender young rattlesnake, no more than two feet long, stretched across the steep path. I had almost stepped right on it.

I had squatted down to observe the elegance of its marvelously patterned camouflage. Sensing that I was no immediate threat, the snake had slithered off into the protective brush covering the hillside. I had scrambled on up the trail, careful from then on not to stick my hands or feet into hidden spaces.

Now, resting and reflecting on the smog-layered hustle and bustle below, I picked out Griffith Park across the way—it appeared as a black expanse within the galaxy of city lights. Then I looked into the distant west beyond. The last ruby hues of sunset silhouetted the hills of Cheeseboro and Palo Comado Canyons.

The cool, deep night gathered around me, even as the lights of the city seemed to grow brighter. I gazed north, absently watching the river of red and white car lights along Interstate 5. So many people, I thought. Where are they going in such a hurry?

I felt a stirring behind me. A dry, downslope breeze carrying scents of sage and mountain earth flooded my memory with images of childhood trips to the Mojave Desert, just beyond the high wall of the San Gabriels at my back. Overhead, some familiar constellations peeked through the skyglow.

Something dark on wings—an owl—glided by just a few feet away, so silently that I jumped in reaction only after it was well past me. I watched its silhouette slash across the starfield of street lights and into the woodland below. I thought of the snake and wondered if the owl might find him tonight.

For a long time after, I was a creature of the Rim, breathing the rhythms of the night, as free from the rush below as that silent owl from the pull of gravity.

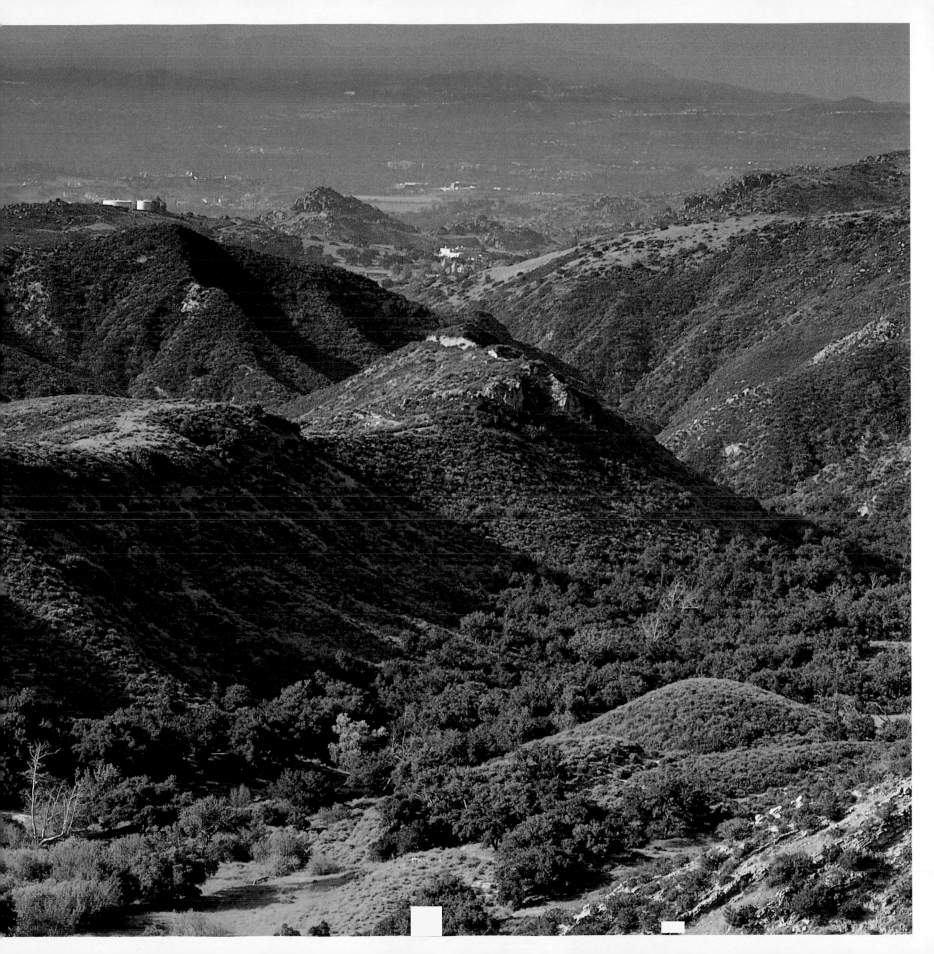

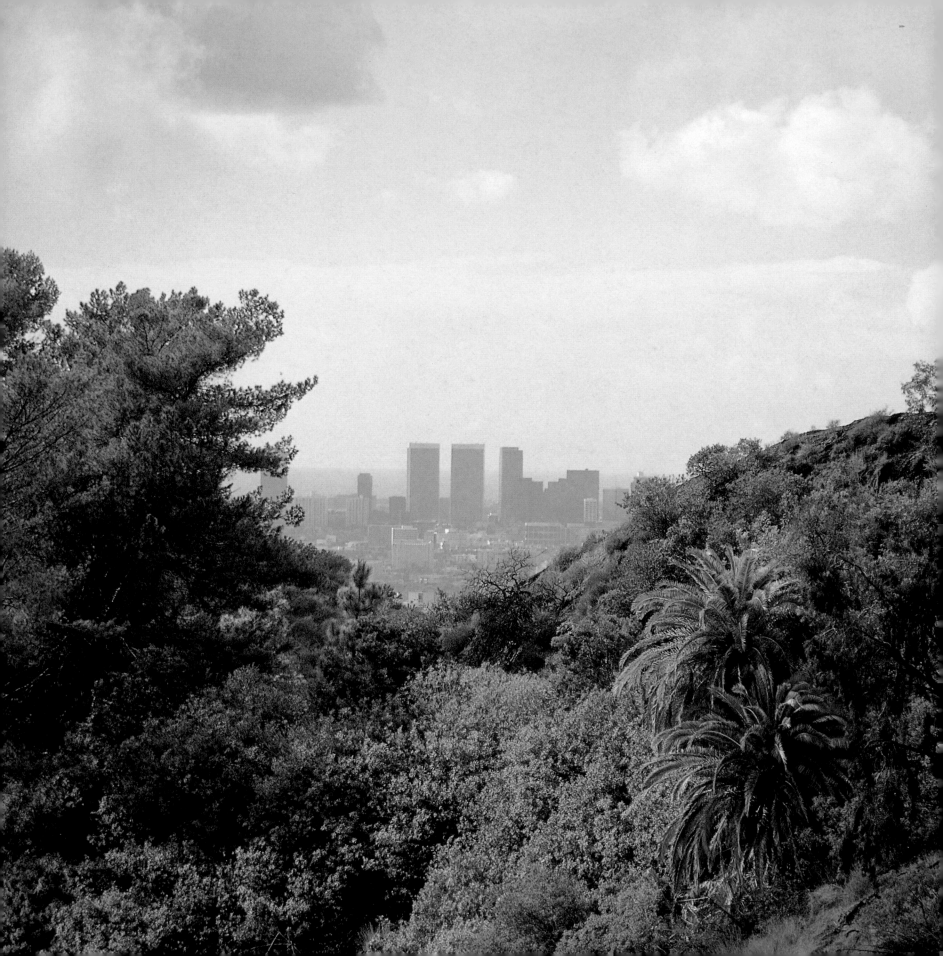

opposite: *Century City from Griffith Park* right: *Plummer's mariposa lily*

Wild in the City

NATURE WILL BEAR THE CLOSEST INSPECTION. SHE INVITES US TO LAY OUR EYE LEVEL WITH HER SMALLEST LEAF, AND TAKE AN INSECT VIEW OF ITS PLAIN.
─HENRY DAVID THOREAU

Wild
L.A.

By the time the Santa Monica Mountains end in the eastern Los Angeles Basin, dividing the city's millions from the one million more who live in the San Fernando Valley to the north, nature seems wholly vanquished by the crazy-quilt expanse of urban development. Houses hang over steep chaparral-covered canyons, hide the rounded hills of the palisades and bluffs above the western Malibu Coast, and threaten to overrun the boundaries of that great bastion of wildness in the heart of the city: Griffith Park. Strip malls and

office buildings pop up here, there, and everywhere. Cars whiz by, always, on the freeways.

Though everywhere the hills wear the muted greens and browns of native chaparral and introduced plant life alike, the notion of discovering a significant pocket of virgin nature within this urban jungle seems ludicrous. And yet, looking closely at even the most relentlessly concretized parts of the Los Angeles area, we find refreshing oases of natural beauty. We can indeed go wild in the city.

In the middle of the San Fernando Valley, just one minute from where the 405 freeway meets the 101 freeway at the bottom of Sepulveda Pass, you can park your car, walk down a lovely curving path, and enter a primitive wetland nestled in a wooded area that beautifully evokes pre-European California. Welcome to the Sepulveda Basin Wildlife Reserve.

The reserve has only recently been restored, part of an immense complex of city parklands, an eighteen-hole golf course, a large fishing and boating lake, even an expansive model aircraft field—all of it a mere fifteen miles from downtown L.A. The area was created by visionary citizens and government planners who saw the potential for a designated wildlife reserve in the 1960s, when much of the Sepulveda Basin was still open and agricultural land was only beginning to come under suburban development pressures.

Today, the reserve protects plant and animal life, especially those avian species that land, rest, and feed here during their epic fall migrations from Alaska to Mexico along the Pacific Flyway. It lies in the low point of the broad flood-control basin built by the U.S. Army Corps of Engineers in 1941 to contain the meandering, unpredictable Los Angeles River—now a fifty-one-mile concrete channel—during winter floods.

Up to 75 million gallons of treated but unchlorinated water flow daily into the reserve's lake from the adjacent Donald C. Tillman Water Reclamation Plant. In past decades, the Los Angeles River channel was virtually dry in summer and fall. Now, with the reclaimed water coursing through the reserve, the downriver miles receive a year-round water flow. In sections along the river, plant and animal life is returning.

The 1,800-foot-long lake within the reserve was reclaimed from a clay quarry mined for dam-construction materials decades ago. Walk along the dirt pathway around the lake and you find yourself immersed in a place you'd expect far from any city. Only the susurrus of freeway traffic to the east begs the question. American coots bank high overhead, then dive down to short, smooth water landings. You may even spot a white gyrfalcon as it glides in from the north, spots prey, tucks its wings, and dives down below the tree line, only to rise back up a few seconds later, unsuccessful in its hunt, to search again.

Monarch butterflies dance among the sage. Western sycamores shade the path with an agreeable canopy of broad, pointy leaves. Mexican elderberry bushes, those most plentiful of Southern California indigenous plants, grow six

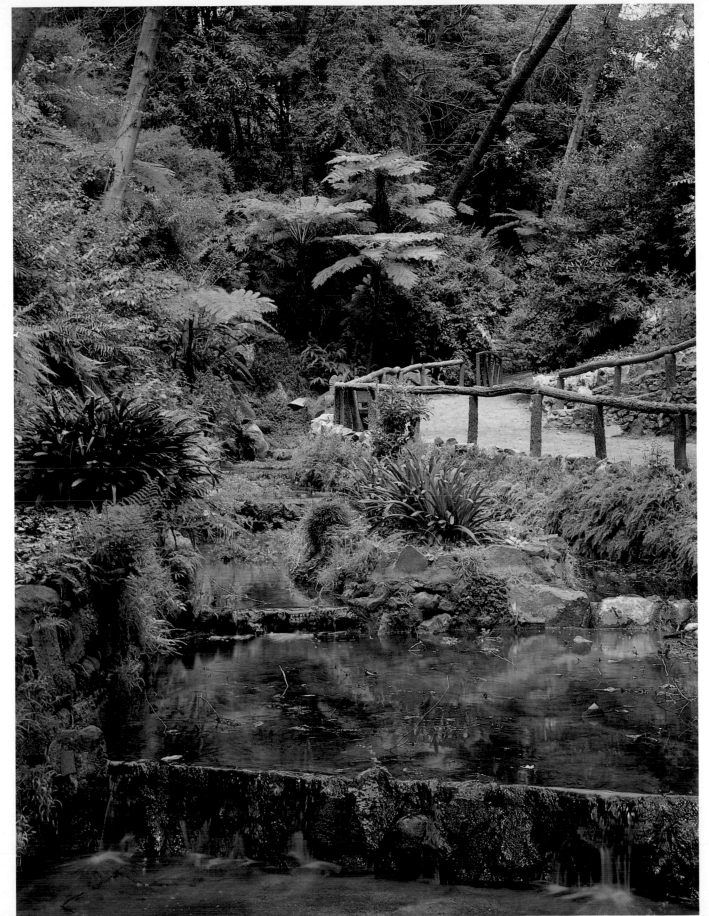

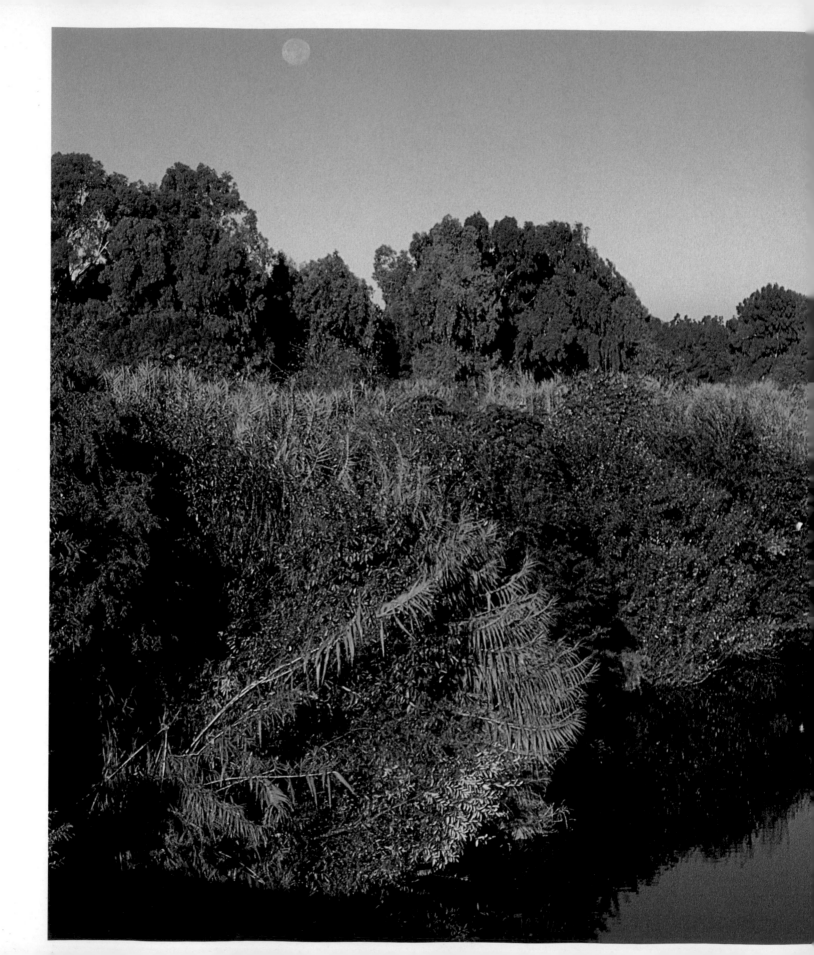

right: *Channel of the Los Angeles River near the Sepulveda Basin Wildlife Reserve*

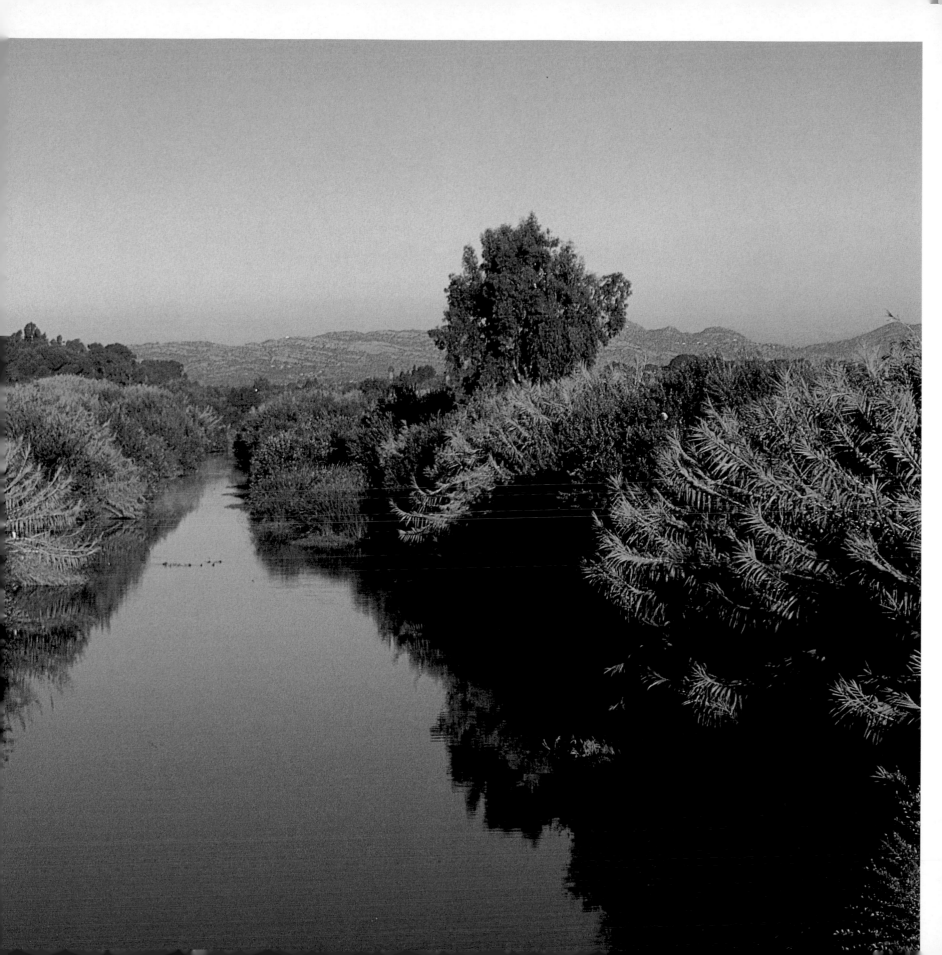

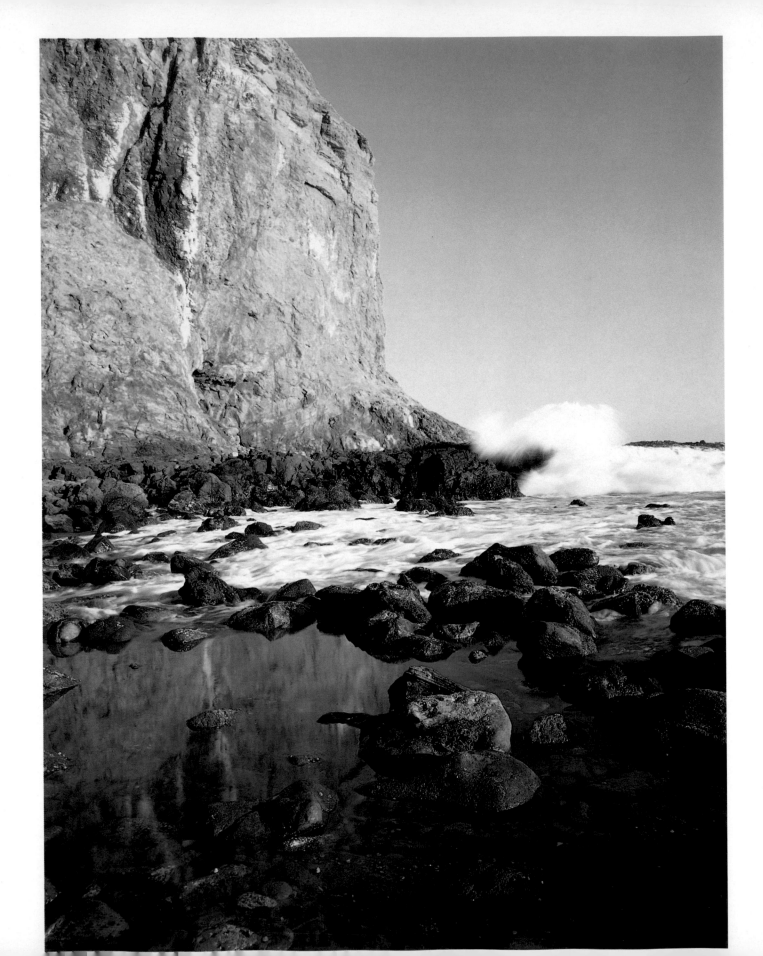

opposite: *Tidepools and bluffs*
at low tide, Abalone Cove
Ecological Preserve on
Palos Verdes Peninsula
below: *Sandstone detail,*
Abalone Cove Ecological
Preserve

feet and taller, decorated with a seductive profusion of lovely (if toxic) bright red berries.

On my first visit, I followed a short trail to a lakeside clearing. A white egret ducked out of sight at my arrival— I'd interrupted its feeding in the shallows. I crept quietly to the lake's edge for a closer glimpse, but it had moved a distance away under the cover of reeds. I watched entranced as it arced its neck like a rattler, striking at prey in the water with quick jabs.

Across the lake, more kinds of ducks than I know the names of swam here and there. Pied-billed grebes, great blue herons, black-crowned night herons, Anna's hummingbirds, cliff swallows, and blue grosbeaks are only some of the species that breed in the reserve in summer. A group of little red-eyed, white-billed, black-feathered coots foraged along a brush- and tree-covered islet across the water, while a great blue heron majestically pranced around the high ground. This is a bird-lover's paradise.

A nearby sign explains that this acreage has been preserved and protected for the benefit of wildlife and people and identifies more than 200 bird species already spotted at the lake. It's easy to believe that number: A rich variety of birdcalls provided background music throughout my enchanted walk. Just a short way down the trail, a lovely stone and metal footbridge arches across Haskell Creek. Reeds and tules, mulefat bushes, willows, sycamores, and Fremont cottonwoods line the narrow creek teeming with fingerlings.

The reserve welcomes us to an experience of the land as it used to be, even as it restores vital habitat for wildlife. It poignantly demonstrates how vision and cooperation among civic agencies and citizen groups can reverse more than a century of callous indifference toward the natural environment.

opposite: *Century City and Hollywood from Angel Point, Elysian Park*

Although Los Angeles has the least amount of parkland acreage within its city limits of any major metropolis in America, there are dozens of natural areas and scores of parks throughout the Greater Los Angeles Basin. Some are fairly recent expressions of environment-sensitive planning. Many lie along the Los Angeles River, which begins in the western and northern mountains that corral the San Fernando Valley, runs east through the Sepulveda Basin, continues past Burbank, and bends southeast around the end of the Santa Monica Mountains, to finally head south to Long Beach Harbor, where it empties into the Pacific Ocean.

Most Angelenos are only dimly aware that a beautiful river once flowed through the region. Fewer yet realize it's still here, though mostly as a sad remnant of the Los Angeles River that so captivated Spanish explorers just 200 years ago. One politician even trotted out a plan to convert much of its current mostly concrete-channel length into yet another freeway. Another suggested a monorail but didn't get past the conceptual stage. A public-office seeker once campaigned on a promise to paint the concrete riverbed blue—to make it more river-like!

But while a concrete riverbed would seem the perfect expression of Joni Mitchell's "we paved paradise" lament, there would, in truth, be no Los Angeles today—at least not the one we know—if not for an extensive flood-control program that brought the river to heel starting in the late nineteenth century.

Dozens of histories of Los Angeles focus on its "discovery" by the famed 1769 Spanish exploratory land party, led north from Mexico to Monterey by Capitán Gaspar de Portolá. The party's purpose was to map and begin the colonization of Alta California. One of the party, Franciscan missionary Father Juan Crespi, wrote an eloquent description of primal California and its indigenous people.

Near the site of modern downtown L.A., where his party stopped for the night, Father Crespi described a "spacious valley, well grown with cottonwoods and alders, among which ran a beautiful river. This plain where the river runs is very extensive. It has good land for planting all kinds of grain and seeds, and is the most suitable site of all that we have seen for a mission, for it has all the requisites for a large settlement." The party named the river Nuestra Señora de los Ángeles de Porciúncula, "Our Lady of the Angels of Porciúncula," after the chapel in Italy where the Franciscan order was founded.

In 1781, Mexican and Spanish settlers established a small colony at the same riverside spot. This Pueblo de Los Ángeles was seated near a Tongva village with the name Iyáangá, or "poison oak place." The Los Angeles River was the waterway along which not only poison oak but as many as 5,000 Tongva thrived in dozens of villages.

The Tongva (who were called Gabrieliños by the Spanish, after the nearby Mission San Gabriel built two years after Portolá's first visit), were part of the Takic, a branch of the Uto-Aztecan family. With the coming of the

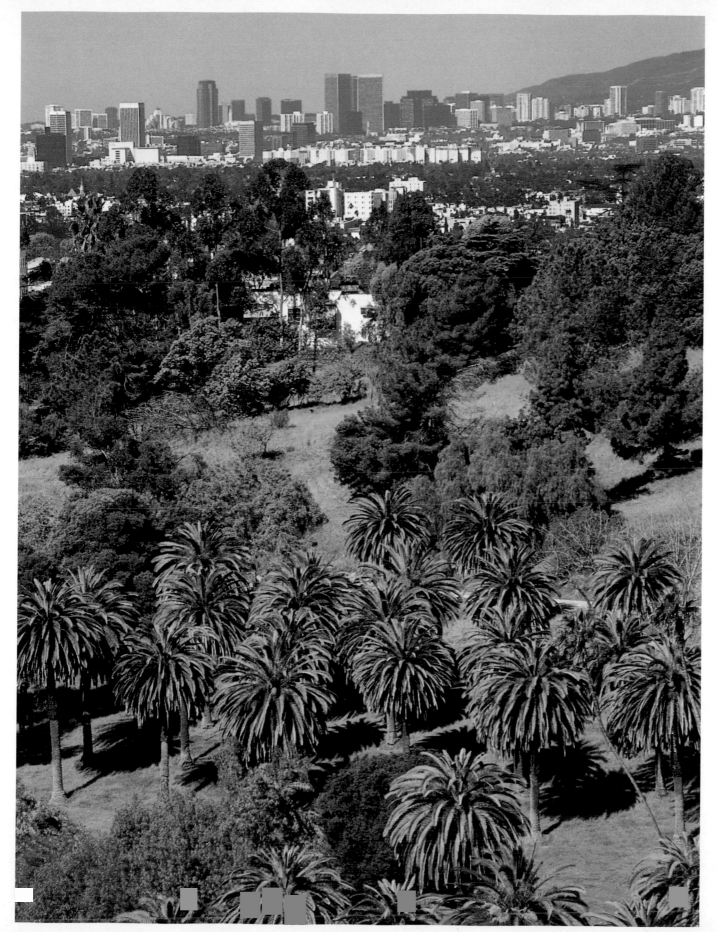

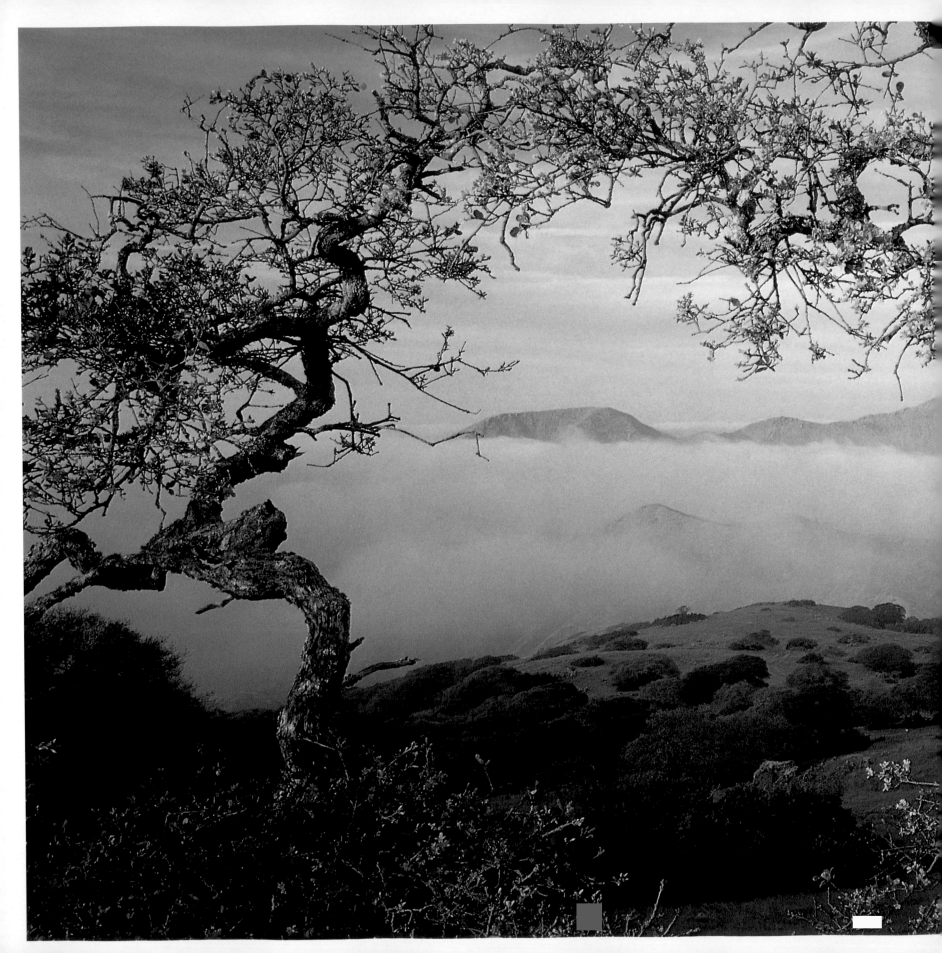

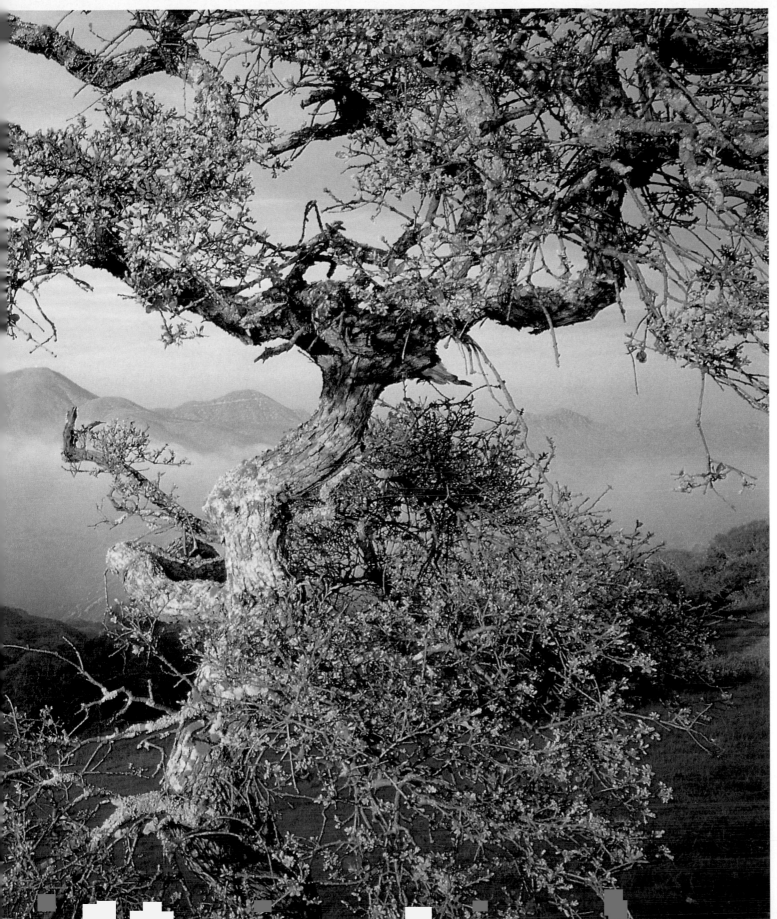

left: *View from Santa Catalina Island scrub oaks to Mount Orizaba*

opposite: *Historic Avalon Bay and its landmark Casino Ballroom and Theatre, Santa Catalina Island*

brutal demagoguery so characteristic of mission life, along with the introduction of European diseases, the Tongva were decimated, with the few survivors assimilated into the new culture within just 100 years. With them went the beautiful river Father Crespi so admired.

The original Los Angeles River rose to the surface from a huge natural underground reservoir beneath present-day Encino, near the Sepulveda Basin Wildlife Reserve. At its source it was only a few feet wide.

Since much of the Los Angeles Basin had bedrock close to the surface, the river's course was a broad, shallow meander that either sank into expanses of sand and gravel or formed expansive marshes, lakes, and shallow ponds. As late as the end of the nineteenth century, 20 percent of this soggy acreage was still a wetlands prone to massive flooding during the rainy winter months—an unacceptable hazard for a burgeoning city.

Extensive flood-plain forests once grew everywhere in Los Angeles. Cottonwoods, willows, sycamores, alder and hackberry, California rose, and wild grapes were abundant. The changing personality of the river spawned a variety of discrete miniature biomes, allowing botanicals as diverse as wetland cattails and arid yucca and other cacti to flourish.

At the rich edges where different habitats meet, wildlife is even more abundant than in homogeneous ecosystems. Deer, antelopes, grizzly bears, coyotes, foxes, and mountain lions hunted throughout the basin. Salmon and steelhead trout filled the river. Smaller animals, such as badgers,

gophers, and the only marsupial native to North America— the Halloween-homely, waddling opossum—thrived in the underbrush. Waterfowl, like the ducks and egrets that are returning to the Sepulveda Basin Wildlife Reserve, were once everywhere, as were hawks, condors, and owls. Though in diminishing numbers, raptors are still found throughout Los Angeles today—except for condors, which cling to survival in the mountains north of the city.

This natural wealth supported what was one of the most extensive populations of Indians in North America. At least forty-five Tongva settlements flourished near the river, which provided a bountiful Eden to these hunter-gatherers. Oak trees provided acorns. Food and hide animals were plentiful, as were reeds, grasses, and other building materials for villages. The water itself was clear and pure, ideal for drinking and bathing.

By the mid-twentieth century, the Los Angeles River had been systematically converted into the network of concrete flood-control channels that remains today. Only three short sections along its entire fifty-one-mile length have soil instead of cement lining the riverbed, one being the Sepulveda Basin.

Still, even these truncated green runs offer hope. Among the three isolated sections, densely wooded sandbars provide a welcome habitat for more than 100 species of birds and waterfowl. At the river's mouth in Long Beach you can find thousands of shorebirds, the largest such congregation in all of Los Angeles County's coastal environs.

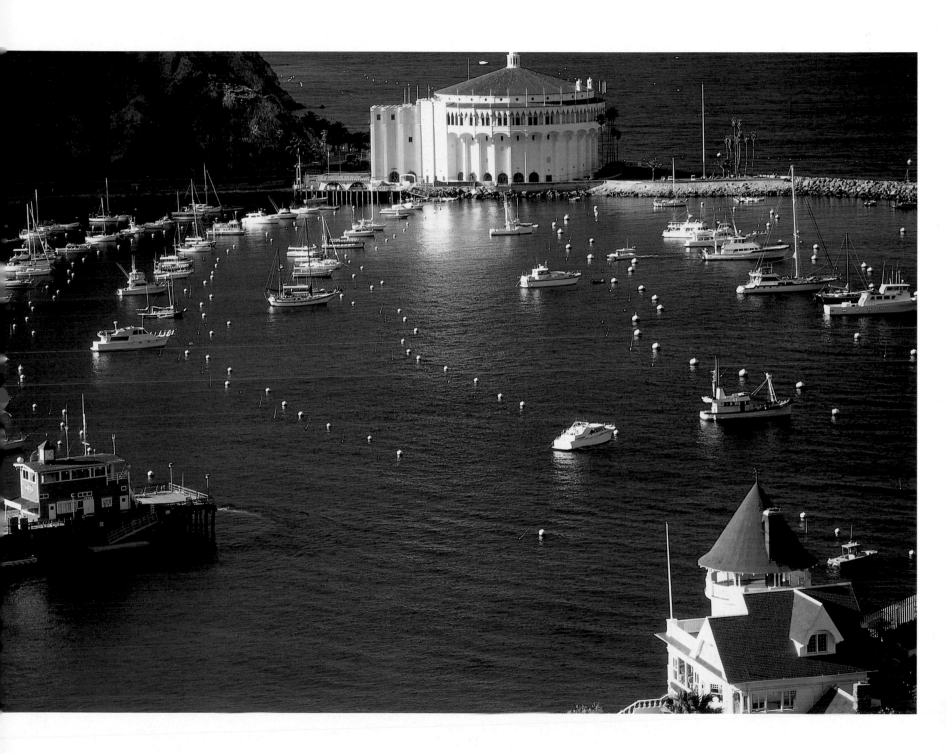

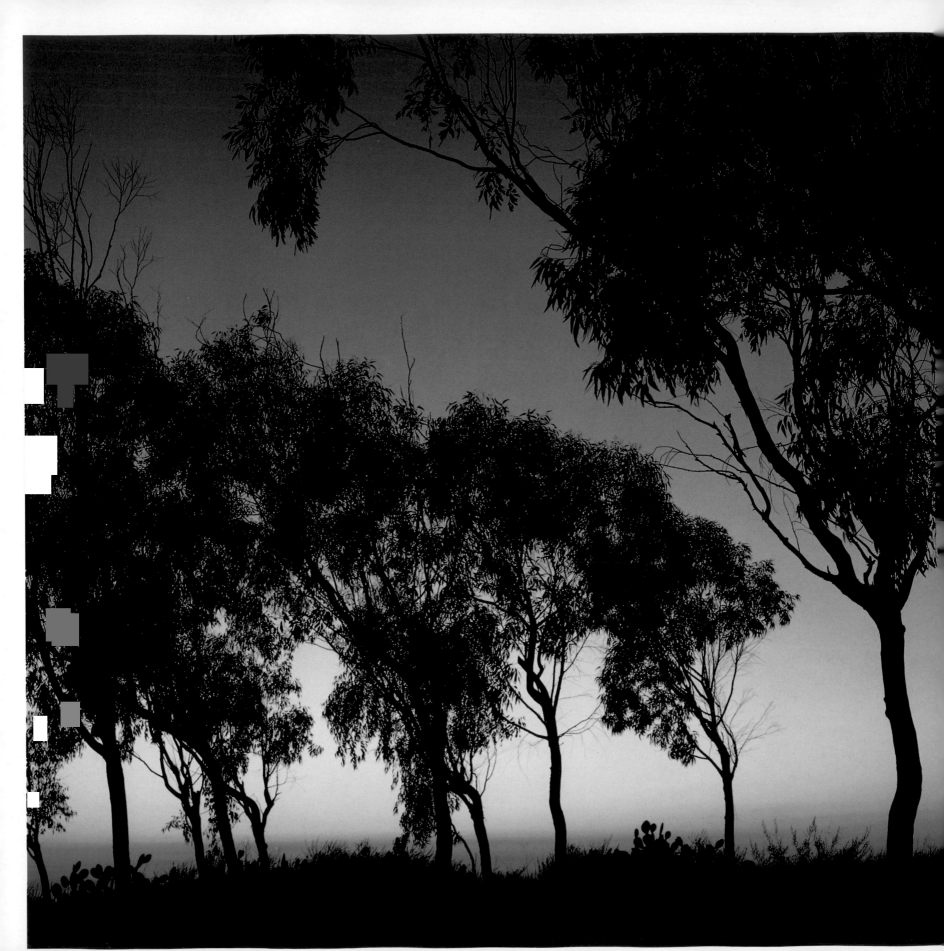

opposite: *Eucalyptus trees at twilight, Santa Catalina Island*
right: *Goldenspined cereus, Santa Catalina Island*

Since 1986, renewed efforts to revitalize the river have included proposals by the Friends of the Los Angeles River (FoLAR), an environmental organization dedicated to restoring the river. Establishing greenbelts, riparian woodlands, and bikeways connecting the San Fernando Valley to L.A. city proper, riverside parks, and hiking trails is the goal of FoLAR's 1,000-plus members. The group has gained local government support. Construction began on the L.A. River Bikeway in 1997, and city and county tax and private monies have been set aside to plant trees and develop other bikeways and natural areas.

The Los Angeles River may someday run green and vibrant again, at least in some sections, as the systematic long-term destruction of its original beauty has run its con-crete course. Numerous opportunities exist to link smaller parks along the river and its tributaries so that we may once again experience a world mostly vanished from the Los Angeles Basin.

Before it endured runaway growth in the mid-1900s, Los Angeles was considered a garden paradise, a city of considerable natural beauty. Griffith Park, established in 1896, was one of the very first parks in the city. It remains the largest municipal park and urban wild area in the nation. Its rough, chaparral-covered hills, with their landmark triple-domed astronomical observatory (built in the 1920s), look out upon the city, as they have since the park was deeded as a gift by wealthy landowner Col. Griffith J. Griffith.

I have always thought of Griffith Park as a multilayered antidote to the ills of city life. More than 4,100 acres of natural terrain (five times larger than New York City's Central Park) offer extensive grass and woodland groves for strolling, playing, and picnicking. On its northeastern flanks, the expansive grounds of the 113-acre Los Angeles Zoo, an eighteen-hole golf course, a world-famous carousel, and other family-oriented amusements draw many of the park's 10 million visitors each year.

But our focus is on those unspoiled, semiarid mountain and lush canyon and valley wilds that command Griffith Park's high ground. The terrain and vegetation are largely unchanged from the hills Father Crespi and Capitán Portolá saw from their camp along the Los Angeles River, just a mile from the present-day park, back in 1769.

Today, hikers and horseback riders looking for a back-country experience can choose from a variety of routes along the more than fifty miles of trails that wind from the park's lowest elevation of 384 feet all the way up to its high point, Mount Hollywood, at 1,625 feet above sea level. Once there, a lovely two-acre wooded garden called Dante's View and a commanding view of the city make the uphill haul worthwhile.

The hills are thick with more than 100 varieties of chaparral and trees, including California oak, sycamore, and eucalyptus, wild sage, manzanita bush, chamise, ceanothus, toyon, and buckwheat. In spring and after fall rains, poppies, bush lupine, wild purple onion, and other wildflowers show up all over the place. Mule deer, foxes, coyotes, skunks, many varieties of snakes, and more than 100 bird species have been spotted by locals over the years.

Perhaps the best example of an urban wonderland where you can fit an almost magical deep-woods experience into the space of a weekday lunch hour is Ferndell, just inside the southwestern boundary of Griffith Park. A curving walkway takes you up through a long, narrow fairyland glen of ferns, exotic plants, and redwood trees on a gentle climb of several hundred feet, an easy round-trip of ten minutes.

Legend holds that the original inhabitants of the region, the Cahuenga Indians, used Ferndell as a council meeting ground. Today, its bubbling brook murmurs of ancient days. Walking there, I stopped once to contemplate, like Hesse's Siddartha, the voice within the flowing stream water. A few minutes later, my eye was drawn to a pattern of wet leaves pressed into the dark, wet clay of the walkway. I thought of fossils in stone. A fresh green leaf fluttered quickly to the path at my feet, to take its place in the mosaic. All this, just ten minutes from downtown L.A.

There are dozens more parks, preserves, and natural areas throughout the immediate environs of Los Angeles city that offer pockets of resistance to the hectic urban experience. Some, like the Sepulveda reserve, bring immersion in nature. Others mix soothing wildlands with well-groomed city parklands, such as Griffith Park's nearby neighbor Elysian Park. Still others are primarily urban green spaces of well-used, midday and weekend playground and open

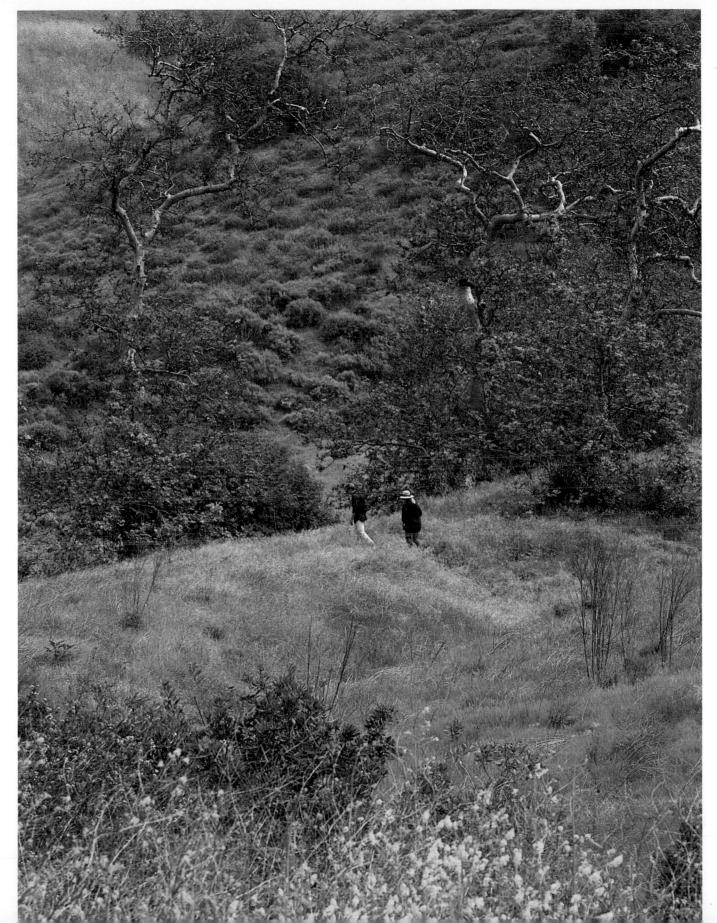

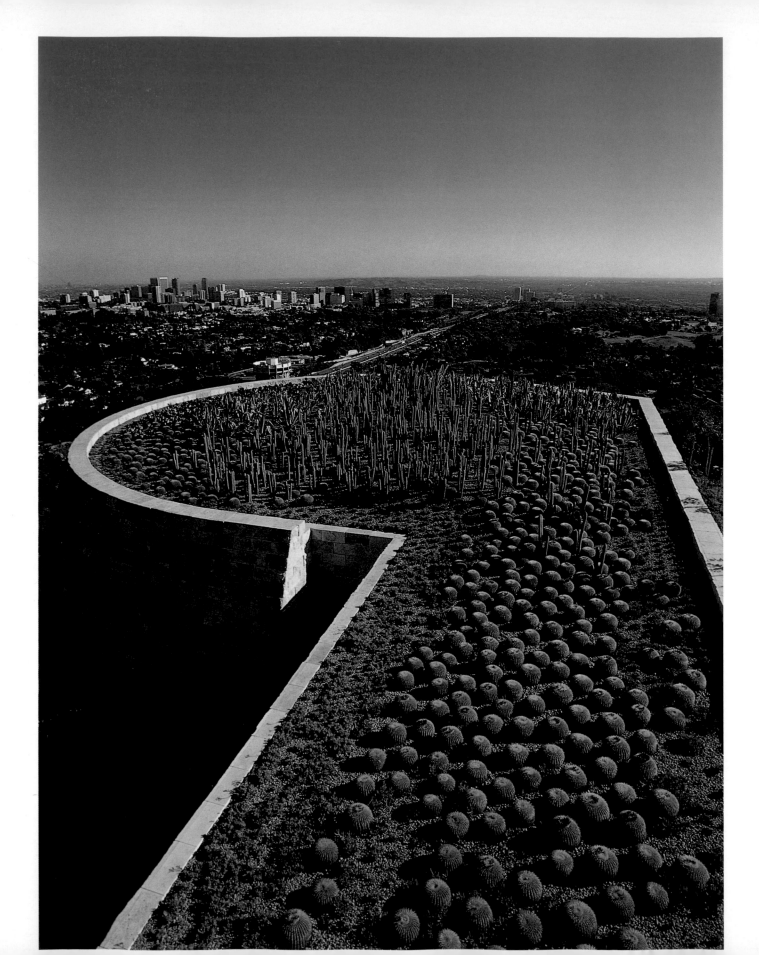

opposite: *South promontory,*
Getty Center, overlooking
Century City

spaces, such as Exposition Park and MacArthur Park, made famous by a popular song, both just a few blocks from the city center.

Two of my favorite midcity nature retreats are Franklin Canyon and the Fryman Canyon Overlook, both off Mulholland Drive in that easternmost, heavily urbanized rise of the Santa Monica Mountains just above Beverly Hills. Many times over the years, I would leave my San Fernando Valley home and within ten minutes find myself walking through hilly brushland. These hikes soothed my jangled workaday nerves, while also helping me deliver my daughters to a sense of nature within the city. The dirt trails winding along ridge tops and through steep chaparral restored our love of exercise and presented us with a fresh perspective on the city spreading below us.

On reasonably clear days, even in the midst of the city, you can see all the way to the coast. There, just below the lofty bluffs of the Palos Verdes Peninsula, which juts into Santa Monica Bay and the Pacific, lies a natural, pristine marine environment: Abalone Cove Ecological Preserve. Sandy and rocky beaches and improved facilities are found nearby, but here is a wild place where you get a real taste of the historical, geological, and biological resources that are unique to all the peninsula.

Tidepools, giant kelp beds that were for a time the last remaining species anywhere (since restored up and down the coast), and beach and offshore areas for preservation and observation of the natural marine environment are all just fifteen minutes from downtown. A rich flurry of wildlife activity keeps you rubbernecking from beach to cliff perches to offshore rocks. Brown pelicans, cormorants, gulls, black-vented shearwaters, and common murres are only a few of the birds that thrive on the upwelling of cold, nutrient-rich waters off the coast. Whale-watching is a great way to spend an afternoon along cliff tops and hiking trails that thread across several bluffs above Abalone Cove.

Looking out across twenty-two miles of Pacific from Abalone Cove, you can see picturesque Santa Catalina Island, a relatively unspoiled paradise that draws eco-tourists and visitors from all over the world. Its seventy-six square miles are rich in scenic natural terrain: 2,000-foot peaks, isolated coves and perfect beaches, broad valleys and high plateaus, and spectacular shoreline cliffs and palisades present a tantalizing taste of the Southern California coast of ancient times.

There is one small town on the island: quaint, lovely Avalon. The rest of the island is undeveloped Mediterranean marine chaparral environment. Reintroduced bald eagles soar high on the inland thermals and coastal-ridge lift. Fifteen species of plants and animals, including the shy Catalina Island fox and Beechey's ground squirrel (a subspecies found nowhere else on the planet), share the ecosystem with descendants of American bison brought to the island in 1924 for the filming of a motion picture.

The Tongva called Catalina "the mountain ranges that are in the sea." Today, guided jeep and hiking eco-tours range

over the rugged open hills and canyons. Rare plants—such as the endemic, endangered island snapdragon, with its deep red blossoms, and the hardy Catalina ironwood—frame historical and archaeological sites reaching back 7,000 years, making for fascinating day trips or extended visits.

Four other natural areas in the middle of Los Angeles deserve particular attention as symbols of civic activism aimed at enhancing the L.A. urban nature experience: Kenneth Hahn State Recreation Area, Ernest E. Debs Regional Park, Whittier Narrows Recreation Area, and the embattled Ballona Wetlands.

The Kenneth Hahn area is noteworthy for its reclamation of a hill once so thickly covered with oil derricks that it was an eyesore visible from miles away. Oil-pumping stations still crowd parts of the Baldwin Hills, but the 2001 purchase of the former Vista Pacifica development project land is a major victory for Angelenos. Park advocates envision joining this property and others together with the Kenneth Hahn area to create an urban park larger than Central Park or Golden Gate Park.

The Vista Pacifica site caps a high hill with an unparalleled view of the entire Los Angeles Basin. In winter, the downtown skyscrapers gleam against the breathtaking escarpment of the snow-covered San Gabriel Mountains rising powerfully beyond. Out to sea, Santa Catalina gleams like a diamond. Up the coast, you can see the long, curving Malibu Coast running below the Santa Monica Mountains past Point Dume.

Kenneth Hahn has nearly 400 acres of surpassingly beautiful hillside grasslands, fishing lakes, hiking paths, and an Olympic Park that commemorates the 1984 games held in Los Angeles. An idyllic pathway through the Olympic Forest leads past charming pools and floating clusters of broad green lily pads blooming with lush magenta flowers. Eucalyptus trees glow in the setting sun, their clusters of elongated slender leaves forming clouds against a rosy sky.

An equivalent natural respite awaits inner-city Angelenos a few miles east of downtown L.A.'s skyscrapers. Ernest E. Debs Regional Park commands a broad hillside in the middle of the Montecito Heights community. You drive up a road from the dense clutter of houses onto a surprisingly open hilltop parking area that leads to 282 acres of arroyo wilderness and picnic lands.

Trails weave throughout an area of trees, small lakes, and a reservoir where fishing is permitted. A grove of black walnut trees, an endangered species, grows within some of the only remaining natural arroyo woodlands in all of Southern California. Eucalyptus, pine, and birch trees offer shade from the hot summer sun. The Audubon Society is developing a bird sanctuary here, and a strong coalition of community leaders and city officials continually looks to upgrade the natural feel of the area, a popular spot for more than 120 migratory and resident bird species.

Just fifteen freeway minutes east of Debs is one of the last surviving natural ecosystems of the San Gabriel River

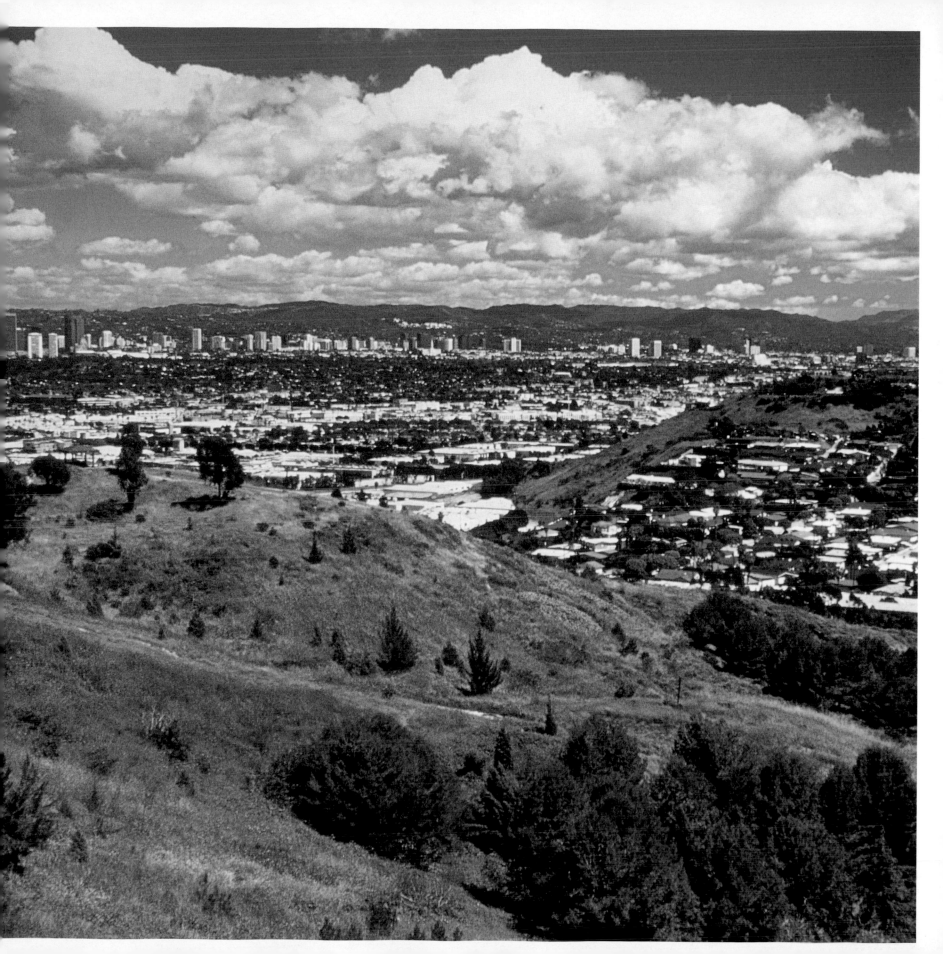

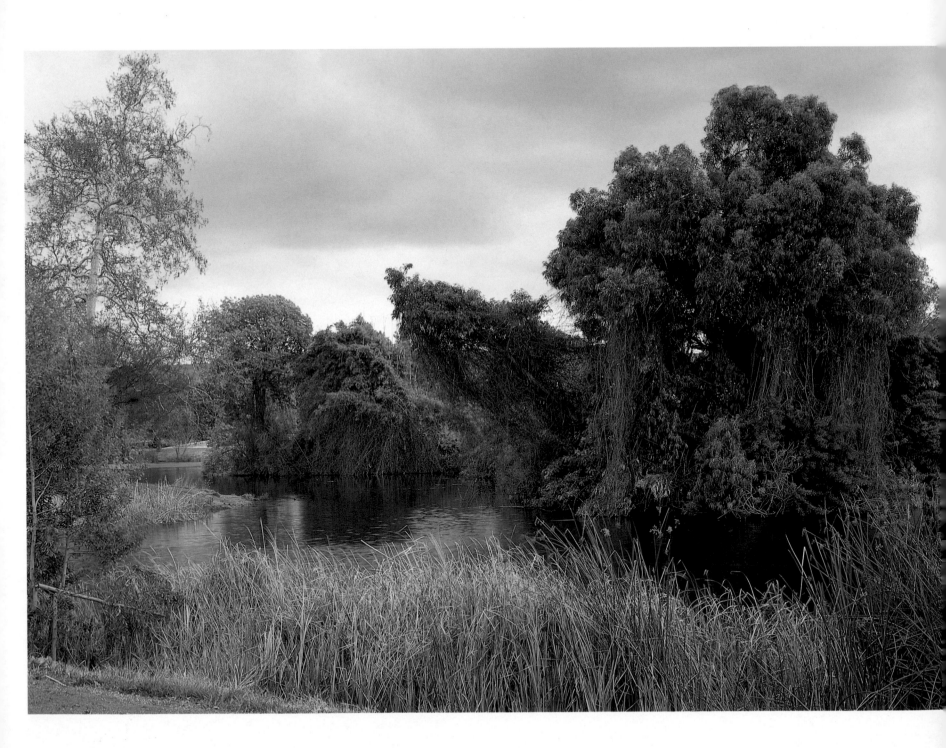

opposite: *Island roost on one
of the lakes at Whittier
Narrows Recreation Area*
below: *Northern pintail duck*

watershed: the Whittier Narrows Recreation Area. The area was the site of the first large-scale riparian restoration project in Los Angeles County. Established in the mid-1970s, its 277 acres of riparian woodlands now feature four lakes and several plant and animal species common to wetland habitats.

Migrating waterfowl draw bird-watchers and photographers to the area. A stretch of the thirty-seven-mile bicycle path that begins in the San Gabriel Mountains winds through Whittier Narrows on its way to the Pacific Ocean. Beyond, vast manicured parklands form a massive assemblage of well-maintained, grassy athletic fields and treed picnic areas. But seekers of true natural ambience find the real thing at Whittier Narrows Nature Center.

The flatland sagebrush and deciduous area, with its narrow dirt trails, makes for a captivating escape, as I discovered on a recent visit. Warm afternoon breezes blow out of the southwest. Squirrels, rabbits, and other wild critters rustle through the underbrush as you walk along. Mockingbirds flit from bush to bush. An iridescent blue-green tree swallow showed its white underparts as it wheeled just above my head, feasting on a cloud of insects. The trail led me to a pond, where I found a dense marshland of reeds and a viewing platform built of logs.

Wetlands such as this are rich ecosystems that provide hundreds of plant and animal species with habitat and food. They ease the impact of floods, filter pollutants, and curtail erosion. Their aesthetic value to millions of potential visitors is immeasurable.

Of California's original 5 million wetland acres, only 5 percent remain. More than 98 percent of L.A. County's wetlands are gone. The Ballona Wetlands, an expansive 1,087-acre parcel wedged between Marina del Rey and Los Angeles International Airport, is the only remaining large coastal wetlands ecosystem in all of Los Angeles County.

In February of 2001, the Los Angeles City Council voted unanimously to support public acquisition of 475 acres of the Ballona Wetlands ecosystem. Another area, still hotly contested between conservationists and determined developers, hangs in the balance. But the tide may be turning. The battle's outcome will determine whether endangered

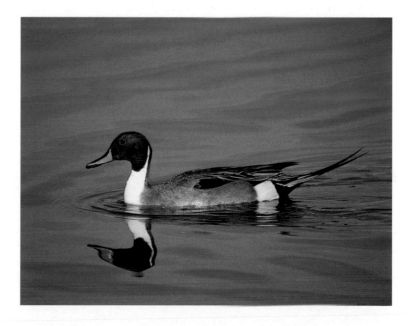

opposite: *Island morning glory,*
Santa Catalina Island

species that are found in and around Ballona, such as the western snowy plover, unarmored three-spined stickleback, El Segundo blue butterfly, and tidewater goby, will remain.

Wild-in-the-city Los Angeles is an ongoing adventure in discovery. Most of the places described here lie within a fifteen-mile radius of downtown Los Angeles. I had never heard of many of them until I began my research, though I was born in Los Angeles in 1945 and have spent much of my life here.

One day after an invigorating stroll through Griffith Park's Ferndell, I drove down the frontage road that parallels Interstate 5. My focus was drawn beyond the power lines, car dealerships, and tacky, peel-paint buildings to the trees lining the freeways. I'd never thought much about them before.

They were eucalyptus, one of my favorite trees. And I realized that my walk through Ferndell had sensitized me to the natural beauty that is everywhere waiting to be discovered in Los Angeles. It suddenly became, to me, a matter of perspective. I realized that Los Angeles still is a paradise. All we have to do is put on our hiking boots and go find it.

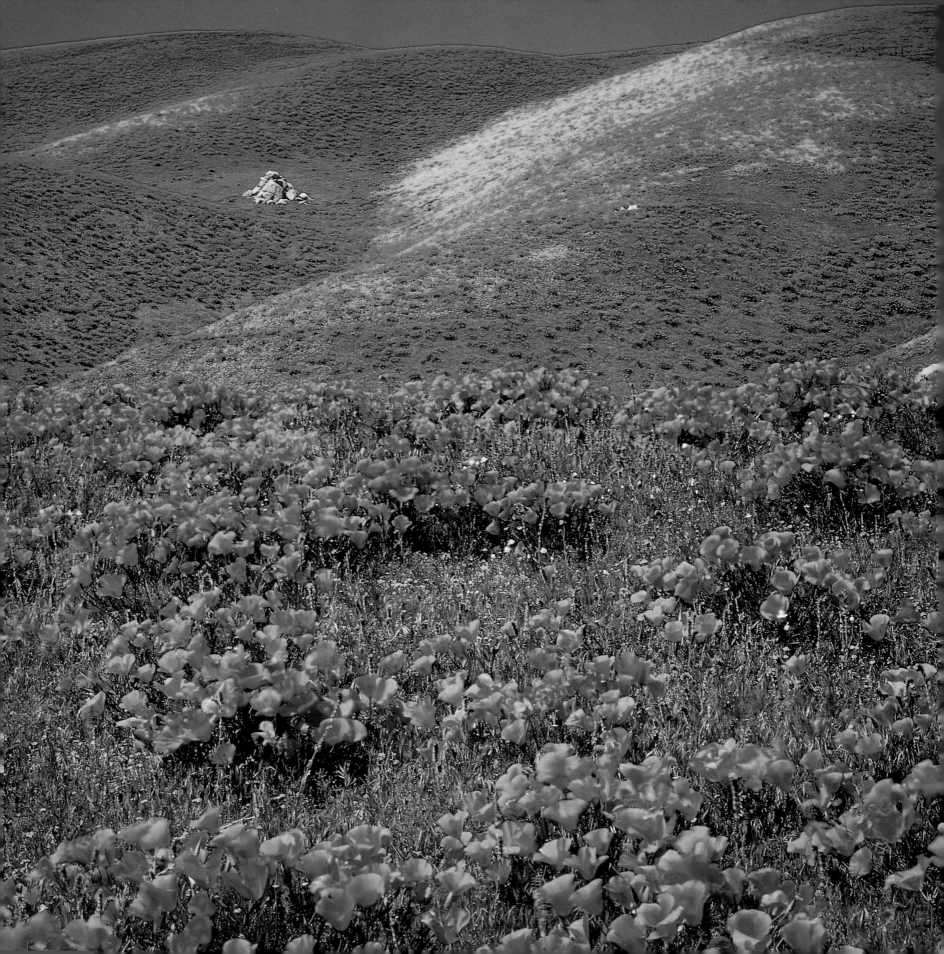

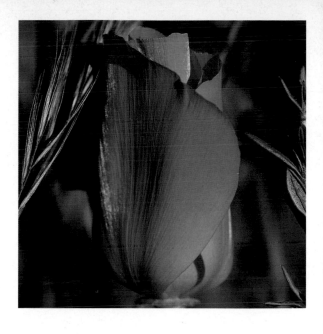

opposite: *Poppies carpeting the Gorman Hills*
right: *Close-up of California's magnificent state flower*

San Gabriel Mountains

EARTH AND SKY, WOODS AND FIELDS, THE MOUNTAIN AND THE SEA, ARE EXCELLENT SCHOOLMASTERS AND TEACH SOME OF US MORE THAN WE CAN EVER LEARN FROM BOOKS. –JOHN LUBBOCK

Wild
L.A.

On any reasonably clear day from anywhere within the Greater Los Angeles Basin or its urban environs, look north. There, claiming half the sky, you'll see a broad, sharp-edged mountain wall. Some call it L.A.'s Little Sierra, but to most Angelenos, the San Gabriel Range is simply "the Mountains." In summer, the range stands in hazy blue relief against the gray-white summer sky. In winter, its white-capped peaks seem closer and more sharply etched by a backdrop of deep lazuli blue. Whatever the time or season, no drive from the city will

below: *Rock scrambling at Vasquez Rocks Natural Area Park, San Gabriel Mountains*
opposite: *Devil's Punchbowl County Park, nestled in the northern foothills of the San Gabriels*

bring you more dramatic changes in terrain and elevation in so short a time as one to the San Gabriels.

The range begins in the mountain country northwest of Los Angeles that separates Southern California from the 500-mile-long Central Valley. From there it runs southeast for 102 miles, forming an imposing eastern barrier to the San Fernando Valley, Los Angeles proper, and its satellite cities. Finally it ends in a sharp drop into the Cajon Pass, just above the city of San Bernardino. Virtually the entire range falls within the boundaries of the Angeles National Forest.

To the north and east, on the back side of the San Gabriels, the Antelope Valley flows down in a kind of foothill preamble to the vast Mojave Desert immediately beyond. Less than an hour's drive from the city, the Mojave is another world in terms of climate, topography, and geology: a true desert that speaks to the weather-making power of the range and its adjacent mountains. Since it presents such a high, steep barrier so close to the ocean (on average a mere twenty-five miles from the coast), the range effectively blocks the passage of marine air flow east and north. Most of the moisture falls on the Los Angeles Basin and the mountains themselves. The drier air that eventually makes it over the hump confers the arid climate that creates the Mojave.

The highest peak in the San Gabriels is 10,064-foot Mount San Antonio, also called Old Baldy. Looking northeast from its peak gives you a precipitous, Swiss Alps-like feel: the range drops sharply to the Mojave Desert floor, some 6,500 feet, in just four miles. On a clear day, the desert appears as if viewed through a curved lens, so distant and vast is the sandy horizon.

In contrast to the general character of the other Transverse Ranges—mountains that run east to west instead of the typical north-south orientation of California's other mountains—the San Gabriels present their most severe

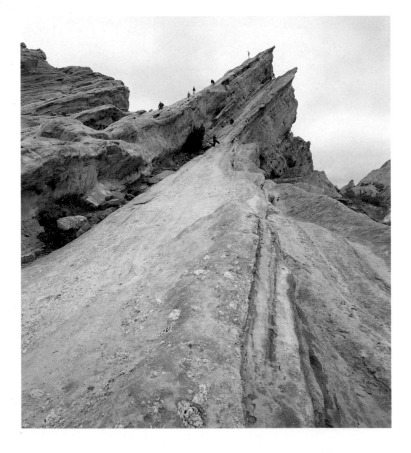

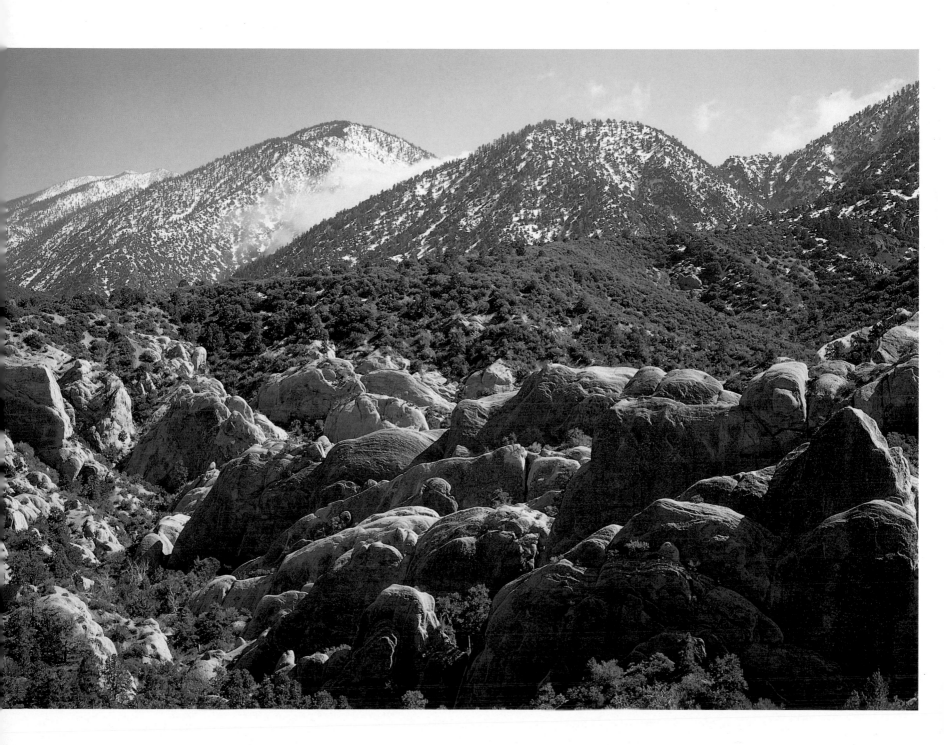

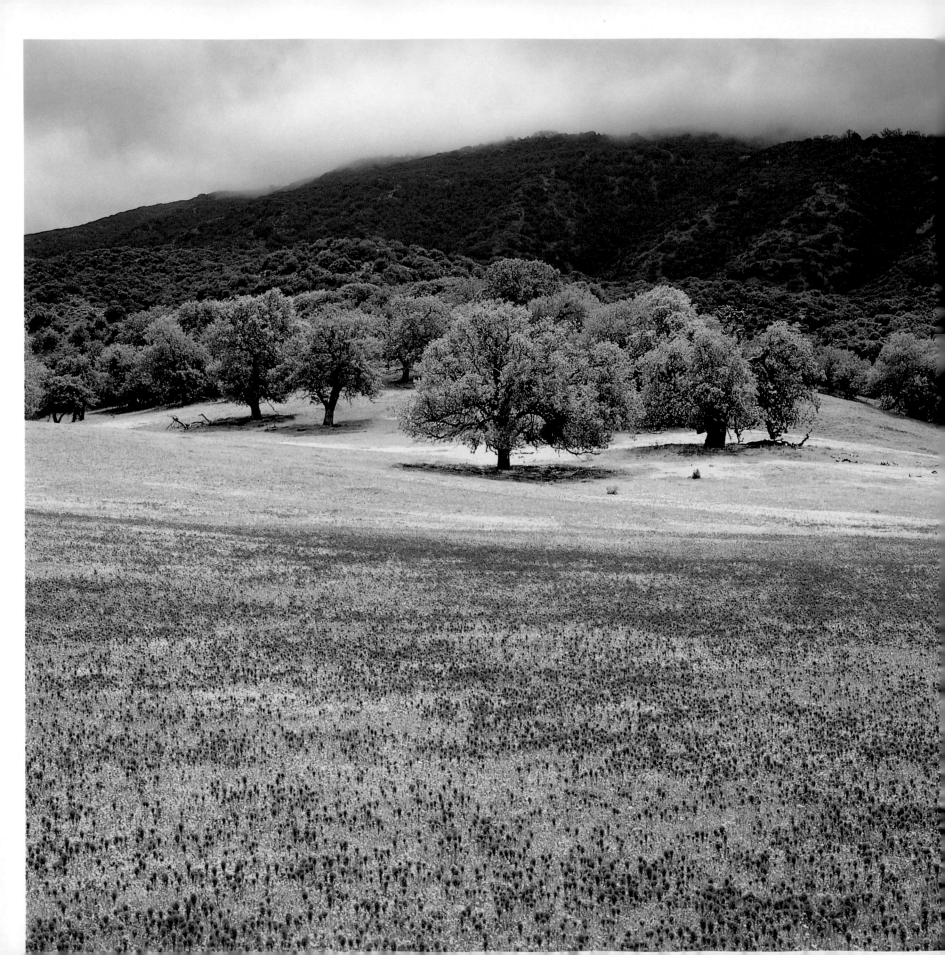

opposite: *Purple owl's clover
and oaks in the Antelope Valley
foothills*

slopes to the southwest and south. It's all the fault of the faults, and there are three of them: the San Andreas Fault, which runs the entire length of the northern, desert-side San Gabriel escarpment; the Sierra Madre Fault system at the foot of the mountains' south-facing slopes above Los Angeles; and the San Gabriel Fault, angling northwest behind the Verdugo Mountains of the San Fernando Valley, all the way to the San Gabriels' beginnings in the Gorman Hills.

Caught in this squeeze play of fractured rock, the range endures continual uplifting and mountain building. On the desert side, the infamous seismic activity associated with the San Andreas Fault presents a string of geological wonders. Vasquez Rocks, Mormon Rocks, Devil's Punchbowl, and Lost Lake make popular day trips for Angelenos with a taste for dramatic rock formations and otherworldly hikes.

The turmoil of tectonic forces helps explain the diverse geology that rock hounds find throughout the range. About 70 percent of the exposed surface is composed of Mesozoic-era granitic rock ranging from 61 to 84 million years old. Yet the granitic rocks of Mount Lowe and Parker Mountain in the northwest corner of the range are nearly three times older than that. And the delightful rock-form wonderland of Devil's Punchbowl, just a few miles away, displays comparatively infantile geology: its rocks are only 7 to 20 million years old.

John Muir described the San Gabriel Mountains as "more rigidly inaccessible than any other I ever attempted to penetrate." While they're not as high as the Sierra Nevada to the north, nor as craggy and forlorn as the eastern, sun-blasted chocolates and ochres of the Great Basin Ranges, these are mountains enough to please any high-country rover. You understand what Muir meant when you stand atop a high vantage point within the range. Look in any direction to see ridgeline after ridgeline of rocky peaks and countless plummeting canyons, meandering trails, and pockets of water-fed greenery.

In olden times, at least two major Indian trade routes crisscrossed these heights, with tributary trails linking all the larger San Gabriel canyon systems. Tongva and Tataviam Indians foraged up and down the many water-carved canyons. High chaparral ground cover provided food and drink, medicines, and materials for building and weaponry. Oaks yielded the year-round staple of the Indian diet: the acorn. Manzanita bush grew berries that yielded a tart cider, as well as leaves for smoking. Greasewood made for excellent arrow shafts. Yucca plant fibers were prized for nets and ropes, while the seeds made an excellent porridge, and the roots were processed for soap. Even poison oak was useful, as a cure for rattlesnake bite.

Today, the San Gabriels still beckon the adventurous, inviting immersion into wild high country that rises right up from the city. Winding up the two-lane serpentine highways, you answer the call of this vertical land of sheer, deep canyons and high mountain forests. Five minutes into the drive, especially from the L.A. side, views of the city become scarce. The main road, Angeles Crest Highway, climbs past one eye-popping plunge after another. Coming up from the

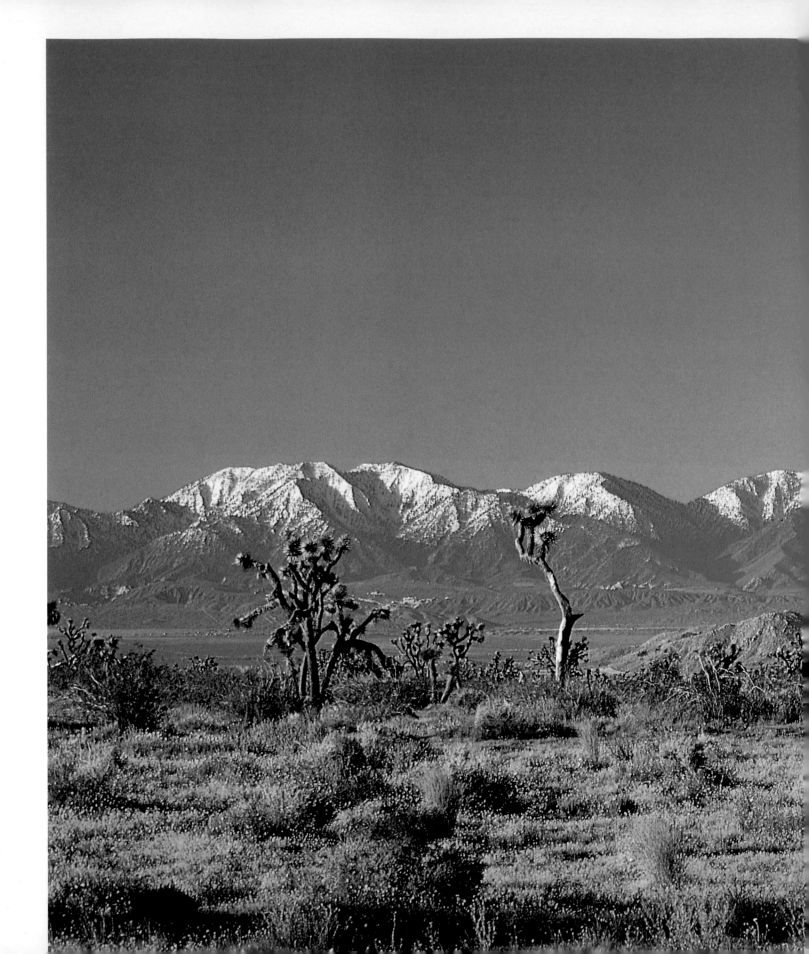

right: *The San Gabriel Mountains, seen from Saddleback Butte State Park, Mojave Desert*

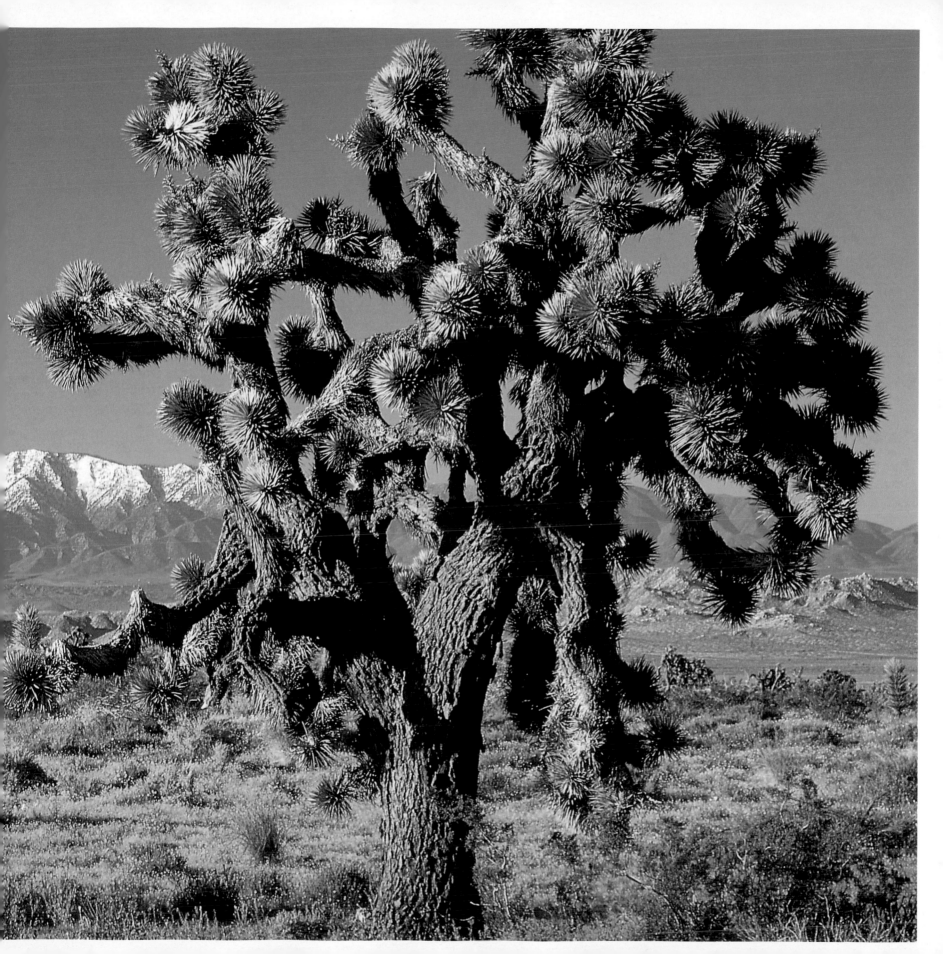

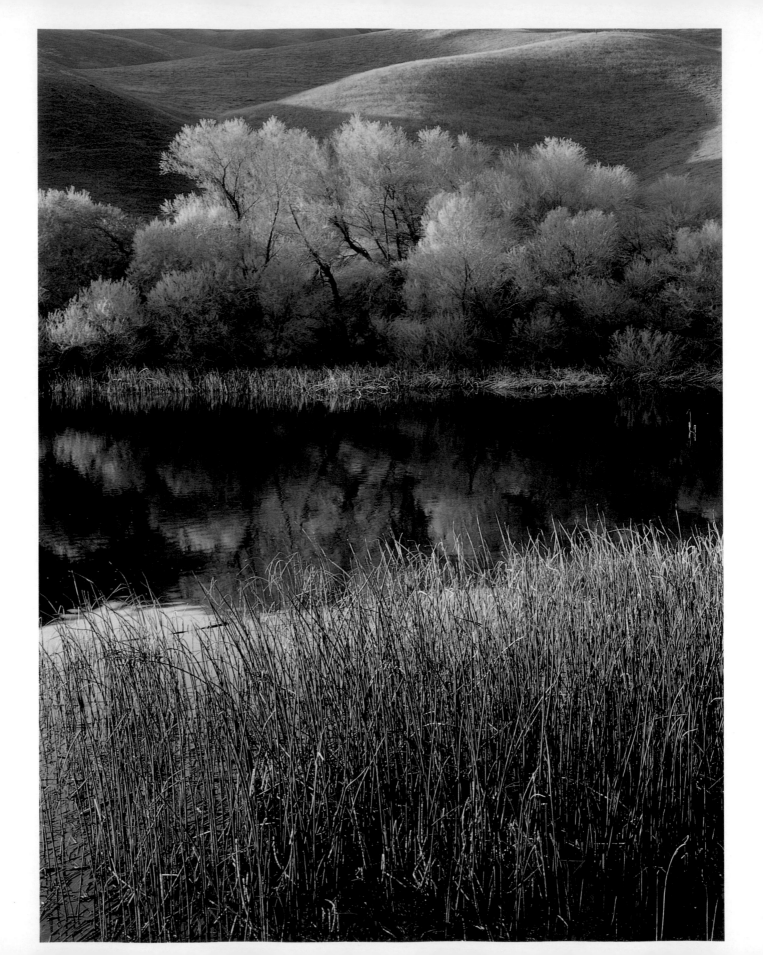

opposite: *Pool reflections,*
Gorman Hills
below: *American wigeon, often*
found on deep freshwater lakes

gateway town of La Cañada Flintridge, you are initially escorted by huge power-line towers, eyesores that eventually give way to a starkly beautiful landscape. Careening around the dozens of hairpin turns, you dare not indulge the slightest distraction: a moment's careless driving invites an unwelcome "off road" experience, as a score or so drivers tragically discover every year.

Acting as silent sentinels throughout this steep high country are lofty, rounded, granite peaks stubbled in dense chaparral scrub, and pine, spruce, and oak forests that reign over the sheer drops. These mountains—actually two parallel and contiguous ridgelines of peaks created by the San Gabriel River and Big Tujunga Canyon—make direct north-south travel nearly impossible. Yet, following the ever-looping Angeles Crest and Angeles Forest roadways, you hardly care as the multitude of peaks glow in glorious amber light. In winter, the peaks wear a pristine white cloak, signaling to the masses below that the four-seasons experience denied them at sea level is waiting up here.

From whichever direction you enter this island world of rock and sky, you won't spend more than an hour to ninety minutes driving to almost any spot within it. That explains the range's appeal and also why those bent on more primitive natural experiences need wander only a bit farther from the main roadways.

The San Gabriels provide a backyard getaway of choice for nearly every type of recreational or wilderness activity imaginable. Thirty-two million people visit Angeles National Forest every year, more visitors than in any other national forest. They roam its rocky shoulders and explore its lush canyons to hike, fish, ride, ski, walk, camp, and refresh mind, body, and soul.

The range also offers a cornucopia of spectacular panoramas. From the 5,710-foot perch of Mount Wilson Observatory, along the south-facing ridgeline, you also can watch with mixed feelings as a milky haze—hang-glider pilots call it the Smog Wall—rises up the coast-facing slopes.

Mount Wilson deserves mention for its unique role in expanding our vision of the universe and sharpening our view of our place within it. Most of the great astronomers of the

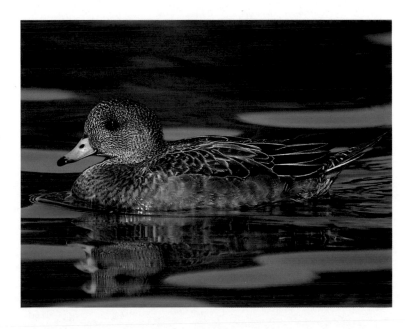

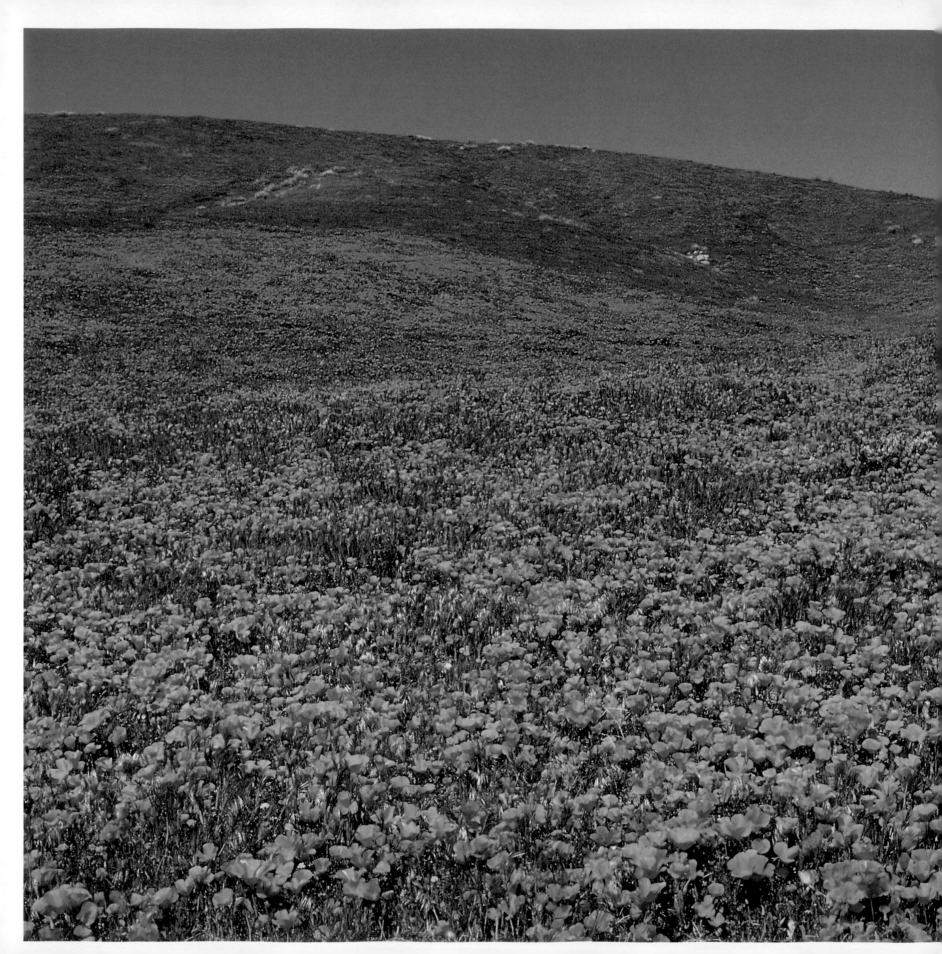

left: *Annual explosion of color at Antelope Valley California Poppy Reserve*

opposite: *Mount Baldy from near Mount Baden-Powell's summit*

twentieth century—as well as Albert Einstein—made the long trek up the mountain to explore the infinite mysteries of space and time through its 100- and 200-inch telescopes. Here is where Edwin Hubble proved the Milky Way was not the only galaxy—merely one of billions. Here, too, Hubble found evidence of the Big Bang and expanding universe theories. George Hale explored and deduced the nature of sunspots at Mount Wilson. Albert Michelson made the first modern measurement of the speed of light here.

Today, made obsolete by more sophisticated astronomical tools, Mount Wilson's star-gazing instruments stand unused. Even so, the eerily silent, fading white towers still attract paying visitors.

On a clear day, you can stand before the observatory, looking west, and swear you're in undiscovered country. Contrary to L.A.'s dirty-air image, there are scores of days of surpassing clarity every year. When the dry, parching Santa Ana winds rage down from the Mojave Desert to the northeast, your view expands to include not only the entire L.A. megalopolis but the Pacific Ocean, Santa Catalina Island twenty-two miles offshore, and more than a hundred miles beyond.

Three protected areas—the San Gabriel, Cucamonga, and Sheep Mountain Wildernesses—take up 14 percent of the entire San Gabriel Range, roughly 92,000 acres. Within these lands set aside under the umbrella definition of the Wilderness Act of 1964, visitors enjoy expansive areas of minimal human impact. Mechanized vehicles of any kind, including mountain bikes, are prohibited. Only "no trace" camping, where vegetation is already sparse, is permitted, in keeping with the act's mandate to establish "an area where the earth and its community of life are untrammeled by man, where man himself is a visitor who does not remain."

The 44,000-acre Sheep Mountain Wilderness is well named: Nelson bighorn sheep, though reduced in number to between 35 and 100, inhabit rocky steeps ranging in elevation from 2,400 feet to more than 10,000 feet. Spend enough time here and you may even see one of the elusive ungulates racing up a sheer, crumbling rock face.

If you're lucky and sharp-eyed, you'll discover a rich variety of wildlife wherever you go in the San Gabriels. Animals typical of Southern California mountain and riparian habitats are found here: coyotes and mule deer, black bears and bighorn sheep, elusive mountain lions, lynx, and bobcats, as well as ground squirrels, raccoons, and opossums.

More than 215 bird species thrive within range, including the warbling vireo, the pine-forest-loving downy woodpecker, and that riot of airborne colors, the red-headed, yellow-bodied, black-winged western tanager.

A number of songbirds can be heard as you move from pastoral oak canyon retreats up to montane forests. Their songs range from the high-pitched peeping of the pygmy nuthatch to the *pit-a-tik* call of the western tanager. Other favorites of bird-watchers are white-headed woodpeckers, white-breasted nuthatches, green-tailed towhees, purple finches, Steller's jays, and mountain chickadees. And

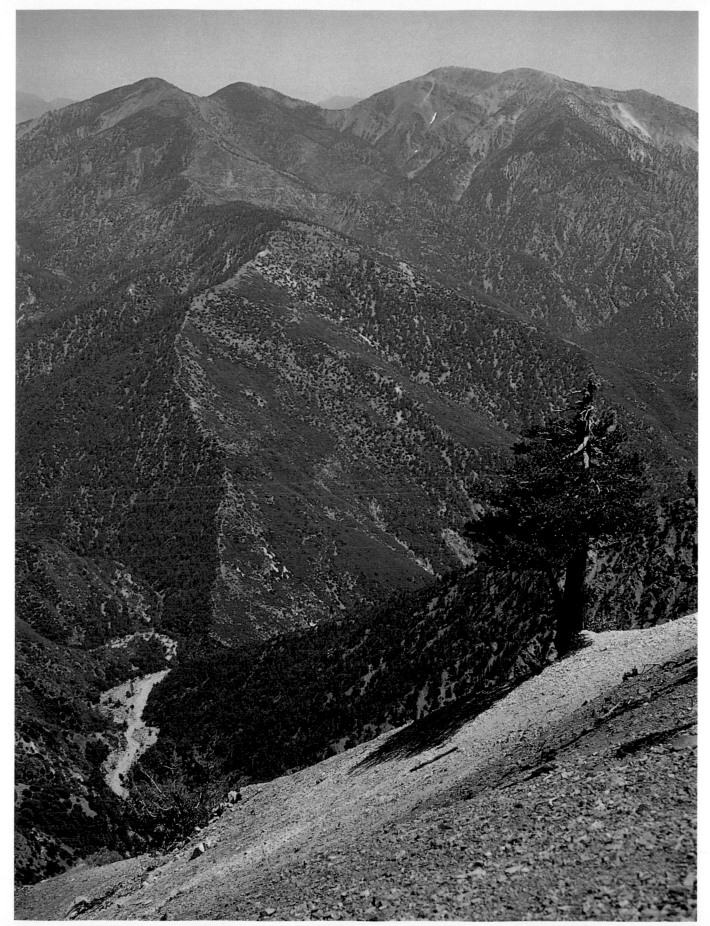

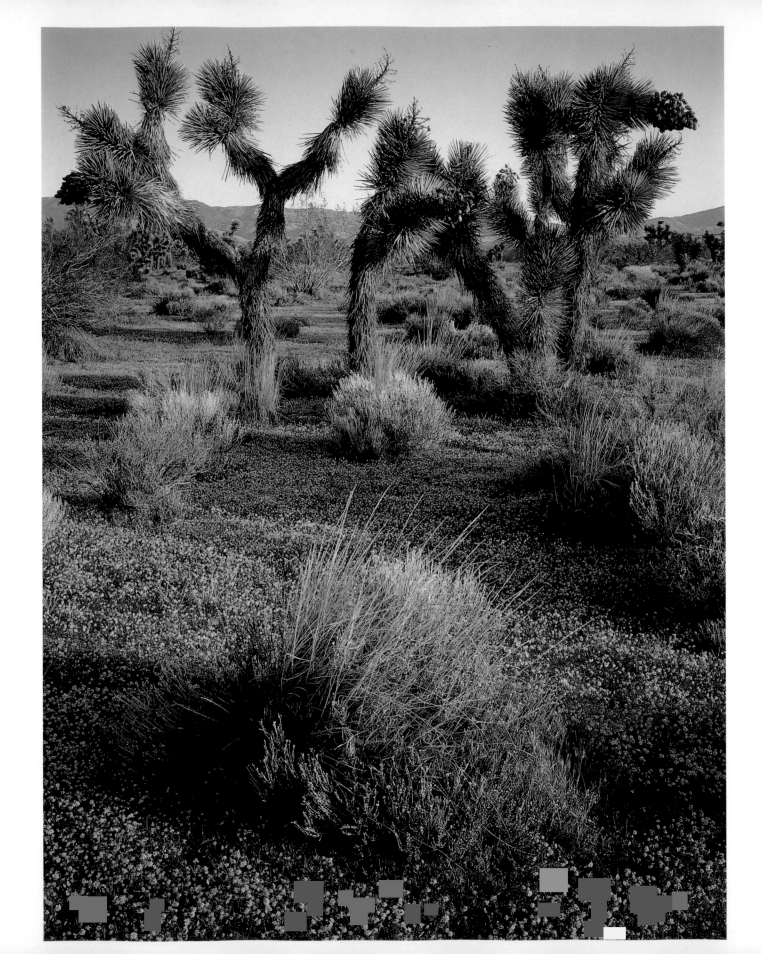

no hiker is immune from the reverie-busting, rude croak of that big, shiny black bird with the thick bill: the irascible common raven, usually found wheeling and soaring in pairs over every habitat of Southern California.

For those of us inclined to slap shoe leather to dirt for both physical and spiritual benefit—whether on a day hike or a week-long backpacking adventure—there are numerous touchstones in the San Gabriels. Hundreds of miles of remote hiking trails thread throughout the range. Many of them weave into the magnificent Pacific Crest Trail (PCT), which runs 2,650 miles from Mexico to Canada, mostly along the high mountain crests of California's Sierra Nevada and the Pacific Northwest's Cascade Range.

The PCT deserves more than passing reference for its bold conception and the glories it bestows on adventurous hikers. Along its 171-mile stretch within the San Gabriels, from Cajon Pass in the east to State Route 138 in the west foothill country above the Mojave Desert's Antelope Valley, the PCT roams the high country through a dramatically diverse terrain that is rich in history.

The trail generally follows the divide between streams draining to the Pacific, or southern, side and those draining toward the north. Ambling along the sinuous route, hikers are privy to the aerial grace of golden eagles, bald eagles, and hawks rising up on thermals from the canyons below. Along the PCT's highest, most open stretches, hikers gain more than just altitude. Breathtaking vistas bring a soul-expanding sense of communion with the natural world, as rocky ridges drop away to olive-green wedges of sycamore, oak, and mesquite bejeweled with creeks, rivers, and lakes.

For the vision that ultimately led to the PCT, we owe a debt of gratitude to Clinton Clarke, a resident of Pasadena. In the 1930s, Clarke lobbied the federal government to create a hiking trail along footpaths pioneered by young men of a local YMCA chapter. Eventually, the government bestowed National Trails System status on the pathway. The last linking section was commemorated in 1993, sixty years after Clarke's first entreaties.

Thousands of hikers, equestrians, and mountain bikers make use of the Pacific Crest Trail every year. To relieve the potential for overcrowding, other major trail systems branch off from it: the High Desert, West Fort, Gabrieliño, and Silver Moccasin National Recreation Trails. (The last is also the name of the merit badge awarded to any Boy Scout who completes its fifty-two-mile length.)

The three wilderness areas offer perhaps the most challenging hiking experiences in the range, precisely because they take you away from those areas people visit more frequently. Windy Gap Trail, near Crystal Lake in the eastern heart of the San Gabriels, typifies the wealth of day hikes you find throughout the range's wilderness country.

The Crystal Lake Recreation Area trailhead for the Windy Gap Trail begins after a thirty-mile drive up Azusa Road (Highway 39), which branches off the front-range-paralleling 210 Freeway. It's a long, hard pull up this foot trail. You start at 5,800 feet and climb the entire way, gaining

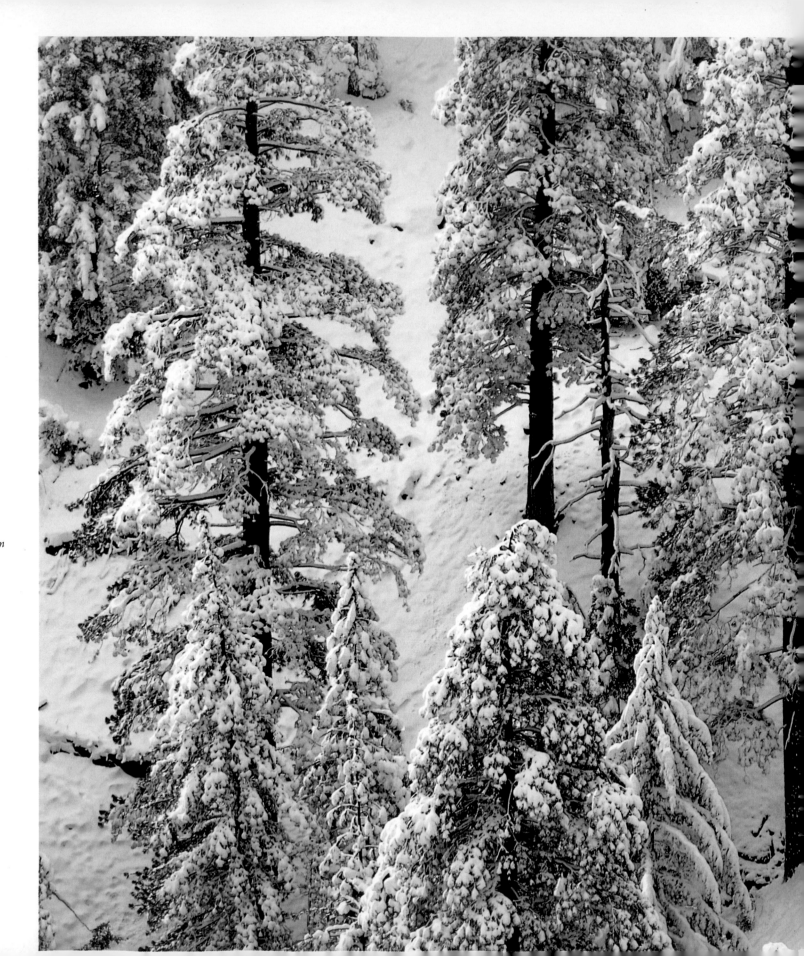

right: *Winter snow on trees in the San Gabriel Mountains*

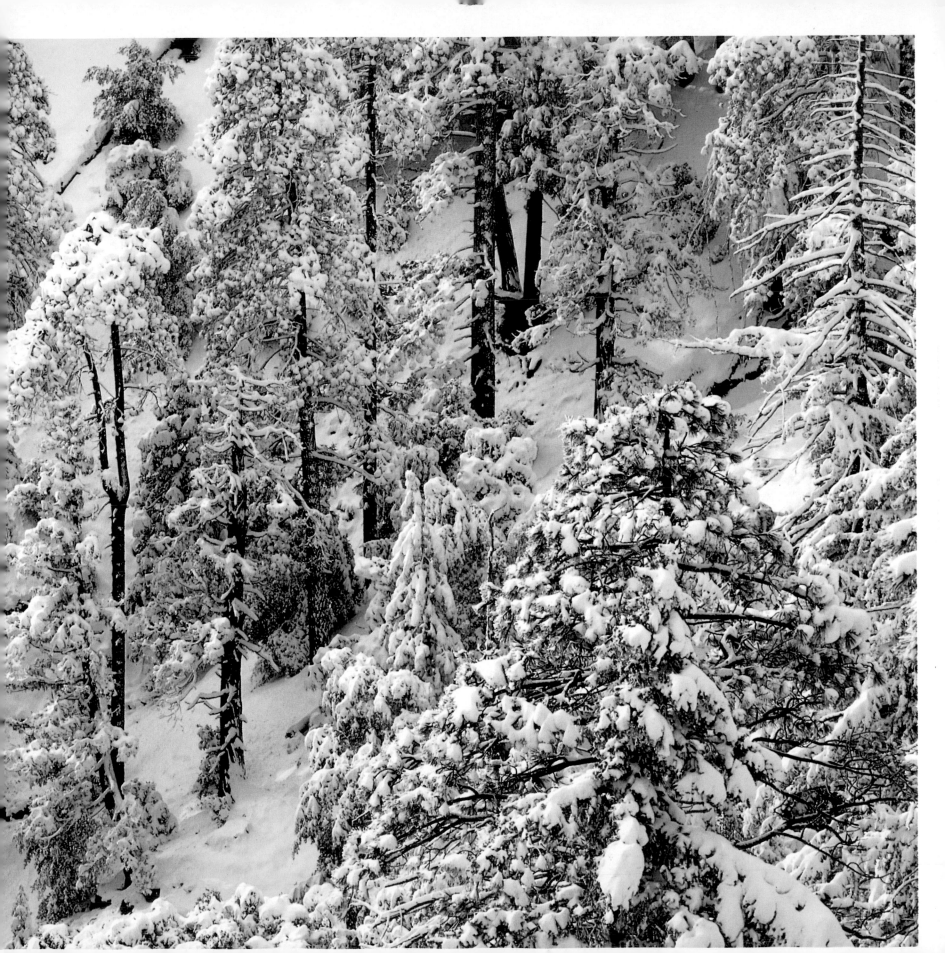

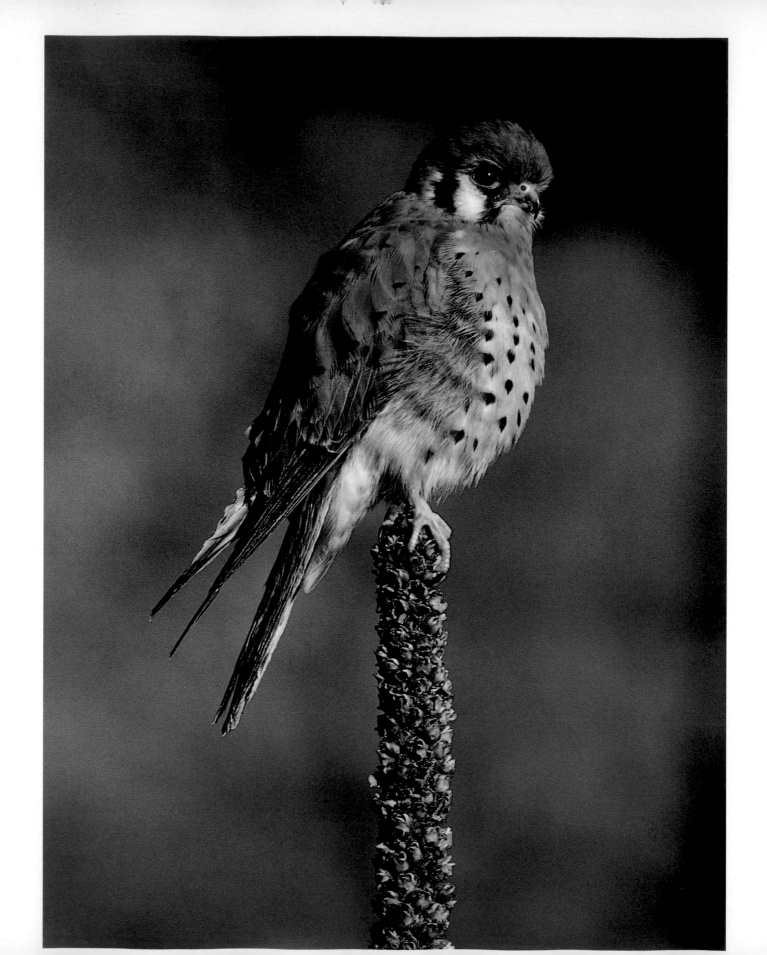

opposite: *American kestrel,*
a common Southern California
raptor

another 2,200 feet before reaching the high point. En route, vast panoramas of lush mountainous terrain, cloaked in timber above the 4,000-foot line in all directions, improve in scope and splendor with each foot of altitude.

Your reward is Crystal Lake, a small, natural catch basin high in the center of the range, and one of only four natural lakes in the San Gabriels. The other three—Elizabeth, Jackson, and Lake Hughes—are all "sag ponds," created by geological upheavals along the San Andreas Fault. But numerous reservoirs with lots of natural-lake ambience catch water for thirsty millions on both sides of the range: Big Dalton, Big Tujunga (part of a major canyon recreational system), Bouquet, Cogswell, Castaic, and finally Lake Piru in the far northwestern corner of the Angeles National Forest. Piru Creek not only generates some of the most exciting whitewater rafting in California, just an hour from downtown L.A., but is the only stream in Los Angeles County being considered for federal wild and scenic river status.

There is one major river system in the range, the namesake San Gabriel River, which courses through sixty-five miles of high mountain ground, collecting an average annual runoff of 148,000 acre-feet from the range before it is subjugated into the concrete flood-control system of the Los Angeles Basin. Seven perennial streams run a total of 240 miles in length, of which 189 miles are suitable for fishing.

Though a first-time summer visitor to the San Gabriels might be put off by the range's dry browns and dark gray-greens, a good guidebook will lead the more determined hiker to several well-known and frequented waterfalls of more than 100 feet in height, such as Leontine, Alpine, San Antonio, and Thalehaha. Most of the falls are found along the city side of the range, due to the geologically active uplift of the San Gabriel Fault system.

Captivating Switzer Falls, just above the city of Pasadena, drops into an idyllic twenty-five-foot-wide pond. Visitors willing to make the twenty-minute drive up from the city to hike the moderate four-mile round-trip trail can revel in a true "old swimmin' hole" experience.

Two other mountain destinations stand out from the myriad escapes awaiting the San Gabriel Mountains sojourner. Both can be reached only on foot. Each offers a different approach to the same lesson: We are finite stones along the infinite pathway of existence. One hike ends at the Bridge to Nowhere, a fascinating concrete archwork—with no purpose whatsoever. The other leads to a grove of twisted trees that tug at our notions of immortality.

To reach the Bridge to Nowhere, you hike a nine-mile loop from the ranger station on San Gabriel Canyon Road, in the heart of the range. Along the way lies a deep, towering rock-wall chasm: the plunging Narrows of the East Fork of the San Gabriel River, the deepest and perhaps most spectacular gorge (descending more than a mile, with an average slope of 75 percent!) in all of Southern California. All this rugged country is part of the Sheep Mountain Wilderness, set aside in 1984 to protect the bighorn sheep that range the region's forbidding rocky heights.

opposite: *Springtime profusion of poppies in the Antelope Valley*

More than a century ago, a gold miner named Alonzo Shoemaker worked a small tributary of the East Fork, not far from the Narrows. Today Shoemaker Canyon leads directly to the bridge, suspended between plunging rocky slopes and connecting…nothing. The graceful arc of concrete is all that remains of two attempts to build highways through the rugged canyon. Both were summarily dismissed by the mountain gods. One road was swept away by a "flood of the century" in 1938. The other project failed after fifteen years' work yielded only about five miles of completed road.

We learn another lesson in humility at the site of the oldest trees in Southern California. Atop Mount Baden-Powell's 9,399-foot summit, stands of bent and twisted limber pines hold the highest ground. As impressive in their hardy longevity as their 4,000-year-old bristlecone pine cousins in the White Mountains, a hundred miles to the north, these trees enable dendrochronologists to learn about past weather patterns from core samples taken from their trunks. The irony of these limber pines' 1,000-year lives is that the same harsh climatic conditions that make their growth so stunted and painstakingly slow also protect them from insects and other natural enemies.

Both here and at the Bridge to Nowhere, we come face to face with how fleeting our time is on planet Earth. When we make the most of what life gives us, we come closest to a sense of immortality. When we try too hard to impose our will on the natural order, we end up literally going nowhere.

Once you have journeyed in body and spirit to high mountain places, they never leave you. So I relive, from time to time, an unforgettable hike I made in the San Gabriels years ago.

On a beautiful spring afternoon I climbed up through fields of purple and yellow wildflowers along the range's northernmost section of the Pacific Coast Trail. Finally, I stopped to rest atop the high broad ridge of Liebre Mountain. The view out to the flat, arid lands of the Antelope Valley, 2,000 feet below, was spectacular. Although it was beyond view, I knew a nearby tract of the region had exploded into a sea of orange-gold flowers—the annual blooming of the Antelope Valley California Poppy Reserve. Just a few miles east, the sensuous, mile-wide Gorman Hills joined in the chorus with undulations of wildflower golds and lavenders.

Near where I sat, an oak, bent over and twisted with age but still impressively stout, brought me musings on this land's original humans. I wondered if an ancient Tataviam had once sat where I was sitting, dreaming of the past and future as he lived wholly contained and nourished within the San Gabriels' high haunts and watered hollows.

The scene is as real to me now as the keys I am using to type these words. I am back in mountain time, where the summits and canyons, snows and blistering summer winds, all neatly weave a cloak that rubs like dirt and flows like stardust.

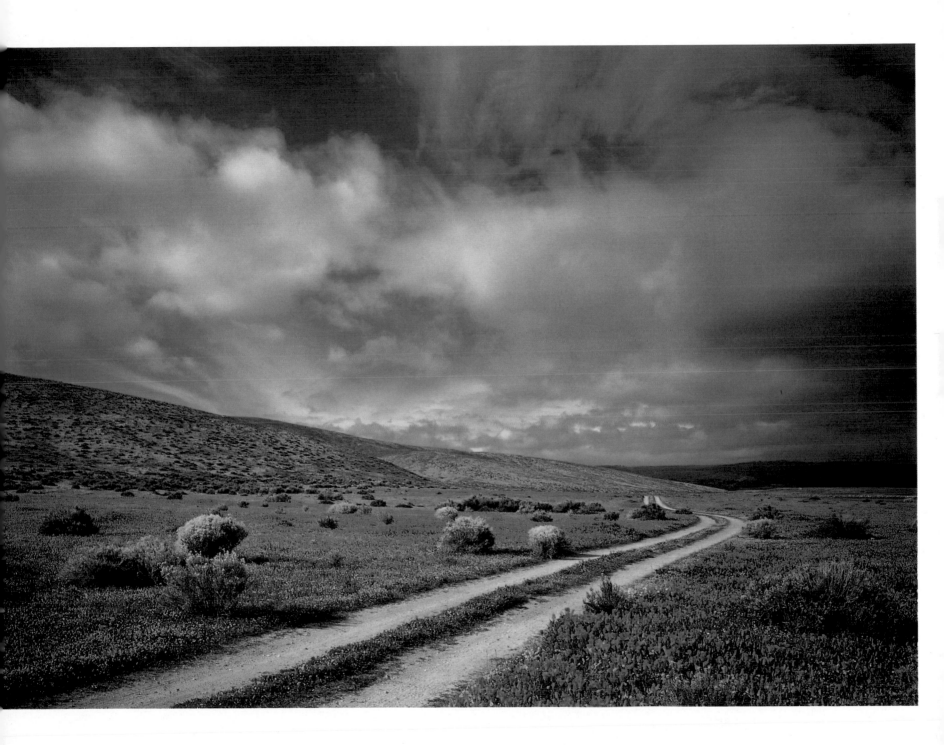

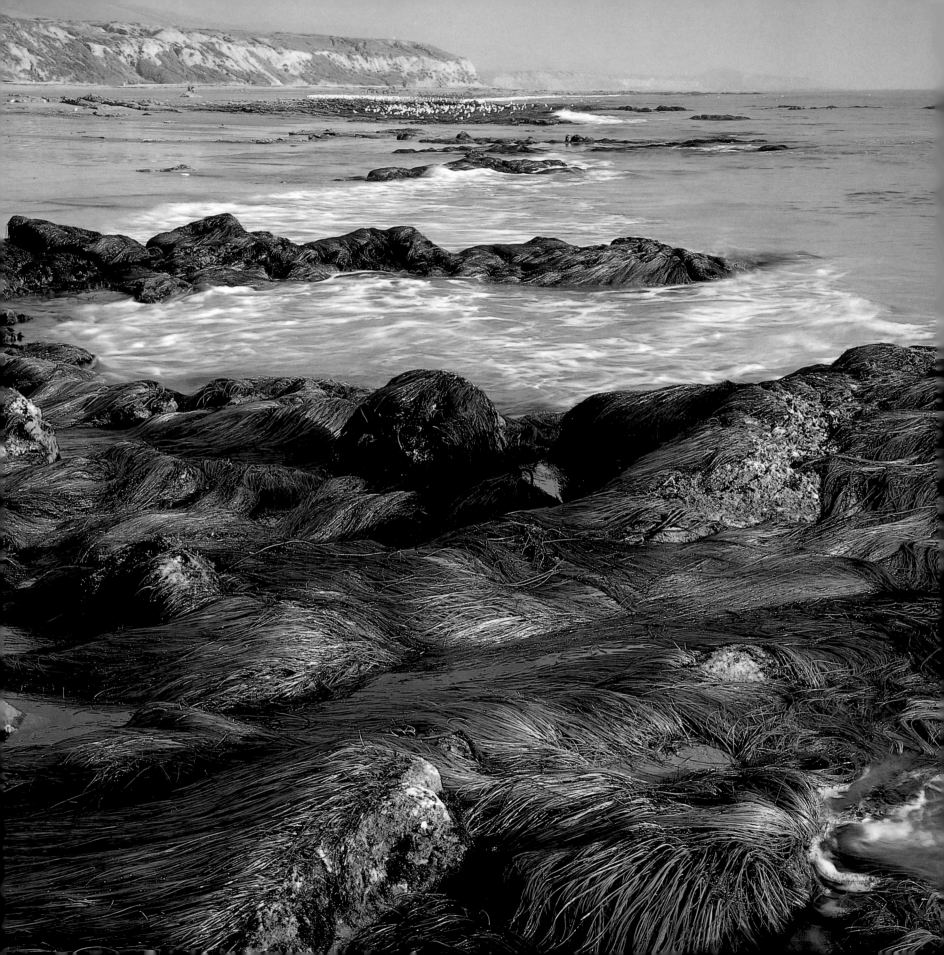

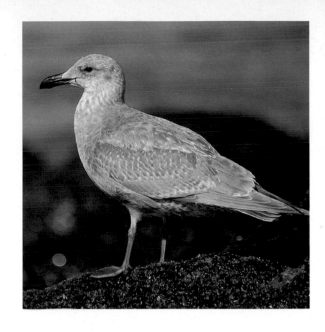

opposite: *Surf grass at Pelican Point, Crystal Cove State Park*
right: *Glaucous-winged gull*

Santa Ana Mountains

I BELIEVE IN GOD, ONLY I SPELL IT NATURE.
—FRANK LLOYD WRIGHT

Look southeast from the San Gabriel Mountains over the broad urban plain of Los Angeles on any hazy or smoggy afternoon, and you might wonder if there was anything in all the world but the crunch of human development. But look farther out, and your eye comes to rest on a commanding line of high mountains and subordinate hill systems rising through the gray haze and running to the sea. The Santa Ana Mountains are the highest of these ranges. Whether seen from on high or at ground level, the Santa Anas stand tall as an icon for the last remaining natural areas we find in our Wild L.A. journeys.

Wild
L.A.

opposite: *Palms at sunset on the*
Orange County coast

The region lies mostly along the eastern border of Orange County, at the edges of the dense suburban sprawl that begins at the foot of the Santa Monica and San Gabriel Mountains and floods the entire Los Angeles Basin to the east and south. Traveling through the cities of Santa Ana, Anaheim, Whittier, Pomona, and dozens of neighboring municipalities, you encounter the first dramatic break in city congestion at the Puente and Chino Hills.

As late as the 1960s, the wide expanses of Orange County surrounding these hills were a verdant land of sprawling dairies and farm fields. Today, you find one bedroom community bumping up against another, punctuated by glass-and-steel high-rises and opulent shopping complexes.

Less than forty years ago, I rode a ten-speed bike all through these once-green farmlands. A fellow Long Beach State student named Steven Spielberg asked me to join the cast of *Slipstream*, his nearly zero-budget bicycle racing film. Every weekend for months, our ragtag band of amateurs sought out the rural areas of Los Angeles—anyplace from Topanga Canyon to the Santa Ana Mountains where we wouldn't be charged a shooting fee.

Back then, the farmlands ran all the way to the south-western-facing slopes of the Chino Hills and rugged foothills of the Santa Anas. To city kids, this was real "country." Today, newly established Chino Hills State Park covers and preserves the wild flavor of most of the Chino Hills, a long, rounded ridge of several miles that rises as high as 1,800 feet. The park ends where the slopes drop into the Santa Ana River Canyon, along its southern boundary. Highway 91, the infamously congested Riverside Freeway, carries its daily commuter hordes through the pass the canyon makes between Orange and Riverside Counties.

Southeast beyond the Chino Hills, the Santa Ana Mountains and coastal San Joaquin Hills rise dramatically in a huge parcel of highlands—nearly 750 square miles of wild country—intermixed with suburban development. These areas are the beating heart of Orange County's remaining unspoiled lands. Undulating terrain ranges from the high slopes of the Santa Anas through foothills, canyons, and grassy plateaus, ending in coastal mountains that drop steeply down to the sea all along the Orange County coast. There, high green slopes, bluffs, and long beaches bring a much-needed natural break on the drive south through the famous art colony of Laguna Beach and the towns of Corona del Mar, Dana Point, Capistrano Beach, and San Clemente.

This southern half of the county's coastline typifies the green, open feel along the Pacific Coast Highway from here to San Diego. The San Joaquin Hills lend their round-shouldered, lush canyon comfort to a number of protected areas, most prominently Upper Newport Bay Ecological Reserve, San Joaquin Wildlife Sanctuary, Crystal Cove State Park, and Aliso and Wood Canyons Regional Park.

Orange County has the second most biologically diverse habitat in California, even though it is one of the smallest, most densely populated counties in the state. Only 38 percent

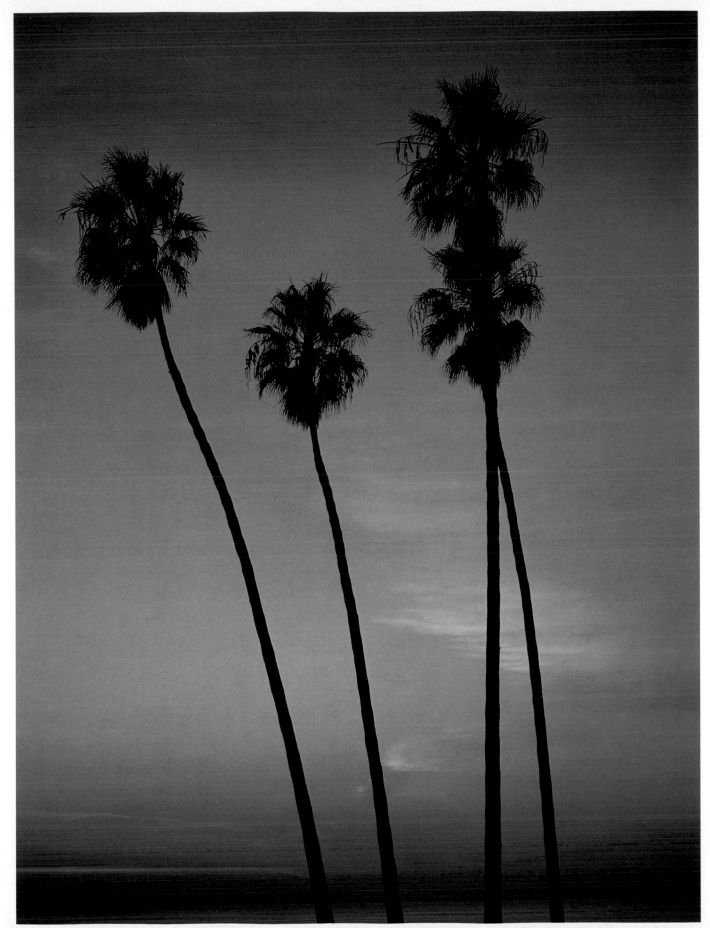

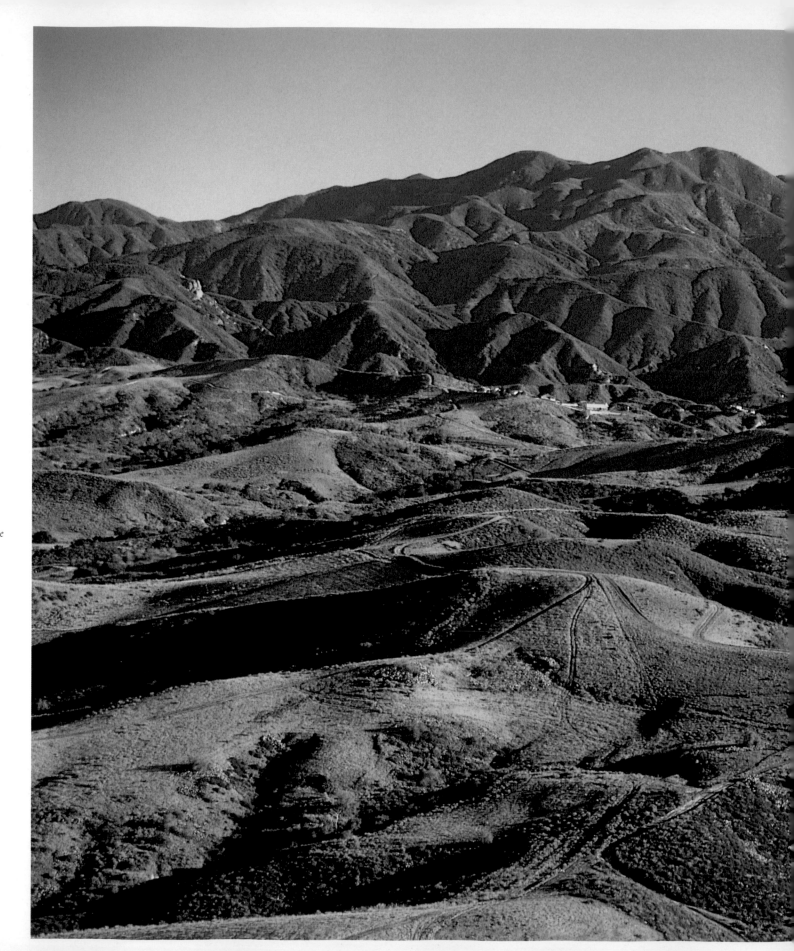

right: *Foothills leading up to the Santa Ana Mountains*

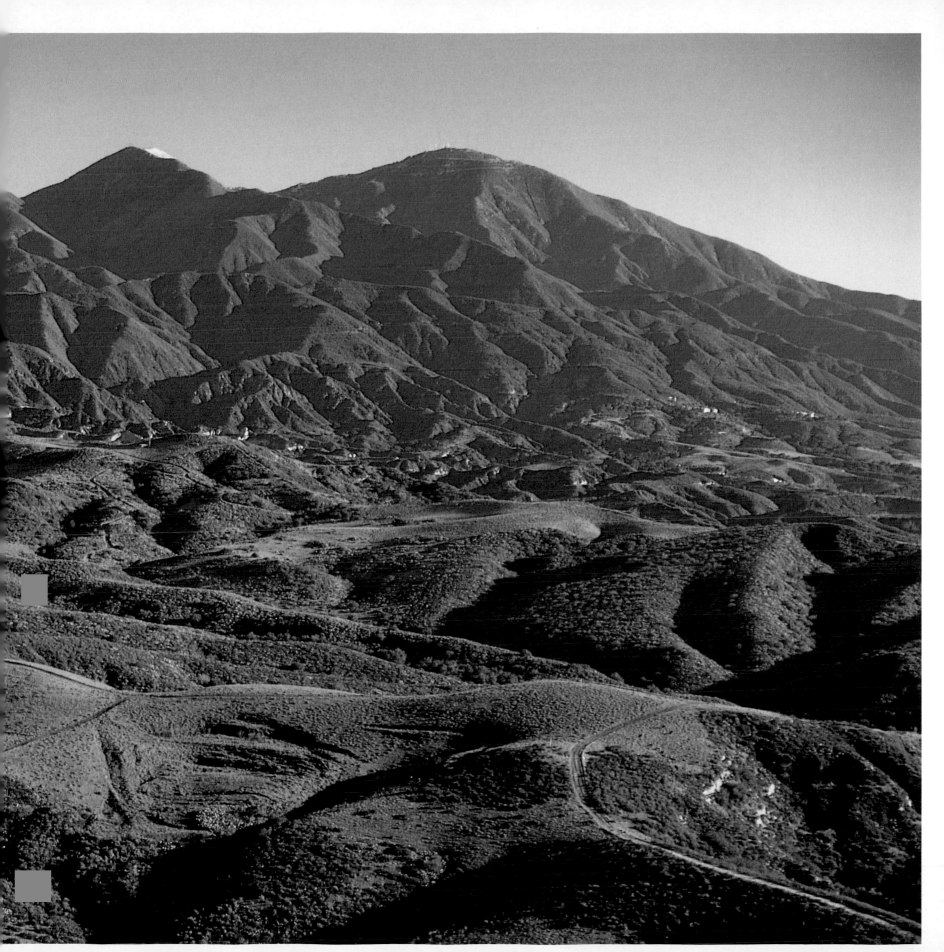

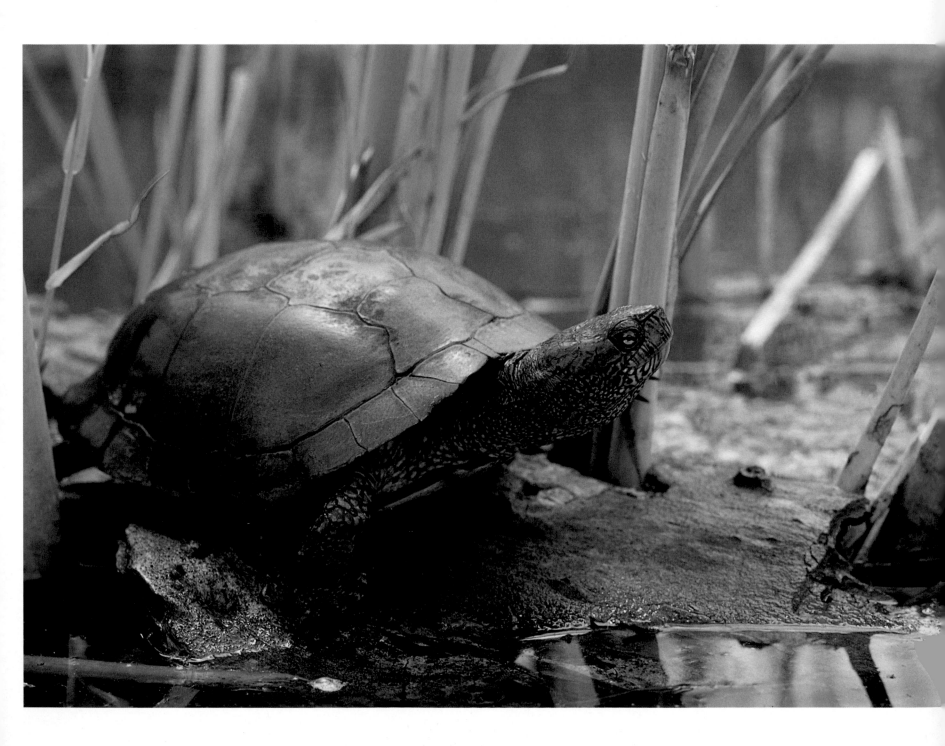

opposite: *Pacific pond turtle,*
Rancho Mission Viejo Land
Conservancy Wilderness
Reserve **below:** *Wild canter-*
bury bells, Santa Rosa Plateau
Ecological Reserve

of the county remains undeveloped, compared to an average 61 percent in other Southern California counties. Still, as population in the prosperous region continues to mushroom, development pressures against the natural landscape remain a constant threat.

Traveling any of the coastal or inland roads and freeways into Orange County's open spaces takes you past examples of most of California's celebrated Mediterranean ecosystem. The land changes character and feel quickly as you move through it: Olive-colored chaparral hills give way to beautiful pine mountain parks. Oak and sycamore woodland wildlife reserves lie adjacent to thousands of acres of existing and proposed wilderness sanctuaries. Lush riparian ravines and canyons suddenly give way to coastal wetlands and sandy beaches, interspersed with rugged, cave-pocked bluffs, echoing Big Sur's plunging headlands.

For me, the Santa Ana Mountains symbolize the drama and power of Orange County wilderness. Driving up the two-lane Ortega Highway from San Juan Capistrano, at the southern end of the Orange County coast, you pass through rising grass, scrub, and woodland hill country. You round a gentle curve and looming before you is a big, broad mountain range—the Santa Anas—rising in a miles-wide rampart to nearly 6,000 feet. Civilization suddenly seems far behind, though you left the suburban clutter of San Juan Capistrano just five minutes earlier.

The Santa Anas belong to the Peninsular Ranges, which extend from the San Fernando Valley south all the way into Mexico. The Elsinore Fault, part of the San Andreas seismic system, runs along its northern walls.

Considered a young geologic formation, the Santa Anas are rich in metamorphic, plutonic, Cenozoic sedimentary, and volcanic rock. The soil is primarily decomposing granite, with outcroppings of large granite boulders

opposite: *Detail, Quixote plant,*
Laguna Mountain Recreation
Area, Santa Ana Mountains

throughout. The first humans, including the Tongva, Juaneños, Luiseño, and San Dieguito peoples reaching back 12,000 years and perhaps much longer, found plenty of bedrock granite outcroppings in which to fashion mortars for processing acorns, fruits, seeds, and animals for food.

These mountains have remained mostly undeveloped, in no small part due to the inhospitable nature of their steep slopes. They are protected from development by the 135,000-acre Cleveland National Forest, although surrounding urban sprawl is encroaching right up to its boundary. The San Mateo Canyon Wilderness, located within the forest, is a rich natural preserve of nearly 40,000 acres, where sixty miles of hiking trails thread through chaparral, coastal sage, and oak and sycamore woodlands.

The potential designation of four additional wilderness areas within the Cleveland National Forest—the Trabuco, Coldwater, Morrell, and Ladd Canyon Wildernesses—would establish an additional 40,000 acres of wilderness in the Santa Anas. Such a designation would preserve an existing wildlife corridor for mountain lions, bobcats, and southern mule deer, as well as provide a significant migratory corridor for birds and butterflies.

I treasure the memory of my own introduction to the wilderness of Orange County. In 1970, atop 5,687-foot Santiago Peak (also called Old Saddleback), I stood with several hang-glider friends, looking west. Falling away from our launch site, the steep, rugged slopes of the mountain gave way to foothill and canyon scrub and woodlands that were not much different from what you see today. My cronies and I ran, one by one, off the peak that day beneath our gliders, hoping to soar all the long way to Escape Country, a private recreational park that used to be nestled in the foothills of Trabuco Mesa.

In the hill country at the foot of the Santa Anas, wilderness lives on, thanks to a number of large parks and protected areas: Riley Wilderness Park, Whiting Ranch Wilderness, Ronald W. Caspers Wilderness Park, the National Audubon Sanctuary at Starr Ranch, O'Neill Regional Park, the Rancho Mission Viejo Land Conservancy Wilderness Reserve, and the Santa Rosa Plateau Ecological Reserve. Three of them give us the full measure of Orange County's natural areas: Caspers Park, the Mission Viejo Wilderness Reserve, and the Santa Rosa Plateau.

Nestled between the Santa Ana Mountains and the San Joaquin Hills, Ronald W. Caspers Wilderness Park protects one of the most undisturbed and primitive Southern California landscapes in all of Wild L.A. Caspers Park serves up more than 8,000 acres of Mediterranean scrub oak, sycamore, and oak forests and woodlands, grassy hills, and tranquil creeks. The extensive trail system makes for a variety of hikes up to ridgetop views, through grassy meadows and woods, or down to the cool shade of moss-bottomed creeks.

Caspers Park affords visitors that rare experience in Orange County: expansive vistas devoid of even a trace of

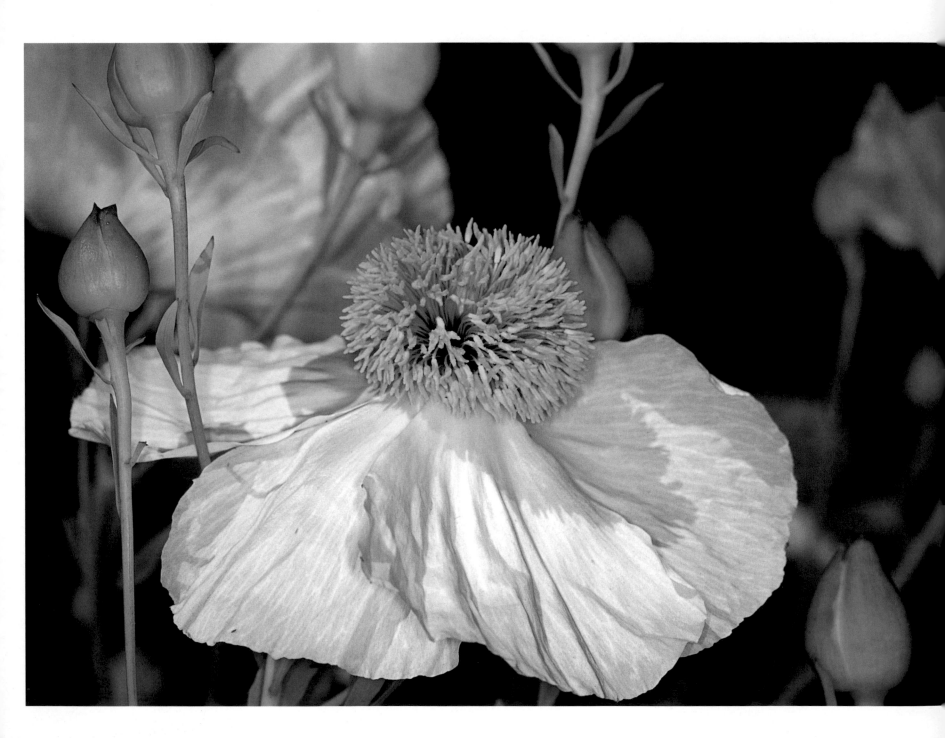

opposite: *Coulter's matilija poppy, Harding Canyon, Santa Ana Mountains*
right: *Rocky pool, Santa Rosa Plateau Ecological Reserve*

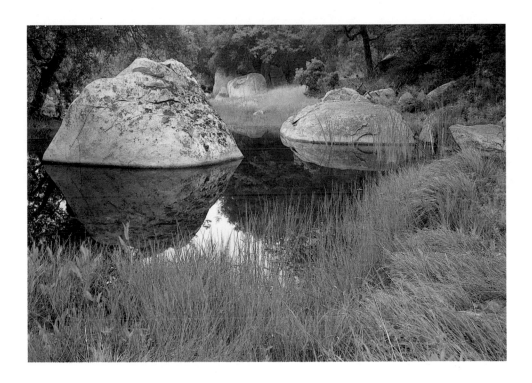

the urban neighborhoods beyond its hilly horizons. Climbing any of the many narrow footpaths through the scrub, past small clusters of prickly pears and drab green or ghost-gray shrubs, you are never for long out of sight of the towering Santa Ana Mountains.

A walk through Caspers Park, accompanied by the fragrance of sage and the sound of shoes crunching on gravel, breathes new life into the soul. Clusters of dark green mistletoe sway from leafless sycamores in winter meadows. Solitary oaks stand strong against the golden meadowed hills. Life feels balanced beneath a sheltering sky.

Your only ties to civilization in this serene realm are fellow visitors and the occasional glimpse of native animals. Mammals endemic to the area include southern mule deer,

bobcats, coyotes, and the iconic mountain lion. Many trailhead postings soberly remind you that encounters with the elusive feline are possible.

Reptile species here are typical of other Southern California ecosystems and include the protected San Diego horned lizard, the two-striped garter snake, and the southwestern pond turtle, as well as that ubiquitous Southern California scrubland predator, the rattlesnake.

Caspers Park's rich and varied habitats nourish hundreds of bird species, both seasonal transients from the Pacific Flyway and local, year-round inhabitants. Vultures, kestrels, sparrow hawks, cadence-tapping woodpeckers, flitting little songbirds like the California towhee, rude and raucous mountain bluebirds, and the protected white-tailed

opposite: *Female mallard,*
Upper Newport Bay Ecological
Reserve

kite and golden eagle all soar these washed blue skies and populate the trees and bushes.

Mallards and several other duck species animate ponds and wetlands throughout the park. Monarch butterflies bring warm color to the blue-green sage. The muted drone of dragonflies, hornets, and bees makes a constant, subtle music.

The Rancho Mission Viejo Land Conservancy Wilderness Reserve, just south of Ortega Highway, adds another section of largely untouched land between Caspers Park and the coastal town of San Clemente. Established as mitigation for a large development adjacent to it, the 1,200-acre reserve, accessible to visitors by advance reservation, is a living classroom in how to protect the natural areas beyond our urban doorsteps. You walk this virgin terrain of low rolling ridges and oak meadows, aware that just ten minutes away, in San Juan Capistrano, identical acreage has been turned into a tangle of tract homes and shopping malls, streetlights and power poles, that hide the land and block the sky.

As if to dramatize the contrast between natural and suburban landscapes, the Conservancy's reserve stands at ground zero of a classic Southern California environmental battle. Orange County's Transportation Corridor Agencies (TCA) wants to build a multilane toll road along the pristine watershed of Cristianitos Creek, with a toll booth a stone's throw from the reserve. Environmentalists warn that the road would devastate the last large unspoiled natural ecosystem in Orange County.

Nearby San Mateo Creek, one of the last, if not *the* last, riparian ecosystem in all of Southern California to run from the mountains to the sea virtually unimpeded by humanity, would also be severely impacted by the toll road, according to Sierra Club studies. The creek supports a host of endangered species—coastal California gnatcatchers, tidewater gobies, and sensitive plant species such as San Diegan coastal sage scrub—within habitat ranging from marine chaparral to woodlands. An even more compelling argument against the tollway is the recent discovery that the creek is the southernmost breeding ground for the rare steelhead trout.

The Conservancy parcel also speaks to efforts of ecologists and conservationists to reestablish and protect major migration pathways for vertebrate predator and prey species throughout Southern California. A thirty-mile-long "island" of open space stretches from the Conservancy's reserve northwest across the Santa Ana Mountains. At the newly acquired Coal Canyon underpass, which allows wildlife to pass undisturbed through culverts beneath the busy Riverside Freeway, the area links to another island: the Puente-Chino Hills Wildlife Corridor. Connecting these two wild regions enables animals to move freely all along an intact migration path that reaches from the Puente Hills in east Los Angeles, through the Santa Anas and their many surrounding open areas, and on into San Diego County, a distance of more than sixty miles.

Radio-collar studies of mountain-lion movement clearly show that such extensive migration corridors are essential

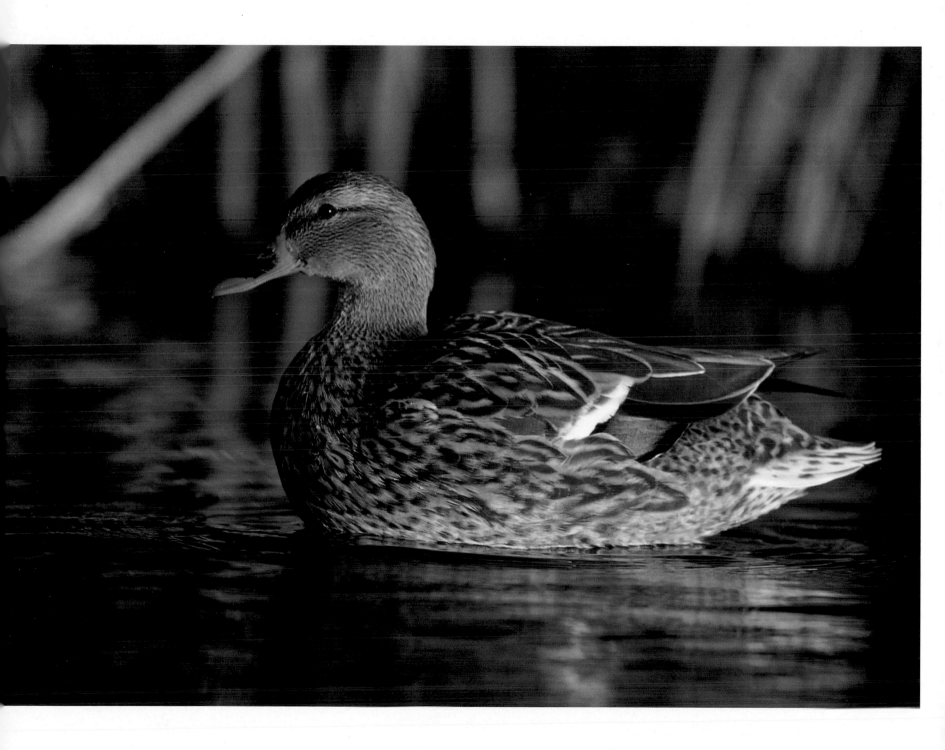

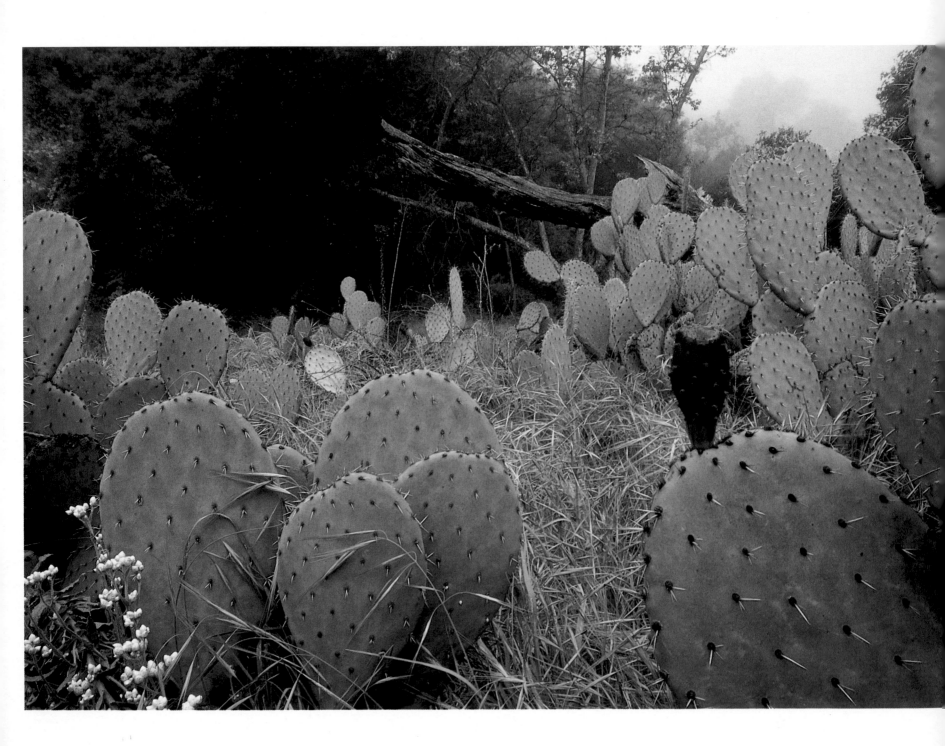

opposite: *Prickly pear cactus in bloom, Ronald W. Caspers Wilderness Park* below: *Coast horned lizard, Rancho Mission Viejo Land Conservancy Wilderness Reserve*

to a major predator's survival. All key predators, such as the mountain lion and rattlesnake—which depend on an intact and healthy food chain—serve as urgent reminders of the need to conserve their ecosystems. Atop the food chain, they help us understand how unbroken habitat makes possible the wide variety of prey animals they require for survival. As the habitat goes, so goes the prey, so go the predators, so goes the entire ecosystem—everything is tied together.

Another spectacular natural area at the southeastern end of the Santa Ana Mountains is the 8,300-acre Santa Rosa Plateau Ecological Reserve, managed by The Nature Conservancy. The reserve is another significant component of the wildlife corridor system: Its Tenaja Corridor extends the ability of wildlife to migrate throughout the Cleveland National Forest.

The region was once known as Rancho Santa Rosa, part of a 47,000-acre, 1846 Mexican land grant to cattle and sheep rancher Juan Moreno. The plateau averages 2,000 feet in elevation. Celebrated and protected now for its profusion of plant and animal species, the area includes what is considered by many to be the finest remaining example of the once common California bunchgrass prairie, so denuded elsewhere in the state by grazing cattle herds.

The plateau's protected area has grown through successive purchases by The Nature Conservancy and other environmental organizations. Human activities are restricted to those compatible with the natural environ-

ment, encouraging more than 40,000 visitors a year to flock to its trails for nature study, photography, hiking, horseback riding, and mountain biking.

The region in general is celebrated for its variety of distinct habitats, which include Engelmann oak and coast live oak woodlands, creekside vegetation, coastal sage scrub,

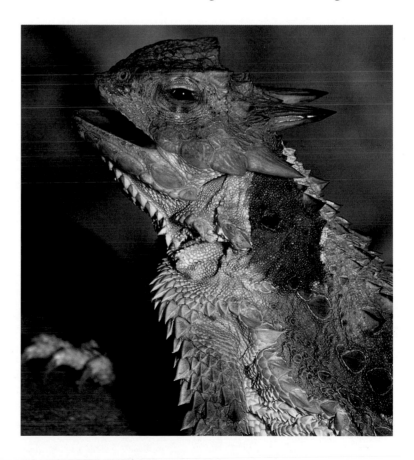

159

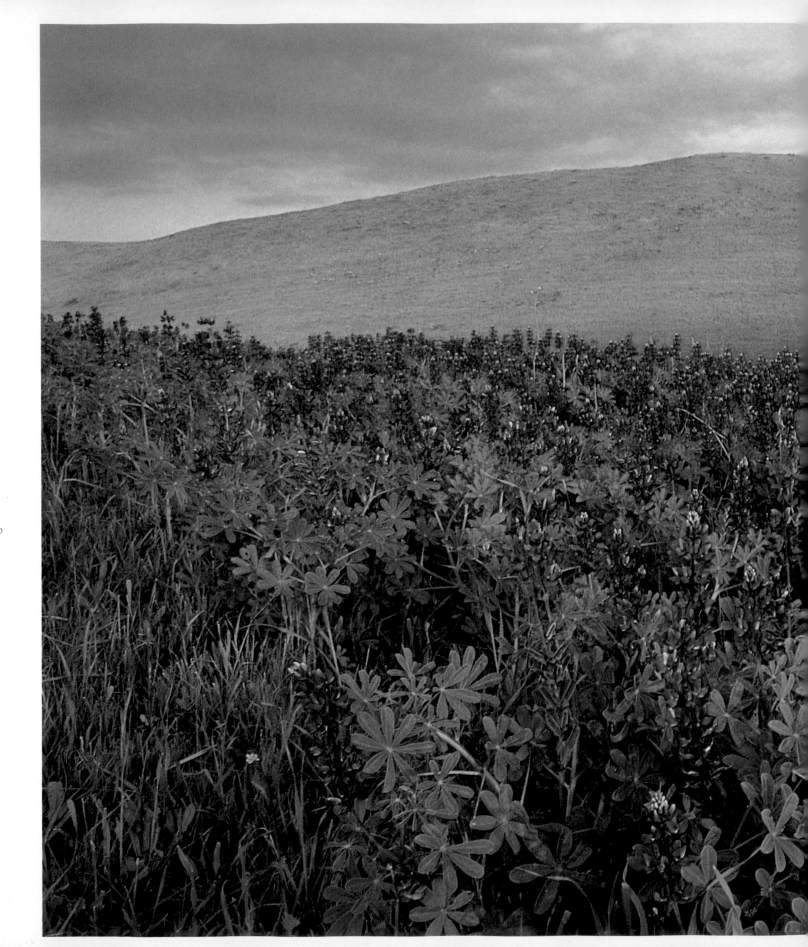

right: *Field of lupine, Rancho Mission Viejo Land Conservancy Wilderness Reserve*

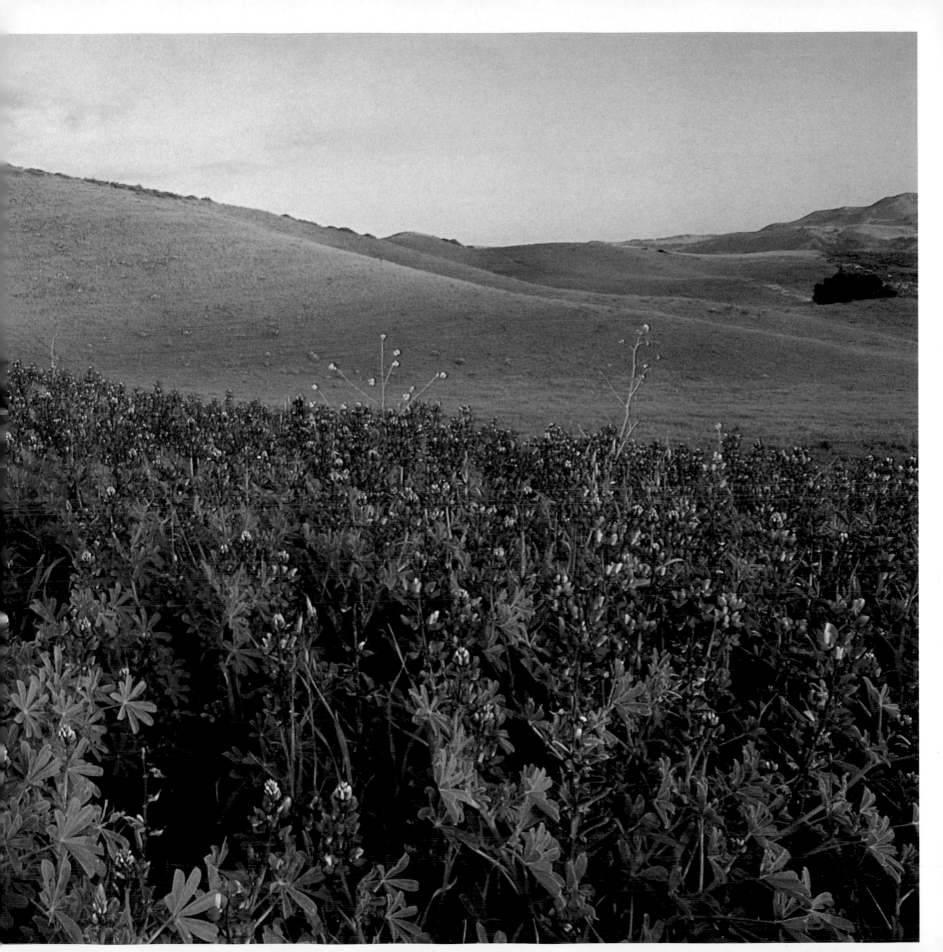

left: *Western ringneck snake, Rancho Mission Viejo Land Conservancy Wilderness Reserve* **opposite:** *Oak grove in morning mist, Ronald W. Caspers Wilderness Park*

chaparral, bunchgrass prairie, and vernal pools. In the spring, the plateau's chaparral explodes in riotous color with white and blue ceanothus flowers, purple nightshade blooms, and trumpet-shaped, red and orange blossoms of coast monkeyflower, the latter a favorite source of nectar for hummingbirds.

Endangered animals of the plateau include the red-legged frog, the southwestern pond turtle, and the endemic fairy shrimp, clinging to life thanks to a stream restoration project. In all, the Santa Rosa Plateau Ecological Reserve is home to fifty-nine plant and animal species, including mountain lions, horned lizards, badgers, bobcats, gray foxes, and deer. Wintering waterfowl make up a significant part of the more than 180 species of birds seen here.

All these lands and the many other parks and preserves in and below the proposed Santa Ana Mountains Wilderness Complex evoke the world of thousands of years ago, when modern Orange County was a mountain-ringed plain covered with herds of elk, mastodon, and bison.

Heading southwest out of the Santa Ana Mountains takes us to the ocean, where the palm-lined Pacific Coast Highway threads along the hilly coast much as it does below the Santa Monica Mountains from Malibu north. California's 1,100 miles of coastline are well represented in this twenty-mile stretch, with its soaring headlands, rocky cliffs, many beaches and coves, gentle bays, and coastal wetlands.

There have been lost battles here, such as the San Joaquin Hills Tollway that slashes south through the hills

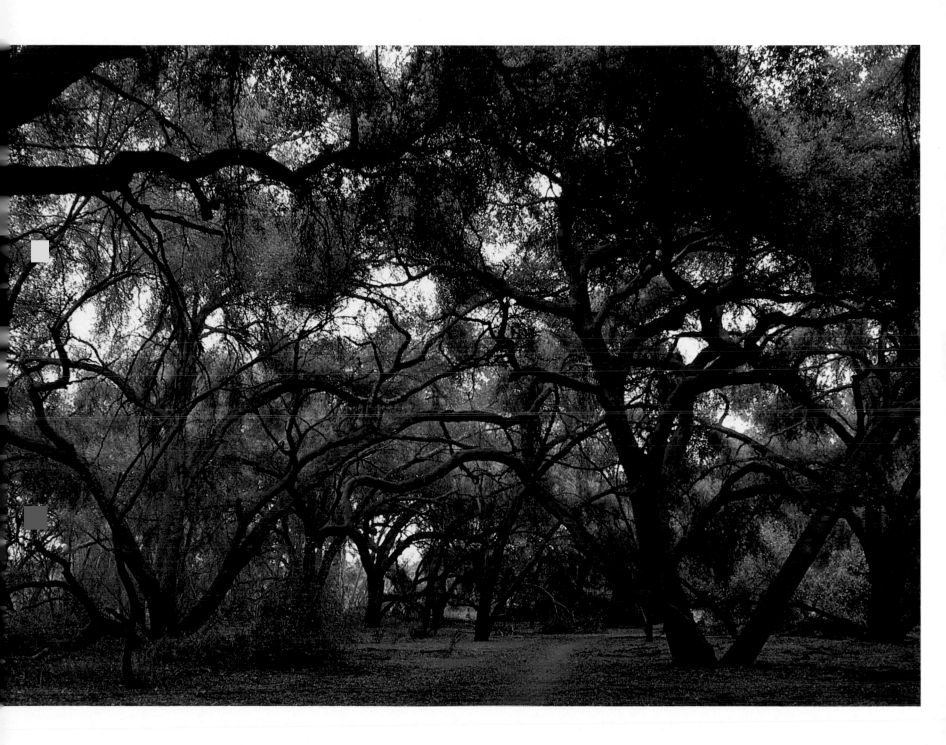

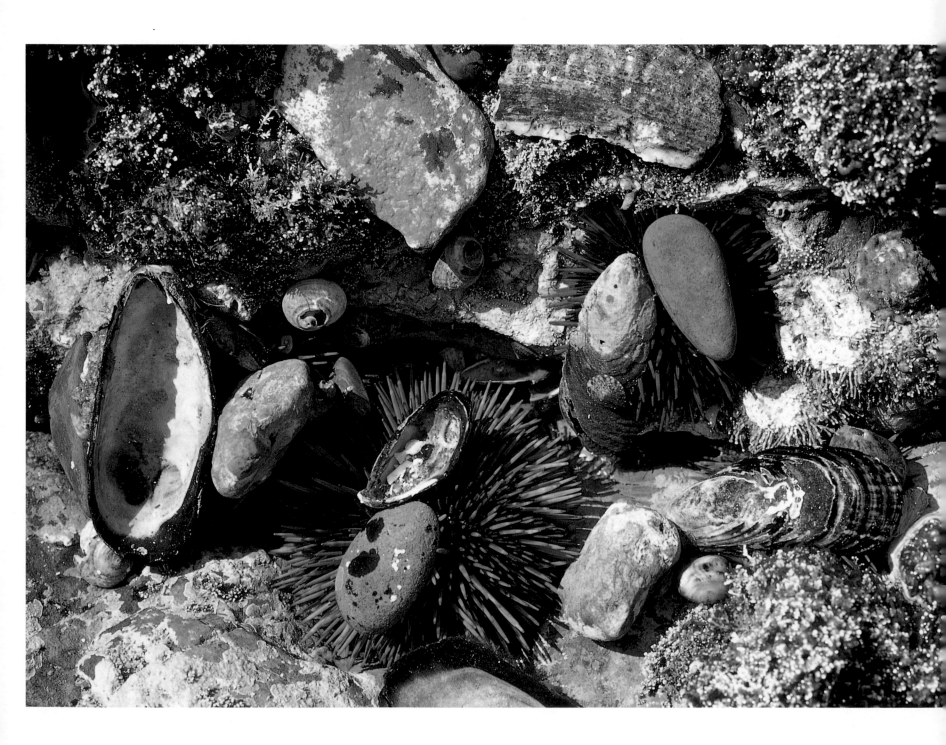

opposite: *Purple urchins, Pelican Point, Crystal Cove State Park* **right:** *Bottlenose dolphins, found along the Calfornia coast*

from Costa Mesa to Interstate 5 at Mission Viejo. There have been many victories as well. Notable among them is the Bolsa Chica Wetlands, site of a recent conservationist skirmish that turned back a determined housing developer.

The 530-acre Bolsa Chica (Spanish for "little pocket") Ecological Reserve is a restored salt marsh and one of the premier destinations on the Pacific Coast for photographers in search of a variety of shorebirds. Pacific Flyway transients and year-round locals are abundant: brown and white pelicans, grebes, terns, seagulls, cormorants, and a wide range of duck species are just the tip of the diversity you find here. There's no shortage of food for them: mussels, California horn snails, jackknife clams, mud clams, California mussels, and more than fifty species of fish help set the avian table.

Moving down the coast from Bolsa Chica, Upper Newport Bay Ecological Reserve and Regional Park, reclaimed and relatively unspoiled, is one of the few estuaries left in Southern California. Its wetland tidal flats help balance the profusion of dwellings lining the high cliffs and steep headlands along the perimeter of the 892-acre estuary. Open water, salt- and freshwater marshes, tidal flats, and upland habitats nurture a diversity of bird species, including several on the endangered list: peregrine falcons, clapper and black rails, Belding's sparrows, and least terns.

Newport Bay is a vital stopover for migrating birds along the Pacific Flyway. In winter, you can see tens of thousands of birds here, as well as the hikers, photographers, and nature lovers who come to revel in their world.

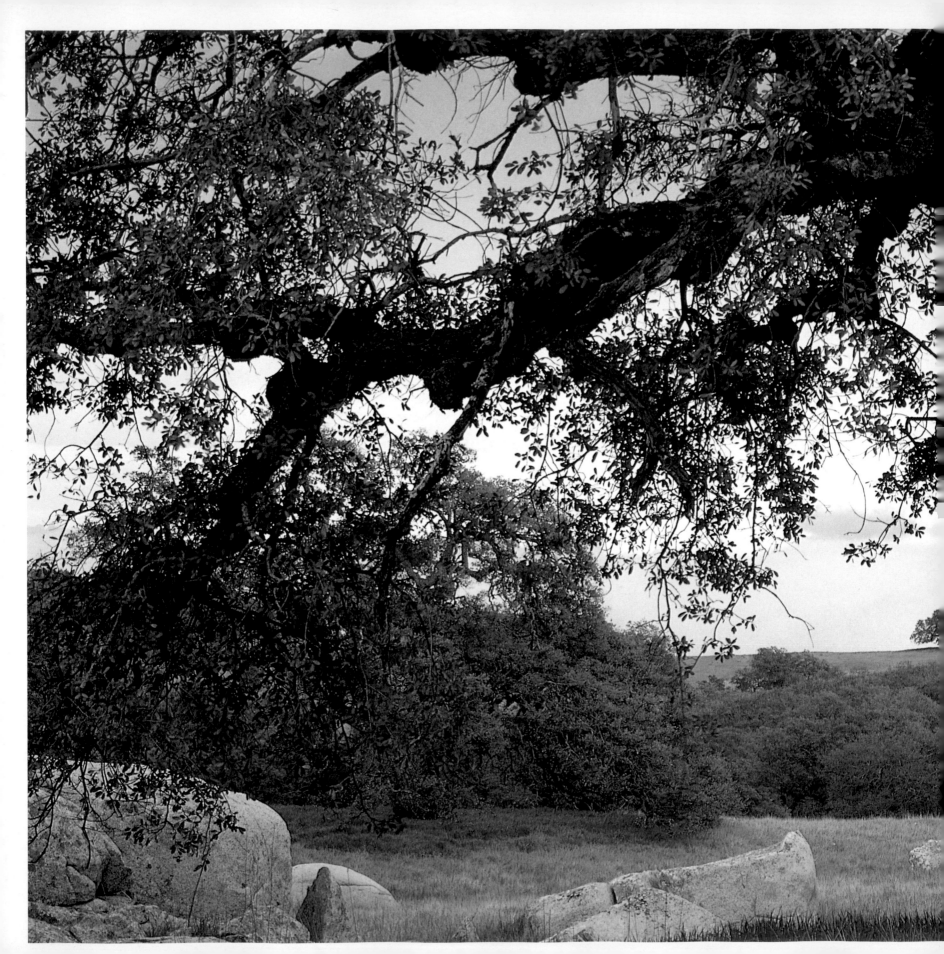

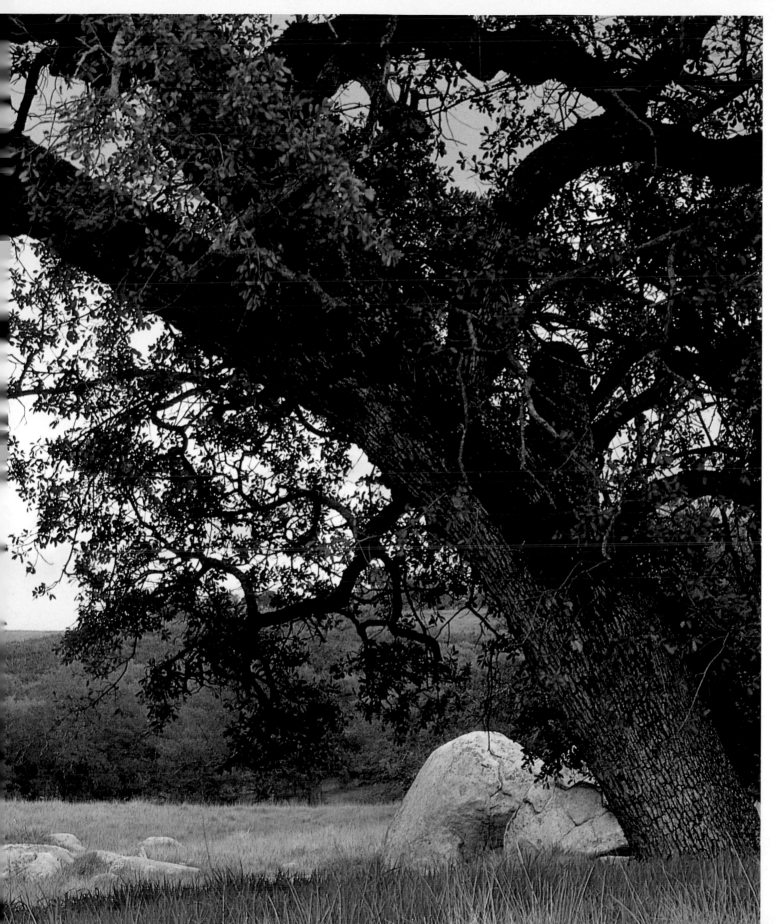

left: *Englemann oaks, Santa
Rosa Plateau Ecological Reserve*

opposite: *Butterfly on milkweed, Rancho Mission Viejo Land Conservancy Wilderness Reserve*

The bay is a textbook wetland: acacias, willows, cattails, bull tules, and California buckwheat paint swaths of earth-tone texture across the looming highlands. Cacti and other succulents, poppies, dragon sageworts, watercress, pickle-weed, and poison hemlock thrive in the protected environment.

During the Pacific Flyway migrations, brown pelicans, cormorants, hawks, and great blue herons are joined by bushtits, hawk species, mallards, green-winged teals, mock-ingbirds, warblers, and western meadowlarks—more than 200 species in all.

Farther south, Crystal Cove State Park, located between Laguna Beach and Newport Beach, is a bold, three-and-a-half-mile run of undeveloped coast linked to a hillside woodland park of roughly 2,800 acres. Even the offshore waters here are designated as an underwater park. Visitors explore rocky tidepools and sandy coves along Crystal Cove's headland-protected shores. Back up in the hills, horseback riders and hikers sometimes hear the haunting cries of coyotes and bobcats.

On a clear day, along the ridges within the park that lie above the long, beautiful beach, you can see up and down the coast all the way from Long Beach to Dana Point, a range of thirty miles. Santa Catalina Island hugs the ocean horizon more than two-score miles away. Now and then, the abundant life of the region reveals itself: migrating whales, dolphins, and sea lions in the ocean swells and among the black, sea-foamed rocks, and cedar waxwings, magpies, gulls, and ospreys in the skies. Surrounded on three sides by hill-hugging coastal develop-ments, Crystal Cove quickly became a treasure of environmental preservation after it was purchased by the state in 1979.

Northeast of the ridges at the top of Crystal Cove State Park, wilderness holds out against encroaching Orange County urban development. Aliso and Wood Canyons Regional Park, at 4,000 acres one of Orange County's largest expanses of wilderness and open space, offers a six-mile stretch of rolling grass and scrub canyons, mature oaks, elderberry and sycamore trees, two perennial streams, and more than thirty miles of trails. The many interconnecting paths draw hikers, horseback riders, and mountain bikers by the droves. Nature is indeed alive and well in Orange County, from this beautiful coastline to the high Santa Anas beyond these ocean hills.

I made my most recent pilgrimage to Orange County on a December walk through the Rancho Mission Viejo Wilderness Reserve and Caspers Wilderness Park. Although just a week before Christmas, it was a summer-like 83 degrees. The harsh Santa Ana winds, gusting more than forty miles per hour, raged over and down through the brown mountain peaks and passes, injecting an edgy irri-tability into the usually balmy marine climate.

The hot, dry winds nagged at my subconscious. I remembered how easily fire rages through these lands when the Santa Anas blow; yet my mind kept drifting back

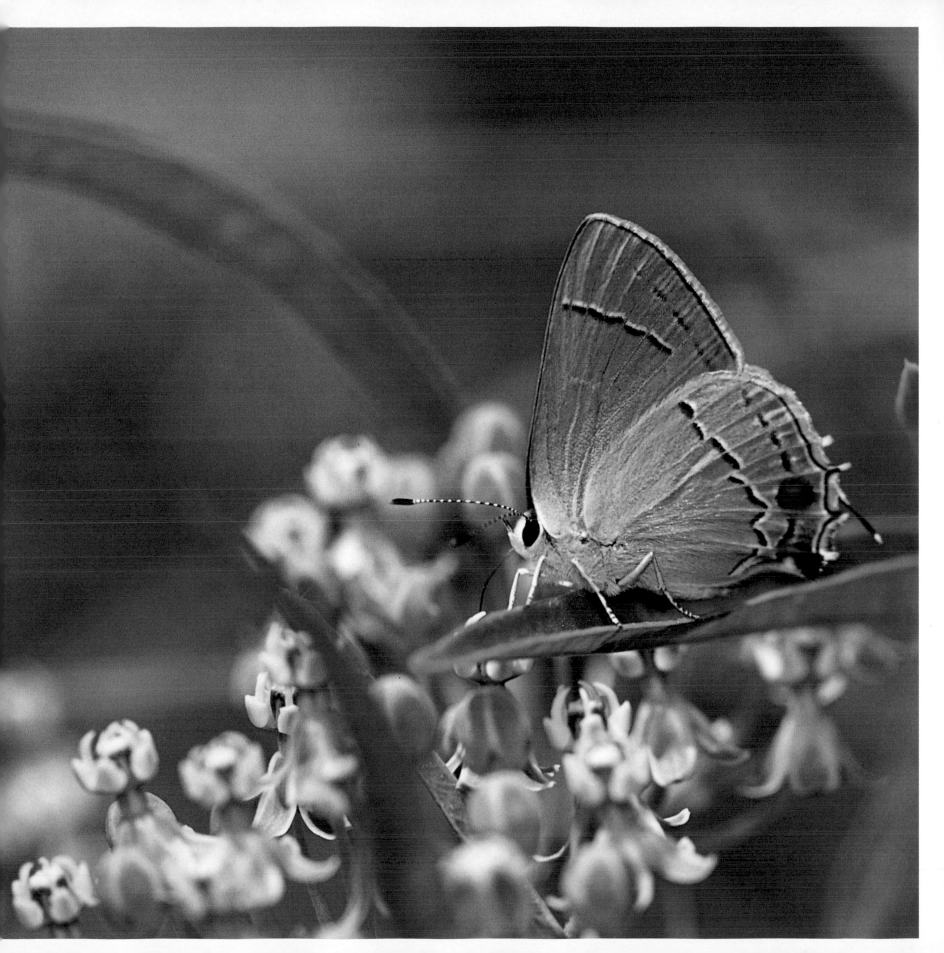

right: *Mature oak grove, Rancho Mission Viejo Land Conservancy Wilderness Reserve*

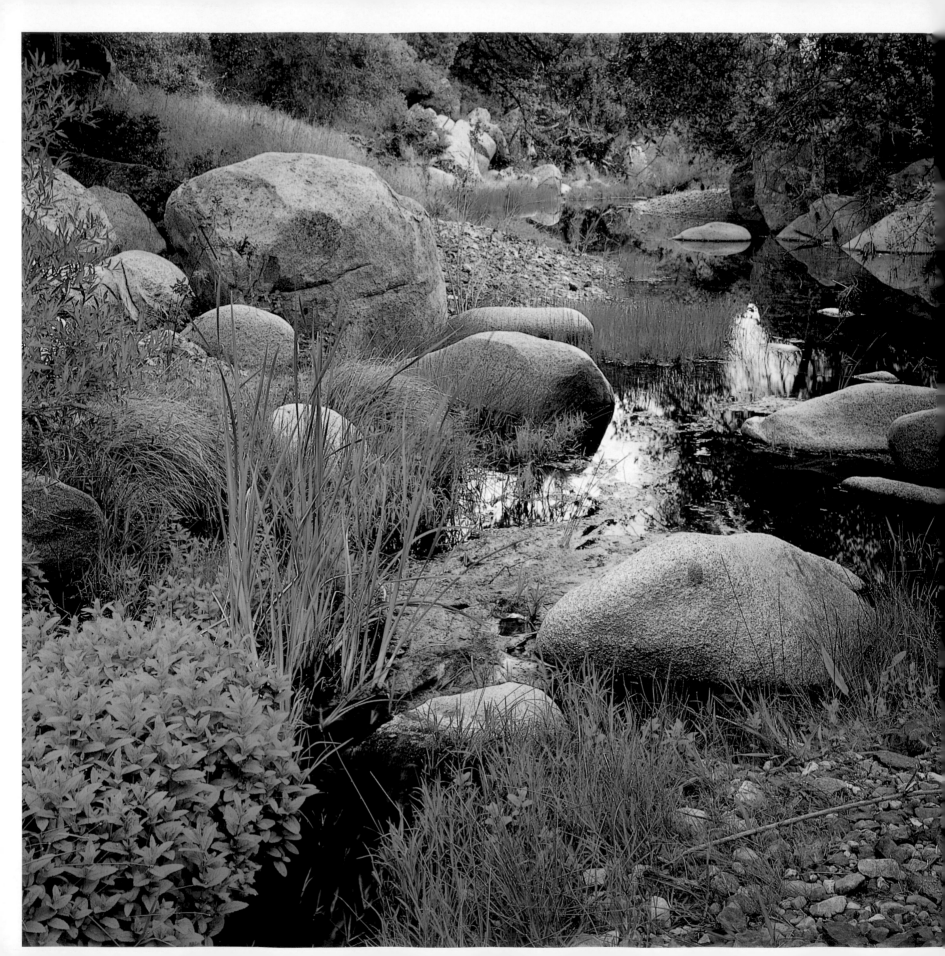

opposite: *Vernal pool, Santa Rosa Plateau Ecological Reserve*
right: *Red dragonfly, Rancho Mission Viejo Land Conservancy Wilderness Reserve*

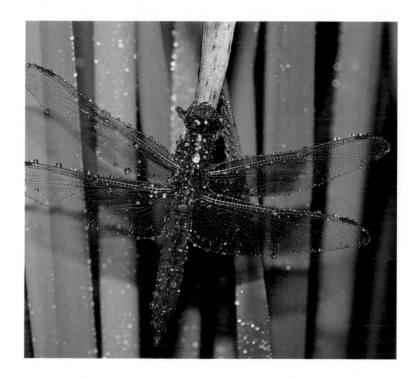

to the wondrous green springs and golden summers of Southern California. Instead of this dusty-blue, swirling air, I recalled gray rainstorm skies and pre-spring blankets of snow that tease Angelenos from time to time with notions of "real" winter.

When we feel the land beneath our feet and hear the insects and birds around us, we bond with earth and sky. The seasons and how they move through the hills, canyons, woods, and wetlands remind us of our mortality even as they fill us with the joy of renewal.

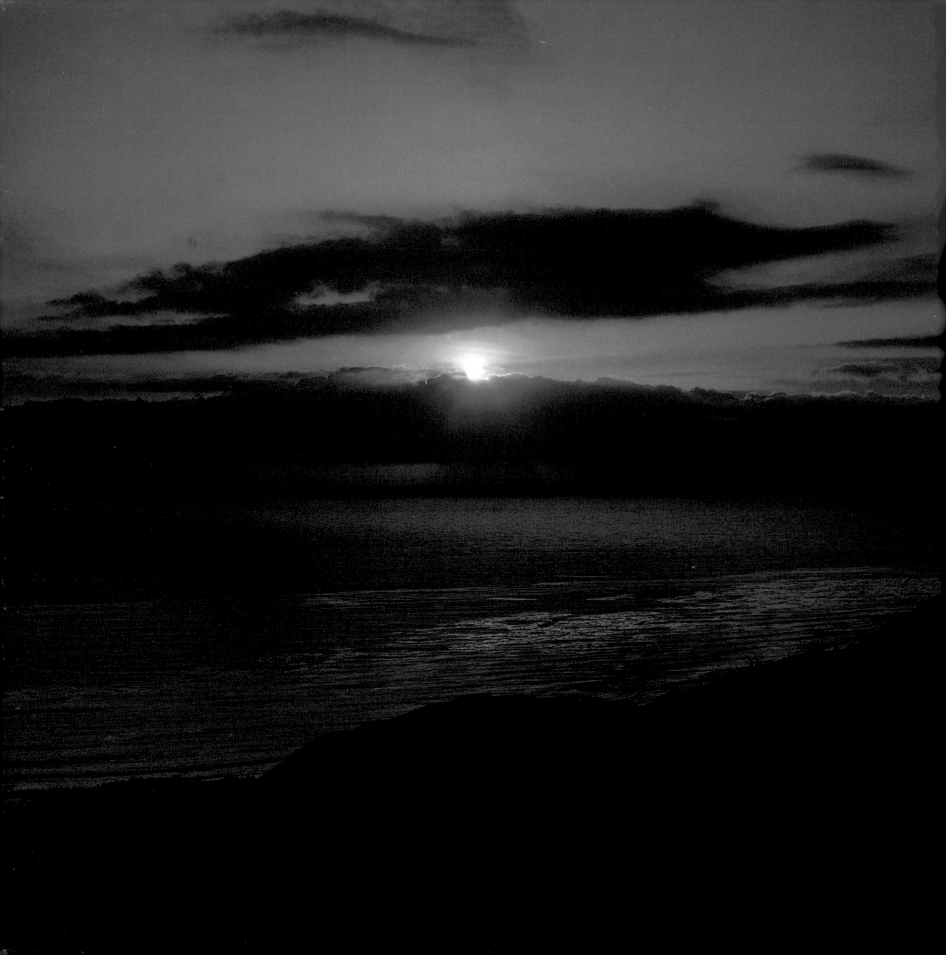

opposite: *Sunset spectacle from the Santa Monica Mountains*
right: *Lupine blooming in fire-blackened chaparral*

The Long View

IF WE CAN TEACH OUR CHILDREN TO HONOR NATURE'S GIFTS, THE JOYS AND BEAUTIES OF THE OUTDOORS WILL BE HERE FOREVER. ─FORMER PRESIDENT JIMMY CARTER

Wild
L.A.

Her name is Julia. She has probably never heard of the endangered unarmored three-spined stickleback, nor would she make much sense of a scientific report on underground aquifer levels. In that respect, she is much like the rest of us.

Julia teaches junior high school in Orange County and lives in the seaside town of San Clemente. Until she and her husband read the fine print of their home's purchase contract, she had never thought of herself as an environmental activist. But the contract alerted her to a proposed toll road to be bulldozed right through the

below: *Killdeer, probably the most widespread shorebird in California* opposite: *The San Fernando Valley from the Santa Susana Mountains*

beautiful state park close to her new home. She decided to do something about it.

"She found a place she wanted to protect," says Bill Corcoran, the Sierra Club's Angeles Chapter Conservation Coordinator. "She came to one of our meetings to find out more, got involved, and began sending letters to the editor. In doing just those things, she is living her values for her three children, rather than just talking about them. And, through her activism, she feels much more connected than before to her community and its future."

Throughout the urban boom of the twentieth century, Los Angeles has been a difficult place to feel connected to.

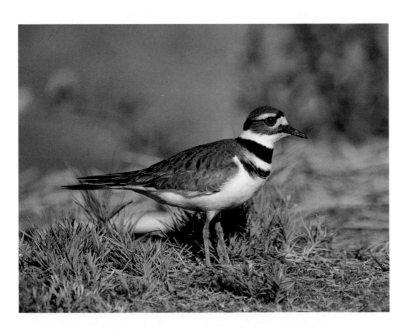

The decades-long subjugation of the Los Angeles River into a concrete channel led to the floodplain being opened up to one tract after another of huge construction projects, with water redirected from hundreds of miles away to fuel the city's growth. From the 1940s to the present day, development has run unchecked, due to the receptiveness of local and state governments to big-money developers. Plains and wetlands, meadows and woodlands, were covered over with cities, towns, factories, malls, and freeways.

To natives and transplants alike, the Greater Los Angeles metropolitan area today can seem despairingly homogeneous; a walk down a Long Beach street looks and sounds very much like its Van Nuys counterpart, fifty miles north. Yet there may be more reason now for optimism—however guarded—than in many decades. For although major conservation battles over pending developments large and small remain to be fought, the great sprawl throughout the basin that has made Los Angeles both famous and infamous has pretty much run its course.

In its place, increasingly mobilized conservation organizations and residents who seem to be waking up to the ecological threats to their communities portend a period in which environmental activities will steadily shift from a siege mentality to one of preservation and restoration.

"We're coming to the end of the era of sprawl," says Bill Corcoran. "There are a few big battles left, but once those are resolved, there's really no place else to build new communities. So our vision needs to be how we will change from a

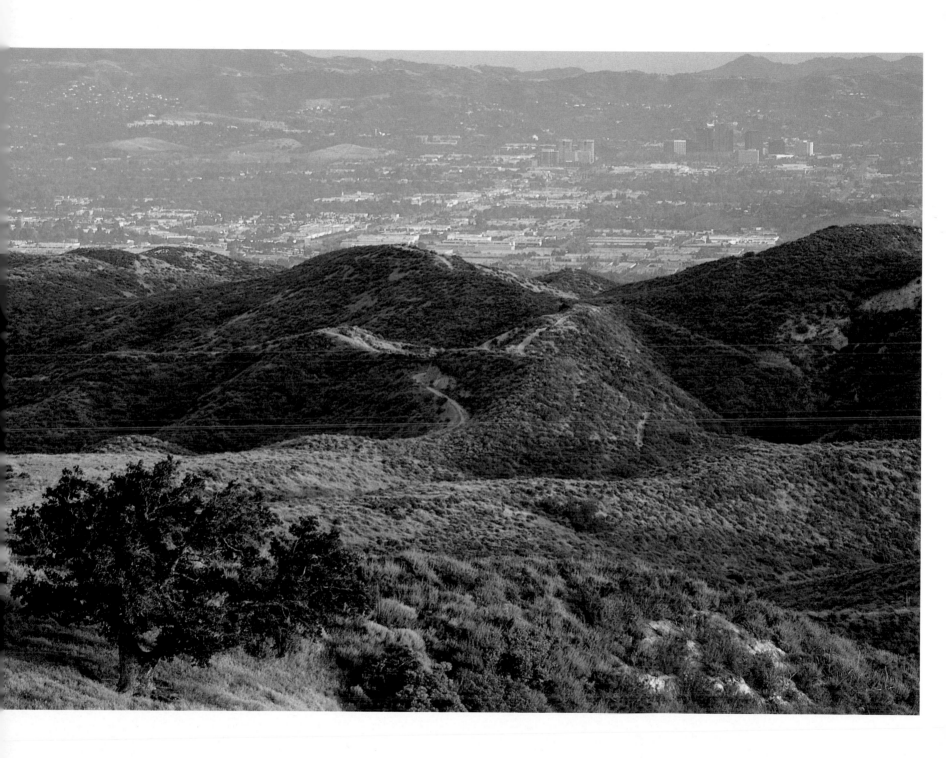

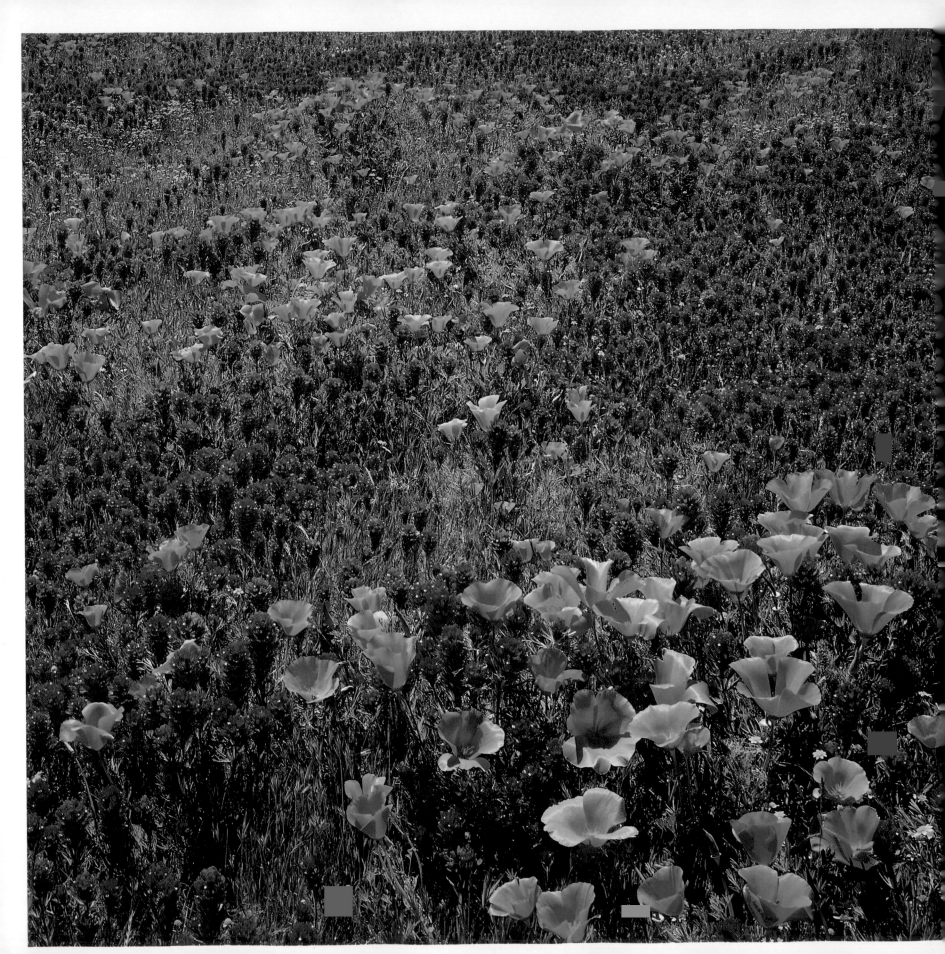

opposite: *Poppies and purple owl's clover*

city that has always looked to its boundaries to build out, to one that focuses on a new Los Angeles—one that is less car-dependent and that protects its last wild places."

This vision requires people coming together in their local communities to find the money and political will needed to restore the region's natural heritage, to the extent still possible. Projects such as those already in progress along the Los Angeles River—creating bicycle trails and miles-long stretches of parkland—are means for securing Wild L.A.'s future.

Conservation activism is not new to Southern California, although it often seems as if too little was done far too late here. Dave Brown, Conservation Chair of the Sierra Club's Santa Monica Mountains Task Force, for decades a front-line activist in the many battles to create the Santa Monica Mountains National Recreation Area, offers his perspective on why Los Angeles has by far the smallest amount of wild acreage and parks per citizen of any major city in America—less than one acre per thousand people, only one-third the national average.

"The environmental movement was late in coming to Los Angeles for a number of reasons," says Brown. "Its people have no roots in the Mediterranean ecosystem. Unlike in the East and Midwest, where kids grow up within nature, catching frogs and having a rich experience of the wild, it's brown and dry here more than half the year. Few think of the Mediterranean climate's hot summers and short, wet winters as a 'normal' green environment. So to be successful in environmental causes, we need to help our citizens understand the specialized workings and unique survival systems of plants and animals, developed over millions of years to fit this ecosystem."

Brown remembers all too well that there were no state parks in Los Angeles until the 1970s. Today there are dozens. "It all started slowly. We had nothing like Mount Tamalpais outside San Francisco, no place close to the city other than Griffith Park where people could go and experience nature. What movement there was, was disorganized, whereas the land developers and the politicians they influenced were very powerful and highly motivated. Today there is a growing environmental momentum, through citizen activism and lots of press coverage."

Since the time Europeans first entered the Los Angeles Basin and saw what Father Juan Crespi then described as "a spacious valley, well grown with cottonwoods and alders, among which ran a beautiful river," until the twentieth century, only a few areas were recognized and protected for their uncommon natural beauty.

Santa Catalina Island, twenty-two miles off the coast of Los Angeles, is considered one of the world's great ecological treasures, rich in plant and animal species, including fifteen found nowhere else on Earth. In the eighteenth and nineteenth centuries, sailors, fishermen, and visitors also praised its seventy-six square miles of mountains, valleys, and pristine beaches as a natural paradise. Over the centuries, however, the island was scarred by extensive livestock

opposite: *The iron-hard bark of a mature manzanita bush, near Switzer Falls, San Gabriel Mountains*

breeding and mining. In 1919, chewing-gum magnate William Wrigley, Jr., bought the island for $3 million and began protecting and beautifying it as a country resort. His work was taken up in 1975 by the Catalina Island Conservancy, which now owns 88 percent—more than 42,000 acres—of restored open space on Catalina.

In a similar manner, the Santa Monica Mountains National Recreation Area would not exist today if not for efforts begun early in the last century to save the lands it encompasses. In 1930, a document known as the Olmstead Report lauded the ecological value of what remains today the only unspoiled American mountain range with both coastal and mountain ecosystems in the midst of a major metropolitan area.

In 1979, the Santa Monica Mountains Conservancy (SMMC) was created by the California State Legislature to acquire, restore, and preserve lands to form interlinking habitats easily accessible to the general public. The SMMC's purview today extends to a huge swath of wild country that sweeps around the northern half of Los Angeles, from the Oxnard Plain to Glendale.

Master plans work best when implemented on the local level, as seen in the success of the Santa Susana Mountains Park Association. Its members began work in 1970 to preserve the Santa Susana Mountains and Simi Hills from explosive suburban growth in the San Fernando and Simi Valleys. In 1998, Santa Susana Pass State Historic Park was inaugurated. The project was just one of many that vision-aries hope will culminate in a Rim of the Valley Trail Corridor National Recreation Area. Ideally, this new stretch of connected open lands would join with the Santa Monica Mountains National Recreation Area (SMMNRA) to bestow a rich heritage upon future generations. A good part of that vision is already in place.

The key question is how we will ensure that there is a future for a Wild L.A. with the fiercely growing pressures on wild lands caused by population growth. It is projected that 6 million people will be added to Los Angeles by the year 2020—the equivalent of two Chicagos. The potential for losing more wild lands is significant.

In a poignant reminiscence, nature photographer Gary Valle describes his experience of a conservation defeat: the loss to development of the western extension of Porter Ranch, in the foothills of the Santa Susana Mountains. "I feel very strongly about the value of wild areas near urban populations and the need to preserve undeveloped land, however small the parcel. The hiking, running, climbing, skiing, hang gliding, mountain biking, and kayaking I have done in these areas have just been poor excuses to get out-side and explore. You don't have to go to exotic locales like Borneo to find wild places; they are all around us, right here in Los Angeles.

"I had become intimately familiar with the plants, animals, and land in Porter Ranch. One afternoon when the bulldozing had just begun, I was compelled to go out and photograph the damage. I came across a huge pile of

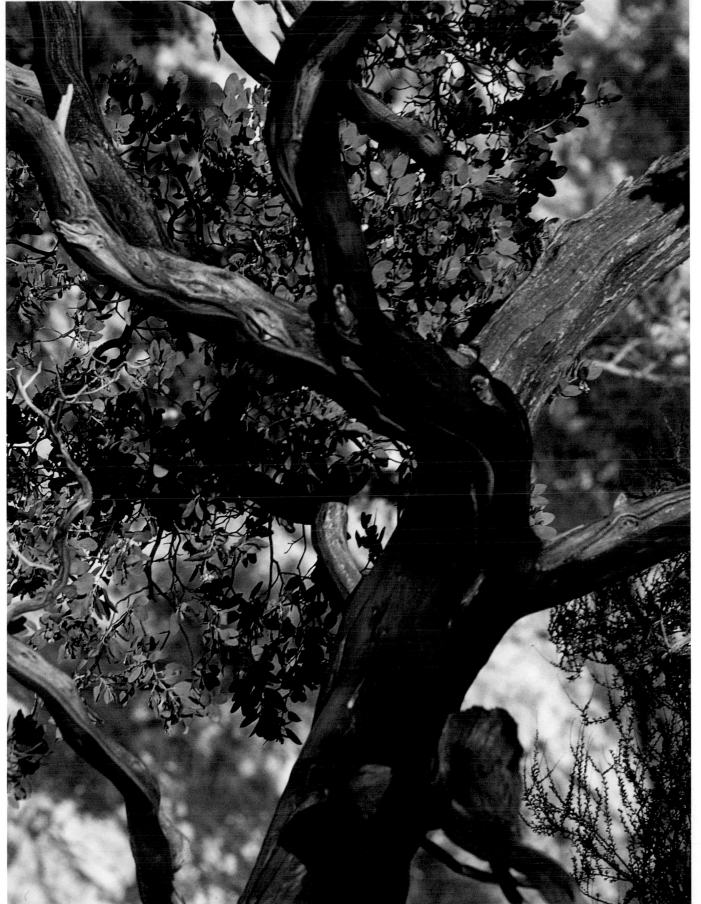

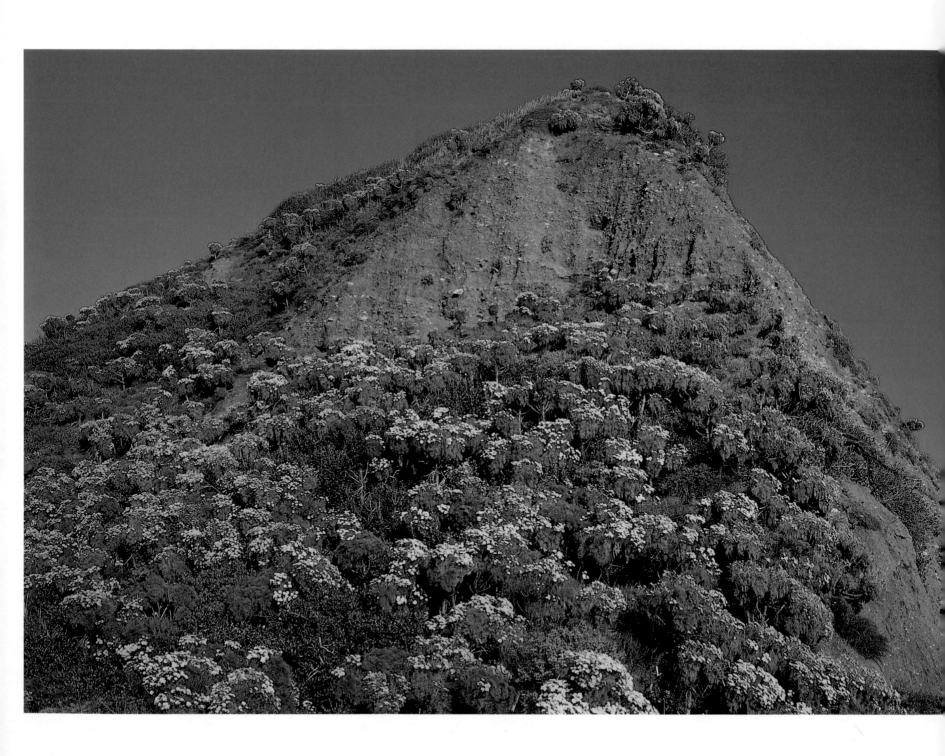

opposite: *Giant coreopsis in spring bloom*

bulldozed chaparral. A pair of scrub jays anxiously jumped from broken branch to broken branch of a ravaged laurel sumac, searching for their nest, their home. It hurt to see it all destroyed."

Dave Brown laments the loss of a parcel of land adjacent to Malibu Creek State Park that the Sierra Club fought to protect for many years. "Its 4,000 acres of hill-ringed valley would have made an ideal main visitor center for the park, just forty-five minutes from downtown L.A. Kids could have come for a couple of days to see deer in the meadows at sunset and hear coyotes howling at night. Instead, a large organization will build a huge complex of buildings there."

Brown also laments the gradual attrition of wild lands, from individual estates that nibble away at uncluttered vistas to small, picturesque valleys filled and developed into suburban communities instead of becoming additions to existing parks and reserves.

One major confrontation still looms large on many conservationist agendas: Newhall Ranch, just north of the San Fernando Valley. Urban sprawl has reached a practical limit against the surrounding foothills of the heavily suburbanized Santa Clarita Valley. The Santa Clara River, one of only two natural river systems remaining in Southern California, and one of its largest watersheds, runs right by the proposed development.

Newhall Ranch would house 70,000 people in 21,600 new homes: the largest housing development in Los Angeles history. It would threaten 12,000 acres of some of the most pristine open space left in all of Los Angeles County, in an area already known for some of the worst traffic and air pollution in Southern California.

Other key battle zones include the Ballona Wetlands on Santa Monica Bay. Playa Vista is a huge proposed housing and commercial development that would destroy the 1,087-acre ecosystem, the last natural coastal wetland in Los Angeles and a major part of the remaining 5 percent of all of Southern California's wetlands. A scientist recently described the site as the worst possible place in all of California to build a new community. If not for environmental lawsuits in the courts, the development would already be a done deal. A battalion of organizations continues to fight the project, among them Ballona Wetlands Land Trust, Sierra Club, Citizens United to Save All of Ballona, EarthWays Foundation, Wetlands Action Network, SaveBALLONA.com, and the Surfrider Foundation.

Another battle involves a proposed toll road to alleviate traffic congestion on Highway 91 between Riverside and Orange Counties that would run right through the Cleveland National Forest, damaging the ecosystem. Bill Corcoran warns that "these kinds of threats will continue to endanger Wild L.A. as long as our public officials still resort to old solutions that have never effectively solved the problem and that have robbed us of far too much already. We need more creative solutions than cutting highways through remaining open space. Why not, for example, create jobs closer to homes so workers aren't forced to commute forty miles?"

opposite: *One of the few perennial streams in the Santa Monica Mountains, at Solstice Canyon*

Still another assault on the natural environment is being faced in the Verdugo Mountains, which are threatened by Oakmont View V, a high-end, 572-home development that would scar a large hillside and halt access to hiking trails. The project illustrates the ongoing pressures to fill in canyons and tear down ridges throughout the region.

The challenge to wilderness is clear. As Dave Brown says, "Wherever open space remains, you have to save it—save it now—or you lose it."

Bill Corcoran sees daily evidence of the good work being done by conservancies and other groups. "But they can only purchase land once the owners decide to sell it," he says. "People need to organize to demand protection for land. To raise county or state or federal money to go toward the purchase of property—and we need a lot because it's so expensive now—we need to band together and influence public officials. That's where the Sierra Club's grassroots motto is perhaps most apt: 'Organized people against organized money.' When elected officials are confronted by angry citizens who demand something be done, they don't know how to get around that. Get enough people organized and you've got a big weapon for change."

A recent case in point concerned a proposal to replace cottages in the historic district of Crystal Cove State Park with a $400-per-night resort. "The park will pay for itself!" crowed supporters of the project. But on January 18, 2001, 700 local citizens attended a meeting and "pretty much yelled at the park's director for two hours," says Corcoran.

Two months later, the California Coastal Conservancy voted to spend up to $2 million to make the developer go away," he adds. "People were angry that the state government had betrayed the public trust by signing a contract with the developer behind closed doors."

Looking to the future, the trend in efforts to ensure a Wild L.A. will focus more on restoration, rather than acquisition, of wild areas. Projects to restore the Los Angeles River are prime examples. Millions of dollars of civic funds are earmarked for projects such as converting defunct railroad yards into natural habitat sections within a Los Angeles River Park, much as the Sepulveda Basin Wildlife Reserve created a wetland out of an old clay quarry. Friends of the L.A. River (FoLAR), in partnership with a broad range of environmental groups, has helped create a number of restoration projects currently under way.

Another recent turnaround came from the very agency most responsible for the original channelizing of the river—the Los Angeles County Department of Public Works—which created a new division dedicated to watershed management. Turning away from the decades-long policy of shunting storm-water out of the Los Angeles Basin as quickly as possible, the new agency is pushing for private and public construction methods that encourage absorption of water into the ground.

Part and parcel of the new spirit in government is the development, in cooperation with environmental organizations and city agencies, of new wildlife habitats and

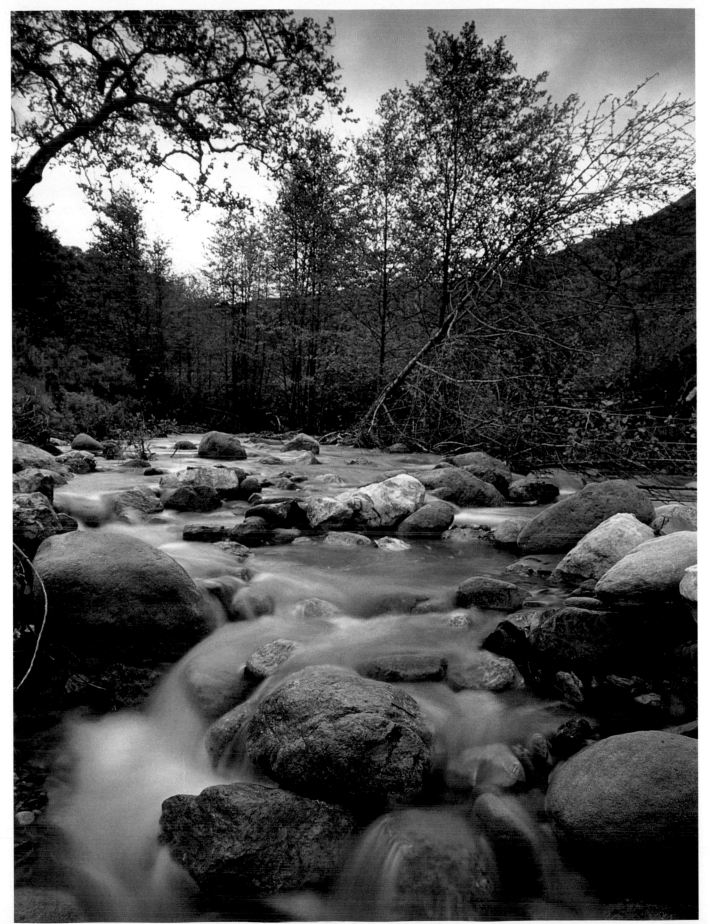

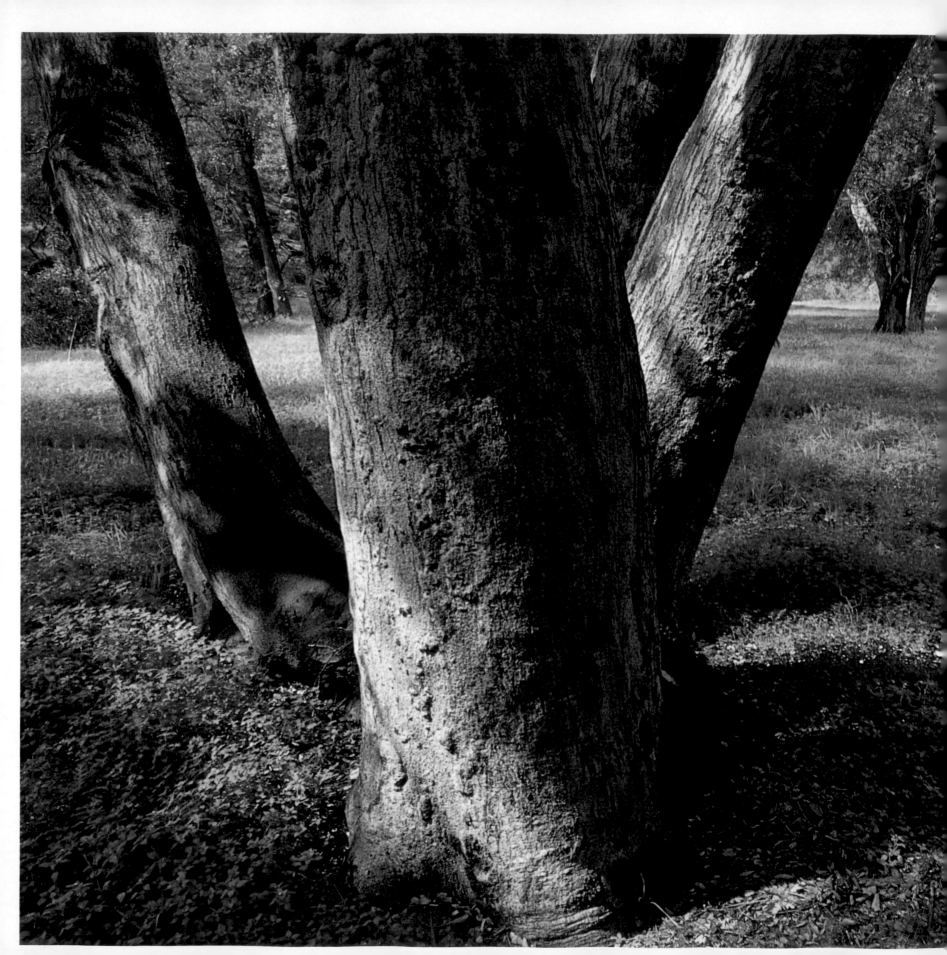

opposite: *Shady grove along China Flat Trail, Palo Comado Canyon* below: *Red maids, Santa Rosa Plateau Ecological Reserve*

alternative natural and recreational areas where flood control will remain functional, but without always resorting to the concrete-channel solution. The hope is that this "green" approach will recharge underground water aquifers while reducing the delivery of trash and contaminants to ocean waters.

"People say that it's too late to save the L.A. River," says Bill Corcoran, "but which river are we talking about? The limpid stream Father Crespi found, with steelhead and grizzlies? Yes, that river is indeed gone. But it has many sections that, treated with more respect, will bring nature—in the form of recreational opportunities and open space—to communities that have been denied such benefits for a very long time. We have to think about what we want. Do we want to make developers wealthy, or build a more livable community?"

The question is compelling. I think of Julia in San Clemente and her contributions, multiplied by a million people, each sending just one e-mail to a representative or writing a poem about wilderness for a local conservation newsletter. I think of the boy in Orange County who created a fund to protect the mountain lion. So far, he has collected $1,500. Imagine if that effort were multiplied by even 1,000.

And I imagine a time, perhaps next summer, when I walk along the Santa Monica Mountains Backbone Trail. Out at sea, the moist marine layer sends puffs of clouds up through the haze, to hover over Sandstone Peak and its chaparral gleaming in the sunset. My daughters, grown now, walk beside me. We hold hands like we always have, smiling and happy, and look out toward the vast urban sea of Los Angeles beyond these wild highlands. The windows of distant skyscrapers and houses reflect the golden sun like pirate's plunder.

Tomorrow, each of us will go back to work alongside the teeming millions who live in that distant maze. But we'll have this place, right here beneath our feet, to come back to. That, I think, is the best treasure of all: a Wild L.A., forever, waiting to receive all the smiling children yet to come.

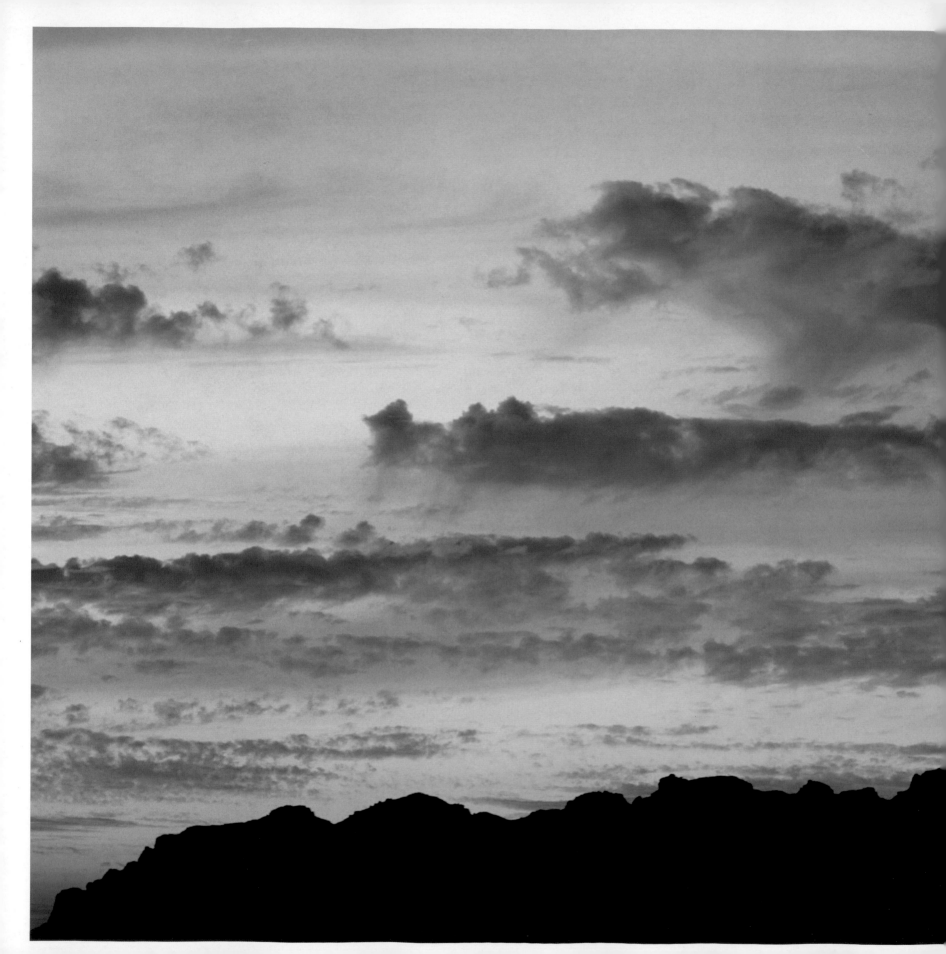

opposite: *Sunrise over Boney Ridge, Point Mugu State Park*

Bibliography

Alden, Peter. *National Audubon Society Field Guide to California.* New York: Knopf, 1998.

Austin, Mary Hunter. *The Land of Little Rain.* London: Penguin Nature Classics Series, 1997.

Bakker, Elna S. *An Island Called California: An Ecological Introduction to Its Natural Communities.* Berkeley: University of California Press, 1984.

Dawson, E. Yale. *Seashore Plants of California.* Berkeley: University of California Press, 1982.

Fisher, Chris C., and Herbert Clarke. *Birds of Los Angeles: Including Santa Barbara, Ventura, and Orange Counties.* Renton, WA: Lone Pine Publishing, 1997.

Fradkin, Philip L. *The Seven States of California: A Natural and Human History.* Berkeley: University of California Press, 1997.

Gumprecht, Blake. *The Los Angeles River: Its Life, Death, and Possible Rebirth.* Baltimore: Johns Hopkins University Press, 1999.

Hinton, Sam. *Seashore Life of Southern California : An Introduction to the Animal Life of California Beaches South of Santa Barbara.* Berkeley: University of California Press, 1989.

Jameson, Everett William. *California Mammals.* Berkeley: University of California Press, 1989.

Johnston, Verna R. *California Forests and Woodlands: A Natural History.* Berkeley: University of California Press, 1996.

Jorgen, Randolph. *Mountains to Ocean: A Guide to the Santa Monica Mountains National Recreation Area.* Tucson: Southwest Parks and Monuments Association, 1995.

Kling, Rob, Spencer Olin, and Mark Poster, eds. *Postsuburban California: The Transformation of Orange County Since World War II.* Berkeley: University of California Press, 1995.

Lillard, Richard. *My Urban Wilderness in the Hollywood Hills.* Lanham, MD: University Press of America, 1983.

Martin, Terrance D. *Santa Catalina Island: The Story Behind the Scenery.* Las Vegas: KC Publications, 1984.

McClurg, Sue. *Water and the Shaping of California: A Literary, Political, and Technological Perspective on the Power of Water.* Berkeley: Heyday Books, 2000.

Merchant, Carolyn, ed. *Green Versus Gold: Sources in California's Environmental History.* Washington, DC: Island Press, 1998.

Muir, John. *Nature Writings: The Story of My Boyhood and Youth; My First Summer in the Sierra; The Mountains of California; Stickeen; Essays.* Edited by William Cronon. New York: Library of America, 1997.

Robinson, John W. *Trails of the Angeles: 100 Hikes in the San Gabriels.* Berkeley: Wilderness Press, 1998.

Schad, Jerry. *101 Hikes in Southern California: Exploring Mountains, Seashore and Desert.* Berkeley: Wilderness Press, 1996.

Schoenherr, Allan A. *A Natural History of California.* Berkeley: University of California Press, 1995.

Schoenherr, Allan A., and C. Robert Feldmeth. *Natural History of the Islands of California.* Berkeley: University of California Press, 1999.

Sharp, Robert P., and Allen F. Glazner. *Geology Underfoot in Southern California.* Missoula, MT: Mountain Press Publishing, 1993.

Sheldon, Ian. *Animal Tracks of Southern California.* Renton, WA: Lone Pine Publishing, 1998.

Stienstra, Tom. *California Wildlife: A Practical Guide.* Emeryville, CA: Avalon Travel Publishing, 2000.

Stone, Robert B. *Day Hikes Around Los Angeles: 45 Great Hikes.* Red Lodge, MT: Day Hike Books, 2000.

Wheat, Frank. *California Desert Miracle: The Fight for Desert Parks and Wilderness.* El Cajon, CA: Sunbelt Publications, 1999.

Wuerthner, George. *California's Wilderness Areas: The Complete Guide. Vol. 1, Mountains and Coastal Ranges.* Englewood, CO: Westcliffe Publishers, 1997.

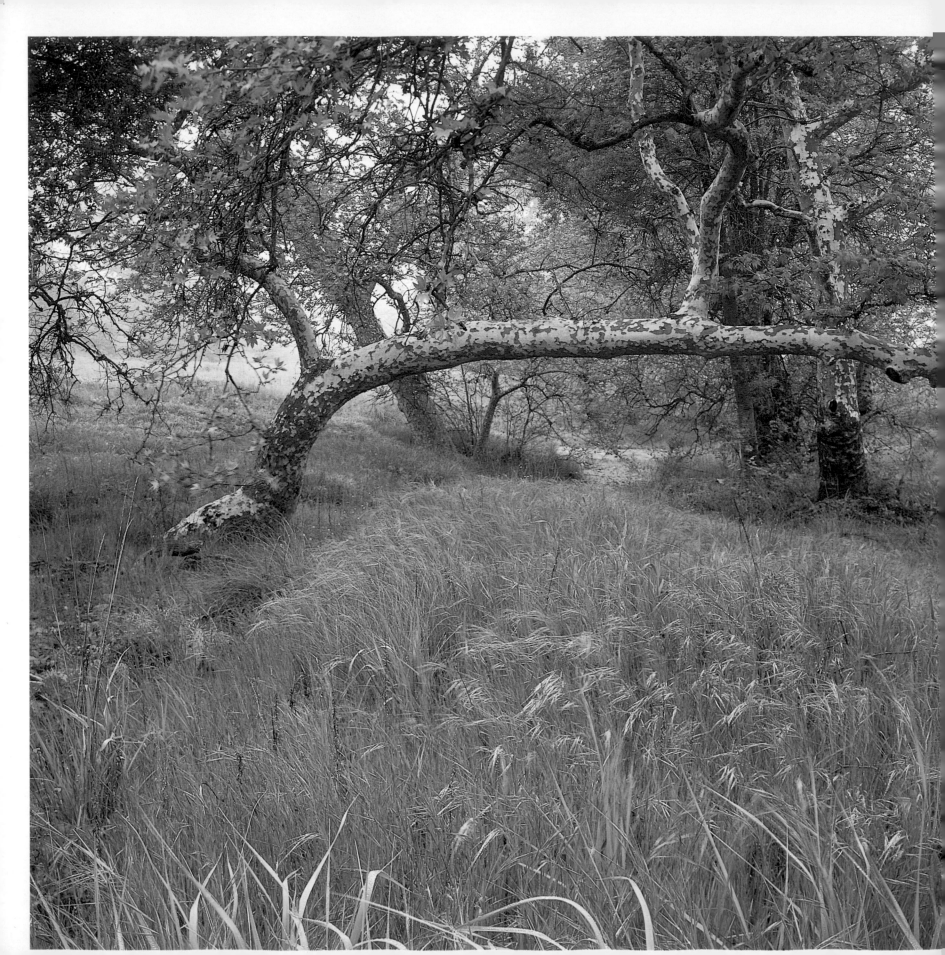

opposite: *Trail through a sycamore grove, Santa Rosa Plateau Ecological Reserve*

Agencies and Organizations

American Land Conservancy
1388 Sutter Street, Suite 810
San Francisco, CA 94109
415-749-3010
www.alcnet.org

American Oceans Campaign
6030 Wilshire Boulevard, Suite 400
Los Angeles, CA 90036
323-936-8242
www.americanoceans.org

Ballona Wetlands Land Trust
P.O. Box 5623
Playa del Rey, CA 90296
310-338-1413; 877-WETLAND
www.ballona.org

Bolsa Chica Land Trust
207 21st Street
Huntington Beach, CA 92648
714-964-8170
www.bolsachicalandtrust.org

California Coast Coalition
1133 Second Street, Suite G
Encinitas, CA 92024
760-944-3564
www.calcoast.org

California League of Conservation
Voters
10780 Santa Monica Boulevard,
Suite 210
Los Angeles, CA 90025
310-441-4162
www.ecovote.org

California Native Plant Society
1722 J Street, Suite 17
Sacramento, CA 95814
916-447-2677
www.cnps.org

California Public Interest Research
Group (CALPIRG)
3435 Wilshire Boulevard, #385
Los Angeles, CA 90010
213-251-3680
www.pirg.org/calpirg

California Raptor Center
School of Veterinary Medicine
University of California
Davis, CA 95616
www.vetmed.ucdavis.edu/ars/raptor.htm

California State Parks
California Department of Parks and
Recreation
P.O. Box 942896
Sacramento, CA 94296-0001
www.parks.ca.gov

Center for Biological Diversity
P.O. Box 710
Tucson, AZ 85702
520-623-5252
www.sw-center.org

Children's Nature Institute
1440 Harvard Street
310-998-1151
Santa Monica, CA 90404
www.childrensnatureinstitute.org

Christian Environmental
Association/Target Earth
Hopyard Road
Pleasanton, CA 94588
925-462-2439
www.targetearth.org

Friends of Ahmanson Ranch
21755 Ventura Boulevard, #207
Woodland Hills, CA 91364
818-386-5998
www.ahmansonranch.com

Friends of the Foothills
P.O. Box 3942
San Clemente, CA 92674
949-361-7534
www.friendsofthefoothills.org

Friends of the L.A. River (FoLAR)
570 W. Avenue 26, #250
Los Angeles, CA 90065
323-223-0585; 800-LARIVER
www.folar.org

Friends of Satwiwa
41126 Potrero Road
Newbury Park, CA 91320
805-499-2837
www.nps.gov/samo/fos

Gabrieliño/Tongva Tribal Council
P.O. Box 693
San Gabriel, CA 91776
626-286-1632
www.tongva.com

Global Green USA
227 Broadway, Suite 302
Santa Monica, CA 90401
310-394-7700
www.globalgreen.org

Green Party of Los Angeles County
2811 Pico Boulevard
Santa Monica, CA 90405-1919
310-449-1882
www.flatworld.net/greens

Heal the Bay
3220 Nebraska Avenue
Santa Monica, CA 90404
310-453-0395; 800-HEALBAY
(CA only)
www.healthebay.org

Los Angeles Audubon Society
7377 Santa Monica Boulevard
West Hollywood, CA 90046
323-876-0202
www.laaudubon.org

Los Angeles and San Gabriel Rivers
Watershed Council
111 North Hope Street, Suite 627
Los Angeles, CA 90012
213-367-4111
www.lasgriverswatershed.org

Mountains Restoration Trust
7050 Owensmouth Avenue, Suite 206
Canoga Park, California 91303
818-346-9675
www.mountainstrust.org

National Park Service Headquarters
and Information Center
401 West Hillcrest Drive
Thousand Oaks, CA 91360
Headquarters: 805-370-2300
Visitor information: 805-370-2301
www.nps.gov

Native Habitats
17287 Skyline Boulevard, #102
Woodside, CA 94062-3780
www.nativehabitats.org

Natural Resources Defense Council
(NRDC)
6310 San Vicente Boulevard #250
Los Angeles, CA 90048
323-934-6900
www.nrdc.org

The Nature Conservancy of California
201 Mission Street, 4th Floor
San Francisco, CA 94105
415-777-0487
www.tnccalifornia.com

Newport Bay Naturalists and Friends
600 Shellmaker Road
Newport Beach, CA 92660
949-640-6746
www.newportbay.org

Orange County CoastKeeper
441 Old Newport Boulevard, Suite 103
Newport Beach, CA 92663
949-723-5424
www.coastkeeper.org

Rancho Mission Viejo Land
Conservancy
P.O. Box 802
San Juan Capistrano, CA 92693
949-489-9778
www.theconservancy.org

Santa Catalina Island Conservancy
P.O. Box 2739
Avalon, CA 90704
310-510-2595
www.catalina.com/conservancy.html

Santa Clarita Organization for Planning
the Environment (SCOPE)
P.O. Box 1182
Canyon Country, CA 91386-1182
www.scope.org

Santa Monica Bay Restoration Project
320 W. Fourth Street, 2nd Floor
Los Angeles, CA 90013
213-576-6615
www.smbay.org

Santa Monica Mountains Conservancy
5750 Ramirez Canyon Road
Malibu, CA 90265
310-589-3200
www.ceres.ca.gov/smmc

Sierra Club, Angeles Chapter
3435 Wilshire Boulevard, Suite 320
Los Angeles, CA 90010
213-387-4287
www.angeles.sierraclub.org

Society for Ecological Restoration
1955 W. Grant Road, #150
Tucson, AZ 85745
520-622-5485
www.ser.org

Surfrider Foundation USA
122 S. El Camino Real #67
San Clemente, CA 92672
949-492-8170
www.surfrider.org

Wetlands Action Network
P.O. Box 1145
Malibu, CA 90265
310-456-5604
www.wetlandact.org

Whale Rescue Team
115 South Topanga Canyon Boulevard
Topanga, CA 90290
whalerescue@earthlink.net

The Wilderness Society
1615 M Street, NW
Washington, DC 20036
800-THE-WILD
www.wilderness.org

Wildlife Waystation
14831 Little Tujunga Canyon Road
Angeles National Forest, CA 91342-5999
818-899-5201
www.waystation.org

Photographer Credits

Scott Atkinson: 99, 102, 103, 118, 124, 125

Noella Ballenger: 31, 105

Frank S. Balthis: 23, 51, 59, 114

Carr Clifton: 10–11, 126, 136

Craig Collins: 91, 92, 95, 113, 117, 177

Kathleen Norris Cook: 24, 82–83, 87, 130, 132–133, 148–149

Ed Cooper: 128–129

Don DesJardin: 43, 64, 72, 85, 119, 131, 145, 176

Tom Gamache: 2–3, 4–5, 8, 14–15, 20, 34, 35, 36, 37, 38–39, 40, 41, 42, 44, 45, 46, 49, 50, 53, 60, 62–63, 65, 66, 67, 69, 71, 74, 75, 76, 79, 80, 84, 88, 96, 174, 175, 182, 185, 188

Jeff Gnass: 106–107, 110, 111, 178

John Hendrickson: 48, 78, 140

Richard Jackson: 12, 21, 25, 28, 52, 57, 61, 77, 123, 150, 154, 157, 158, 159, 160–161, 162, 163, 165, 169, 170–171, 173

Galen Rowell/Mountain Light: 16

Santa Monica Mountains Conservancy, 186

William Smithey, Jr.: 54–55, 166–167

Ron and Patty Thomas Photography: 138–139, 155, 172, 190

Larry Ulrich: 19, 32, 56, 73, 109, 122, 143, 144, 147, 151, 153, 164, 187

Gary Valle: 135, 181

Deidra Walpole: 7, 58, 70, 90, 97, 100–101, 121